Low 'n slow
LOWRIDING IN NEW MEXICO

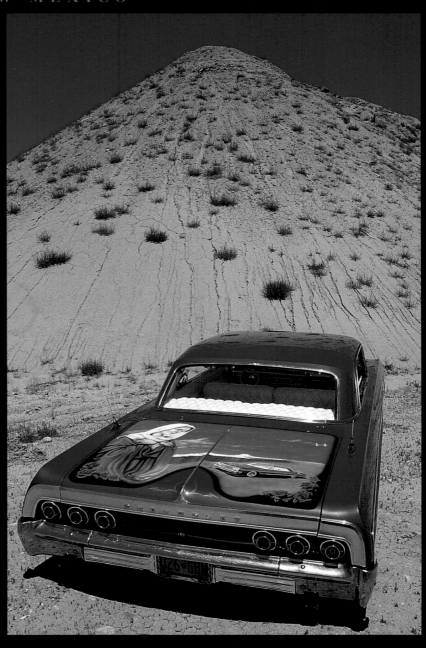

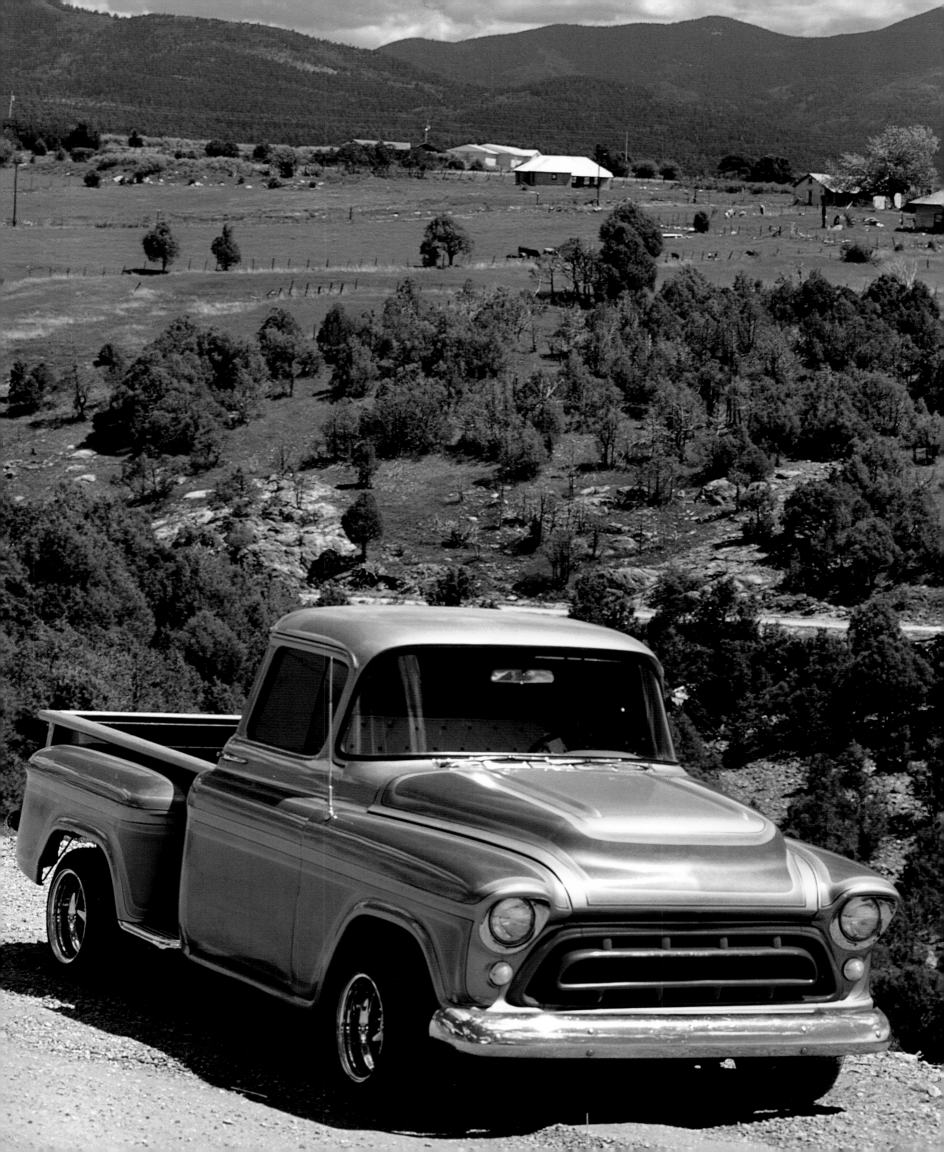

Low 'n slow

LOWRIDING IN NEW MEXICO

PHOTOGRAPHS BY JACK PARSONS
TEXT BY CARMELLA PADILLA
POETRY BY JUAN ESTEVAN ARELLANO

MUSEUM OF NEW MEXICO PRESS
SANTA FE

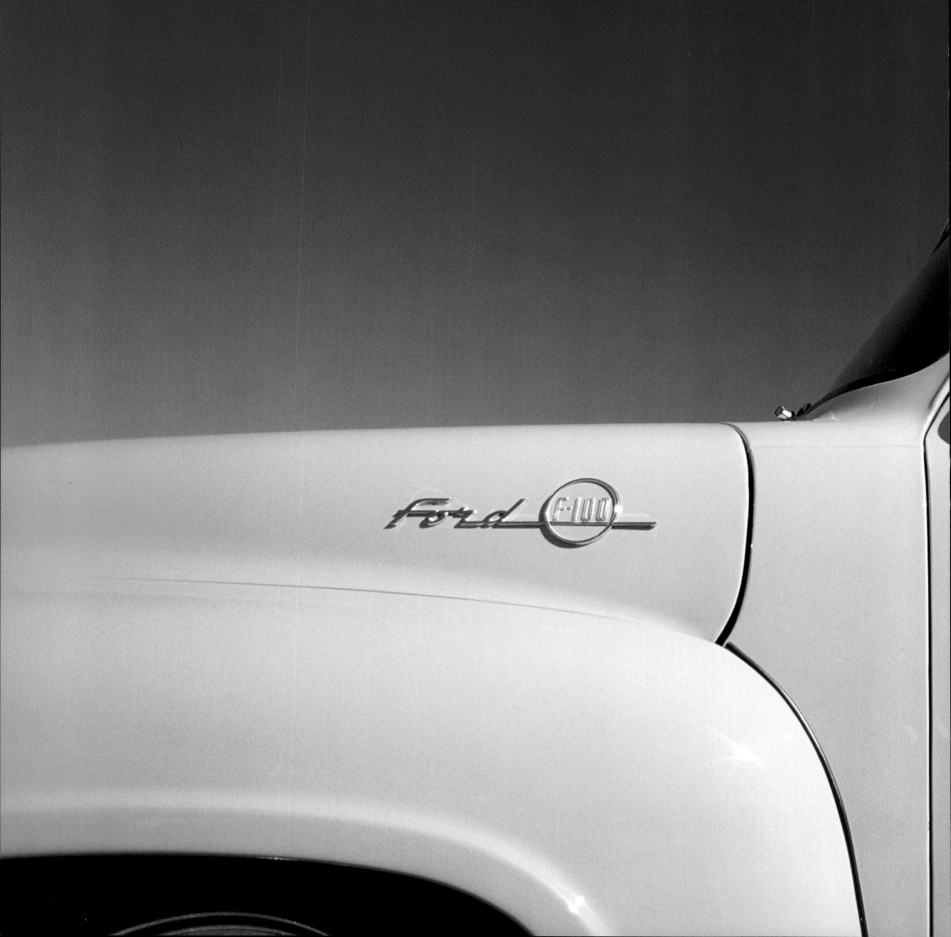

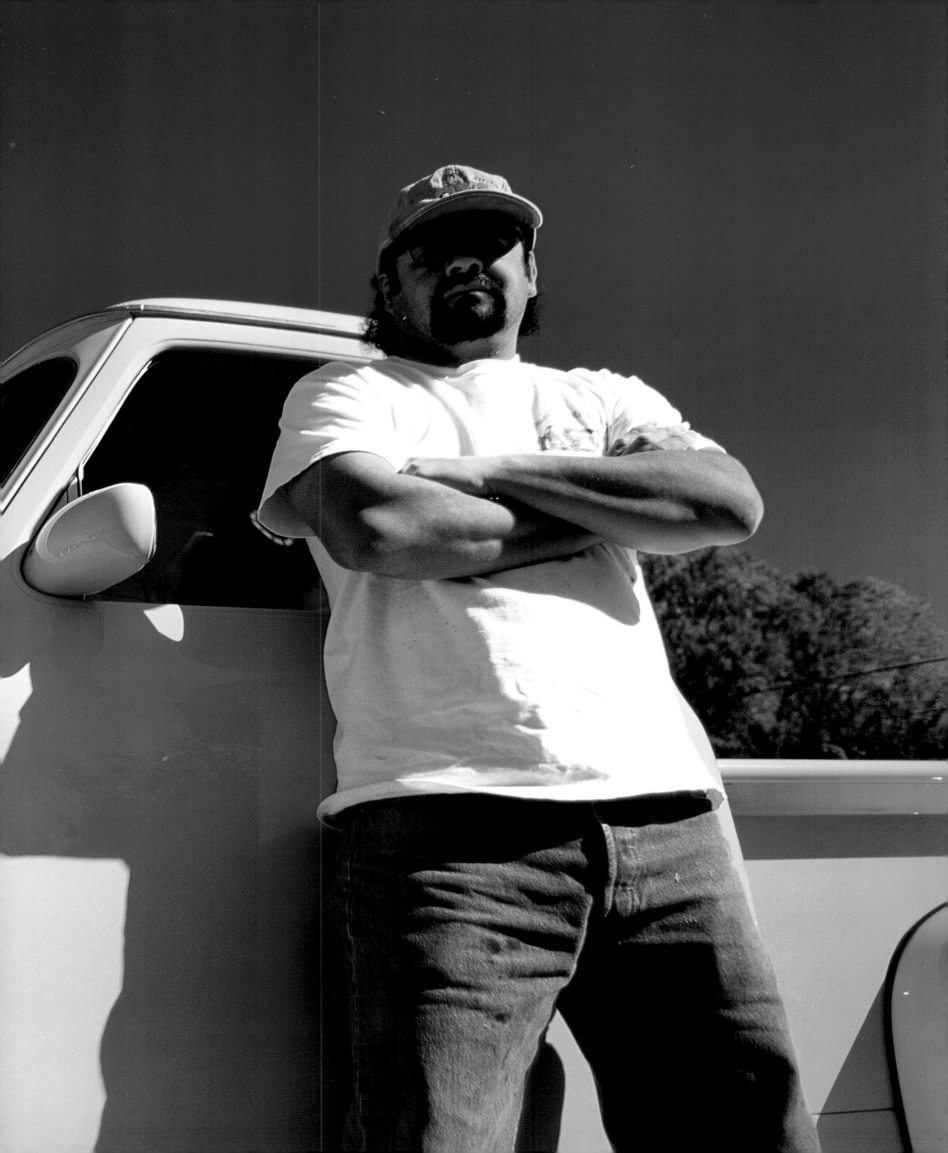

For Patrizia, who got me started,
and for Becky, Chris, and Alex.

With Love,
Jack

For Luis,
whose lowrider knowledge and unwavering support helped
me maneuver many rocky roads throughout this project.

Con Amor,
Carmella

Project Editor: Mary Wachs
Designer: David Skolkin
Typeset in Bauer Bodoni with Snell display
Manufactured in Hong Kong at C+C Offset Printing Co., Ltd.

10 9 8 7 6 5 4 3 2 1

Library of Congress Cataloging-in-Publication Data

Parsons, Jack, 1939-
 Low 'n slow : lowriding in New Mexico / photographs by Jack Parsons ; text by Carmella Padilla : three poems by Juan Estevan Arellano.
p. cm.
 ISBN 0-89013-372-7. – ISBN 0-89013-373-5 (pbk.)
1. Mexican Americans—New Mexico—Social life and customs—Pictorial works.
2 Mexican-Americans—New Mexico—Social life and customs. 3. Lowriders—New Mexico—Pictorial works. 4. Lowriders—New Mexico. 5. New Mexico—Social life and customs—Pictorial works. 6. New Mexico—Social life and customs. I. Padilla, Carmella. II Arellano, Juan Estevan. III. Title.
 F805.M5P37 1999 98-31198
 978.9´0046872073—dc21 CIP

MUSEUM OF NEW MEXICO PRESS
POST OFFICE BOX 2087
SANTA FE, NEW MEXICO 87504

page i
'64 Chevy Impala
Owner Eddie Gallegos of El Llano

page ii
'57 Chevy pickup
Owner Dean Tafoya of Truchas

page iv–v
'54 Ford F100
Owner Clarence Pacheco of Santa Fe

Contents

'52 Chevy Fleetline
Owner Floyd Montoya of Córdova

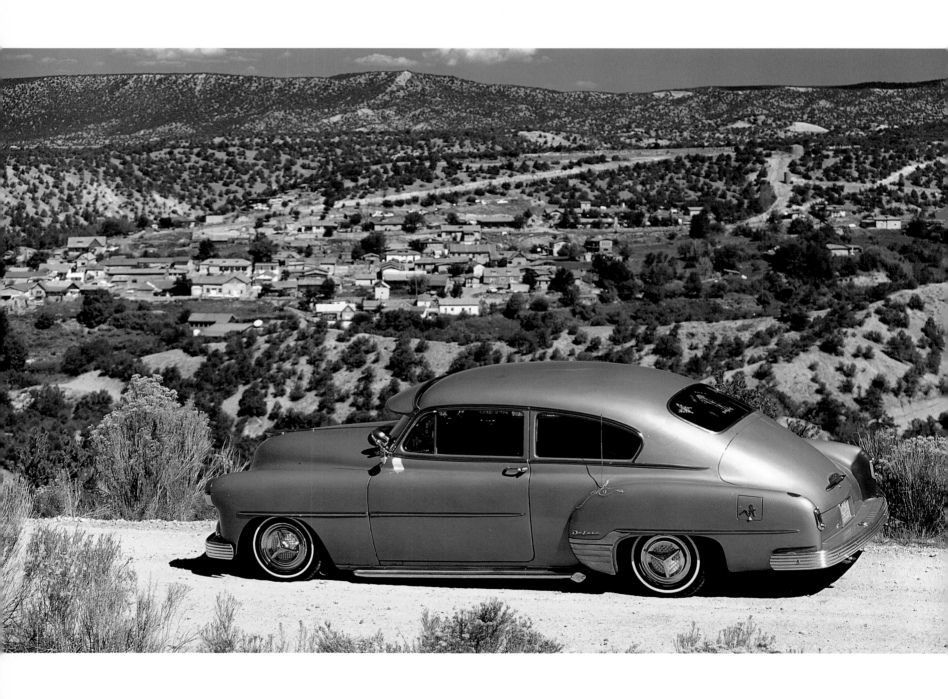

W*hoooosh.*

A balmy, midmorning breeze streams in through the side windows of Floyd Montoya's 1952 Chevrolet Fleetline as he drives at a steady 40-mile-per-hour cruise. After briefly lifting his hands off the steering wheel to adjust his beret, Montoya rests his left elbow upon the open window frame and relaxes his right steering hand into an easy grip. Tattooed biceps bulge beneath the sleeveless shoulders of Montoya's clean white T-shirt, and a gray string of a goatee hangs from his chin. A rosary, green-and-white dice, and various other knickknacks swing from the rearview mirror as the proud pilot gracefully rounds a curve and surveys the landscape before him. All along the hilly roadside, majestic stands of spruce, ponderosa pine, and fir stretch heavenward like pillars holding up the sky.

"If the sun shines and the highway is open, you can bet somebody's going to be out cruising," Montoya says. "This is my everyday car; I cruise it everywhere. I go to Santa Fe, Española, Albuquerque, to Denver. I've been all the way to Elkhorn, Nevada, in it."

On this August morning, Montoya is cruising along New Mexico State Highway 76—the "high road" to Taos—from his home in the mountain village of Córdova. Destination: Chimayó, a scant four miles southwest. One doesn't have to go far, Montoya explains, to reap the benefits of a cruise. Any drive is worth it, he says, when you're going "low and slow."

"How can I describe the feeling I have when I'm in my lowrider?" Montoya continues, switching on the oldies station. He turns the volume up enough to where the wind doesn't drown out the music and the music doesn't interrupt the conversation. "It's like everything in the world stays behind me when I'm going forward in my car."

Ever since 1987, when he tumbled two stories down an elevator shaft, breaking his back and disabling him for life, Montoya has had good reason to want to leave parts of his world behind. The pain and inactivity sent him into a depression made worse by his dependence on alcohol. But once he stopped drinking and started working with cars again, he found reason to move ahead. To date he has redone some twenty cars in all.

"I'm really thankful to God for giving me this trade because it has really helped keep me going in the hard times," he says. "It gives me a feeling of accomplishment. It keeps me going in the right direction."

Montoya had just restored the '52 Fleetline at the time of his accident. He replaced its original parts with everything from power disk brakes and power tilt steering to a push-button starter. "All the goodies of a modern car," he says. Then, he lowered the car as low as it would go.

"My thing has always been to get a Chevy, make it the lowest lowrider I can make, and fix it up till it rides like a Cadillac," he says. "This is it. I call it my Chevylac."

The horn from an approaching automobile momentarily interrupts Montoya as a carload of shrieking teenagers streaks past. He waves and returns the honk, only to be greeted by another horn blast and a thumbs-up

signal from the driver of the car next in line.

"Every time I go out in this, there's nobody that doesn't wave at me," Montoya says with pride. "When I go to Santa Fe, around the old plaza, there's people snapping pictures of me all over the place. I enjoy people noticing my car. It makes me feel kind of special."

Montoya suddenly veers off the sloping road into the dirt parking place in front of La Mesa del Rincon, a tiny drive-up café *cum* mobile home. He leaves the engine humming as he walks to the window to order a couple of Cokes. Then, he carefully folds himself back into the car so the sodas don't spill, turns the car around, and starts back up the road.

Heading north now toward Truchas, the highway grows increasingly steep, prompting Montoya to gun the engine in preparation for the ascent. He races the car for a stretch before resuming a slow cruise and launching into his vision for the future:

"Little kids come around my house to see my car and I try to get them interested because what else is there for them? I tell them that one day, if they want to get into this, that maybe I can help them express themselves. Because that's what makes New Mexico lowriders unique: Everybody's got their own style. Some people like hydraulics, some don't. But everybody does their own thing."

Montoya goes silent now and for the next few minutes just stares straight ahead and drives. The sounds and rhythms of the roadway merge into a strangely soothing lullaby. Nearing the Córdova exit, he shifts his dreamy gaze toward home. As he leaves the highway asphalt for the dusty village road, he sighs.

"One day, if the Lord gives me the time, I plan to cruise this car for three months straight," he says. "I plan to just keep driving without ever coming home."

'63 Ford Thunderbird
Owner Floyd Montoya of Córdova.
Mural by Alexander Rokoff, concept by Jeremy Morelli.

left
detail from Montoya's '52 Chevy Fleetline

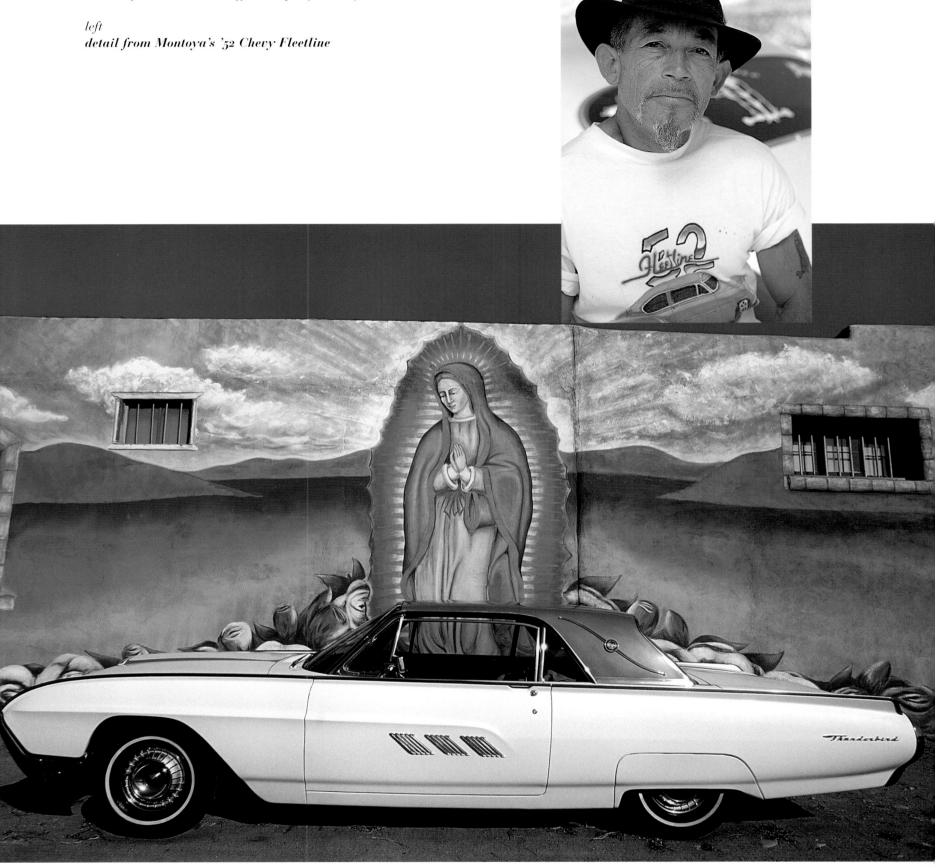

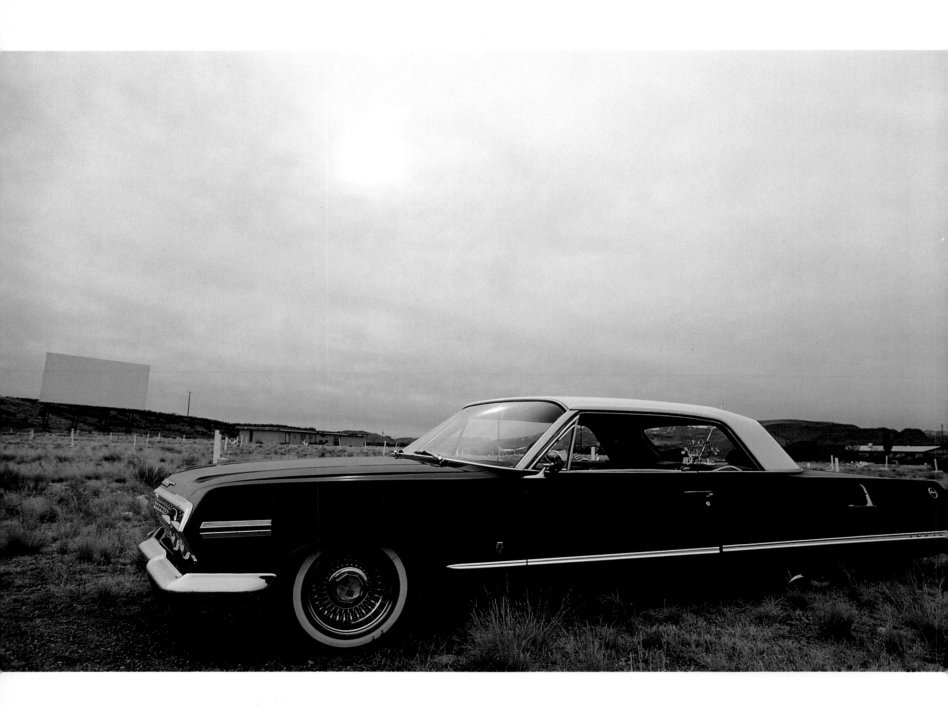

'63 Chevrolet Impala
Owner Carlos Carrillo of Socorro

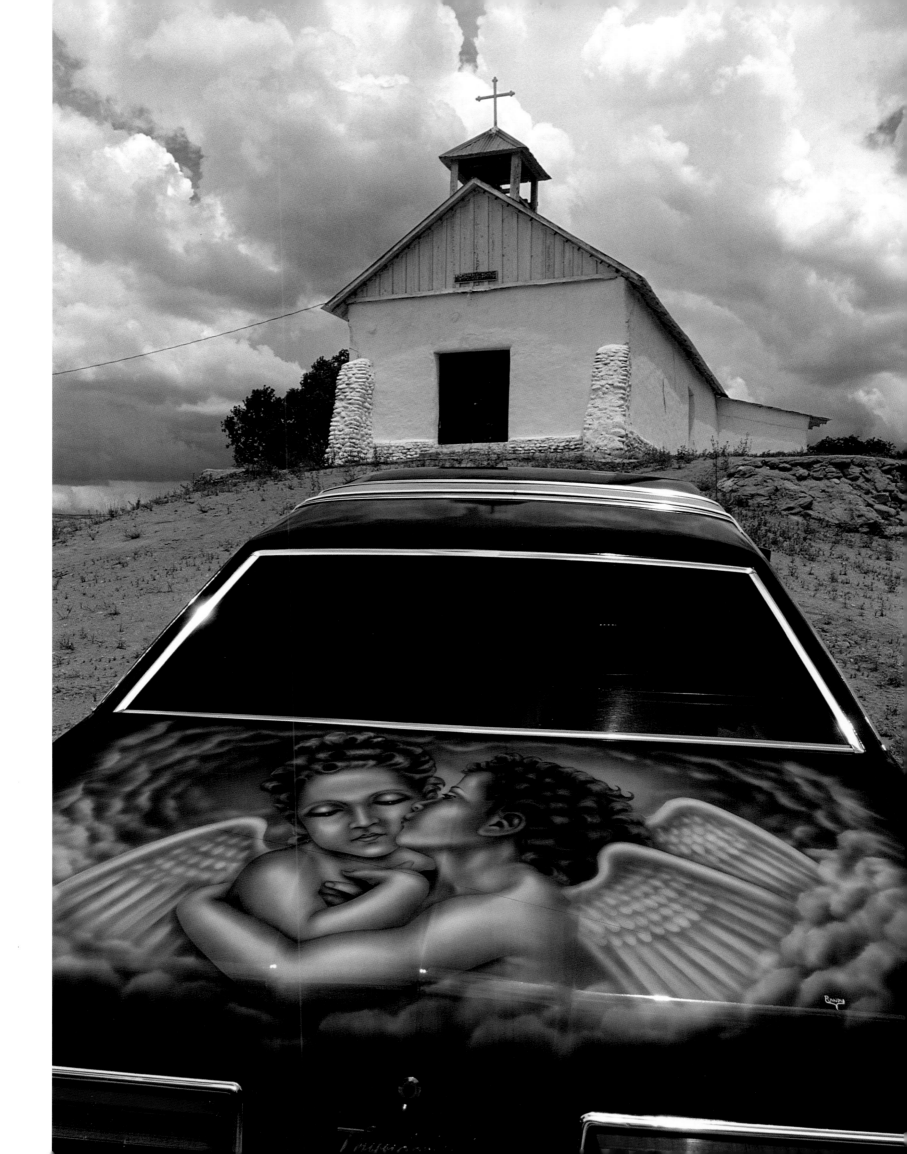

The late Nick Gallegos and son,
Antonio, of Española

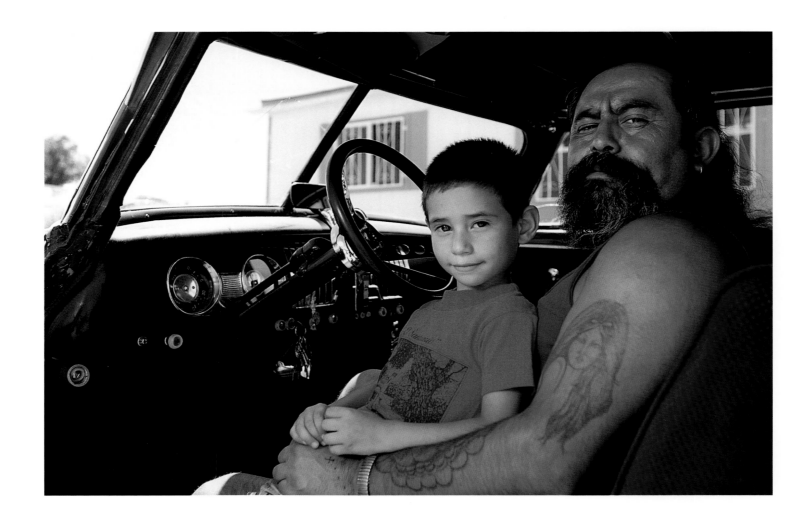

¡Dale Gas!
(Give It Gas!)

The light turns from yellow to red, bringing the midafternoon traffic to a halt. Side by side they sit in the middle of town waiting for the light to change, engines idling, tail pipes shooting exhaust into the dry summer air. The scene is quiet, almost serene, until a long, low '73 Cadillac glides to a stop beside another low-bodied classic. The drivers peer at each other through open side windows, then turn to watch the light turn green.

The light changes, giving the adjacent lowriders their much-anticipated cue. In an instant, the silence is swallowed up by the sound of the engines' thunder as the cars shift into gear and begin an arc of spectacular gyrations. Jumping, jerking, and jolting in great spasms of metal and glass, the cars convulse down main street. Then, their automatic hydraulics switched to off, they resume their fluid cruise down the roadway.

Welcome to Española, New Mexico, the self-proclaimed "Lowrider Capital of the World." It is here in this small town of nearly fifteen thousand that lowriders from across Northern New Mexico have for decades converged. Los Angeles may

have Whittier Boulevard, and San José the intersection of Story and King, but Española has Riverside Drive, the undisputed main drag of the lowrider nation.

If the word "lowrider" were to be found in the dictionary (and usually it is not), it would be defined as a noun that describes either a car whose suspension has been altered in order to lower its body only inches from the ground or one who drives such a car. Beyond the literal definition the lowrider lexicon holds a host of underlying meanings and themes that helps to explain the cultural context in which the cars thrive. From such fundamentals as faith and family to concepts as subjective as art or as exact as economics, New Mexico's lowrider phenomenon rests upon a broad foundation of culture, creativity, and community. Although it shares common ground with the car cultures of Los Angeles or San Antonio, and with the international markets they feed, Northern New Mexico has become a hub for some of the most distinctive custom cars in the United States.

The uniqueness of New Mexico's lowriders was affirmed in 1992 when curators from the Smithsonian Institution

saw fit to put a Chimayó lowrider on permanent exhibit in the National Museum of American History. Such institutional recognition was more than overdue for a modern expression of a culture that for centuries has based its survival on innovation, creativity, and skill.

The New Mexico lowrider community is a diverse group of men, women, and children bound together by a desire to transform ordinary, often dilapidated cars into grandiose works of art. From the body shop to the hydraulics shop to the mechanic's garage, the upholsterer's scissors to the painter's brush, from neon bumper to spoked hubcap to gold-plated grill, a lowrider is the product of the work of everyday individuals whose peculiar passion has made them accomplished engineers of metal, glass, and chrome. Their creations are personal expressions of individual taste as well as of the values of their communities and culture. Collectively, they have taken the automobile further than Henry Ford ever dreamed.

The New Mexican lowrider legion is comprised primarily of Hispanics who live in the small villages and towns that their Spanish, Mexican, and Native

American ancestors established in the region beginning four hundred years ago. One such village is Chimayó, known as the Lourdes of lowriders.

Perhaps more than its lowriders, Chimayó is best known for the famous Santuario de Chimayó, the early-nineteenth-century Spanish Colonial church where countless miraculous healings are said to have occurred. Inside the twin-towered Catholic shrine stand the works of acclaimed early-nineteenth-century *santeros*, artists who fashioned *santos*, or depictions of saints, out of wood and paint pigments collected from nearby mountains and valleys. Their works have stood for centuries as symbols of the unwavering devotion of local people to their church and their God. Today, Chimayó residents and pilgrims to the site continue to worship here.

Just as the early New Mexico *santeros* sought to define the elusive link between religion and daily life, the lowrider has evolved as a modern-day metaphor for contemporary Hispanic life in New Mexico. Objects of religious faith keep lowriders close to their roots: Miniature plastic saints have a place on the dashboard altar and rosary beads swing from the rearview mirror. Joining the Sacred Heart Auto League is more important than a membership in AAA.

Dave Jaramillo of Chimayó demonstrated his faith for nearly two years on a '69 Ford LTD that he transformed into the consummate lowrider. Jaramillo died before the car was complete, but his wife, Irene, and other family members and friends finished the project in his memory. The car included everything from flared fenders and an interior color television to candy-apple red crushed velvet upholstery and an exterior portrait of the Jaramillo family. They named it "Dave's Dream."

In 1992, Dave's Dream was purchased by the Smithsonian. Before it was shipped to Washington, D.C., more than five hundred well-wishers gathered at

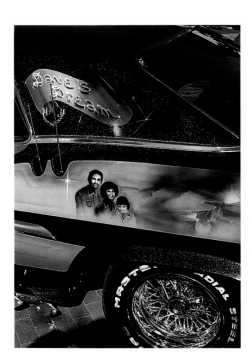

Dave's Dream, a '69 Ford LTD.
Photograph by William Clark.

the santuario for the priest's blessings. Gallons of holy water were showered upon the acclaimed automobile. Today, thousands of miles from home, the car's license plate will always read "Chimayó."

Transportation is the compelling reason for owning a car, but few escape the considerations of image. In the world of the lowrider, however, image is never a secondary consideration in deciding what to drive; it is the reason to drive. Image is what motivates a person to salvage a seemingly worthless car for the sake of rebuilding its ruins into a sunken showcase of lacquered paint, velvet, neon, and chrome. It's what inspires a person to want to turn a smooth cruise into a high-powered hiccup with the flick of a hydraulics switch. It's what makes a person take a second mortgage or a third job to make the bucks—sometimes upwards of $30,000—needed to produce a prize ride.

As Fred Rael of Española, owner of a '64 Chevy Impala convertible, a '76 Chevy El Camino, and an '81 Chevy Coupe de Ville, explains it, "I skipped

going to college so I could fix up my cars. It was that important."

Exactly where the classic lowrider image originated is a subject of intense ongoing debate. While many New Mexican Hispanics claim that the lowrider tradition is rooted in New Mexican soil, their counterparts in East Los Angeles insist that the low-and-slow custom-car movement was born there. (No doubt, lowriders in Arizona, Texas, Colorado, and other places where the cars are popular make similar claims.) What most camps seem to agree upon is that the cars were first created in the 1940s, when some imaginative car enthusiasts began lowering their cars by tossing bags of sand or cement into the trunks. No one knows exactly what inspired them to sink their sedans but some theorize that it was a conscious rebellion against the standard factory-made cars driven by the Anglo-American middle class.

Whatever the case, the lowered look quickly caught on as individuals began altering the height of a car either by cutting its suspension springs or melting them with a blowtorch. In time, colorful paint jobs, spoked rims, chain steering wheels, hydraulics systems, and other decorative touches were added. Regular lowrider gatherings were convened for the purpose of showing off custom-car creations. The great American cruise had begun.

Benito Córdova, a professor of social science at the University of New Mexico and a former lowrider consultant to the Smithsonian Institution, believes that the historical origins of the lowrider in New Mexico may go back as far as the Moors, who invaded Spain in the eighth century. According to Córdova, the Moors' habit of decorating their horses with elaborate silver saddles and other gear, sometimes even draping their animals with roses, was adopted by the Spaniards and imported to the New World in the conquest.

"There are great parallels between the horse's place in Spanish society and the place of the car in modern New Mexican society," Córdova says. "Lowriders are like modern-day *caballeros* (horsemen), except that they don't ride elaborately decorated horses, they drive elaborately decorated cars."

However, unlike the *caballero*, who usually held a place of respect in Spanish society, Córdova says that today's lowriders have yet to be properly recognized for the skill and ingenuity it takes to, as he puts it, "turn a pumpkin into a carriage."

"These people are really great engineers," he says. "They have an idea of something in their minds, but they can't go to Ford or Chrysler so they have to figure it out for themselves. What they do with these cars takes lots of time, lots of commitment. They should be respected for that."

While the "Eurocar," a contemporary car model such as Honda's Accord that is lowered and clad in traditional lowrider appointments, is popular among some younger car buffs, today's lowriders are mostly reinvented classic cars. A Chevrolet Impala, for instance, preferably a convertible of 1964 vintage, is among the most popular choices in lowriding circles. For the true lowrider aficionado, through, any oldie is a goodie.

"You can't work on modern cars the way you can the old ones. The metal is too soft," says Floyd Montoya of Córdova, whose fleet of lowriders includes a '52 Chevrolet Fleetline, a '69 Dodge Super B, and a '63 Ford Thunderbird. "No matter what kind of car comes out, I haven't been able to leave the oldies."

Nicholas Herrera of El Rito, owner of a restored '39 Chevy Coupe he calls "La Bomba," adds: "Nowadays, kids buy a new truck, lower it, put some rims on it, and that's it. But that's not a to-the-bone lowrider. A to-the-bone lowrider is when you start from scratch, build it all."

Although Carlos Sanchez of Española owns a modern Honda Eurocar, he admits, "I'll always be a traditionalist. The older cars are a challenge. You have to find them, make sure the body's right. Then you put everything you have back into them to make them the best."

The goal behind most lowriders is not only to be the best but to be the only. The one-of-a-kind qualities that distinguish one lowrider from another can mean the difference between a car that barely inspires a second glance, one that earns a trophy at the local lowrider happening, and, in the rarest of cases, one that earns a place in a national museum. Achieving such a unique car character usually involves mixing and matching various car parts, often from different car models, as well as blending the skills of various individuals. Perhaps most importantly, customizing demands constant reconfiguration of the car's detailing and design.

"You want to keep on top of things," says Bettie Córdova of Alcalde, who along with her husband, Lee, maintains a '78 Ford Thunderbird and a '63 Chevrolet Impala. "You want to change things every three to four years. That way, people don't get tired of seeing your car every year with the same old thing."

Nonetheless, some of the boldest lowrider statements are also the most permanent: those made with exterior paintings that adorn the car's body. Such artistic accoutrements range from simple border patterns to ornate and complex murals. The paintings commonly reflect personal expressions of family (a deceased loved one's portrait, for instance); images of Catholic faith; or purely individualistic iconography, such as a bust of Elvis Presley.

One of the best-known lowrider artists in Northern New Mexico is Randy Martinez of Chimayó, whose mobile gallery includes nearly one hundred cars, the majority featuring Catholic saints and other devotional icons. Part art, part adoration, Martinez's creations are the

ultimate embodiment of faith, fashion, and function.

Finally, for many lowriders, a car is not complete, its individuality not fully expressed, its image not pinpoint defined, until it has a name: La Bomba, Royal Elegance, Stitches, Liv'n Large, Dave's Dream. So what's in a name? Ask Lawrence Griego of Albuquerque, who, with his father, Albert, has formally designated their 1950 Chevrolet Deluxe Fleetline "Chantilly Lace" and their 1964 Chevrolet Impala "Glamorous Life." "It's like a baptism or a christening," Griego says. "It can be nonsense or it can make sense. It gives the car its identity. It makes the vehicle whole."

In 1979, rumor spread throughout the national lowriding community that President Jimmy Carter had declared April 1 to 7 "National Lowrider Week." Carter's alleged support for lowriders was purportedly an effort to project to the larger public an image of lowriders as slow, safe drivers whose overwhelming choice of American-made cars made them patriotic individuals. National Lowrider Week never got further off the ground than a lowrider without hydraulics, but for a brief while, at least, the positive slant of the rumor was enough to promote a more public positive image of lowriders.

In 1995 New Mexico's governor sparked an uprising in lowriding circles when he told reporters that he was fearful of low-slung, slow-going cars and what seemed to be their gang-affiliated passengers.

The comments made national news and were such a low blow to Northern New Mexico lowriders that members of area car clubs drove to the state capitol building in Santa Fe for a protest and car exhibition.

No matter how hard most lowriders work to build cars that embody a unique image of style and taste, they are constantly drawing criticism for their avoca-

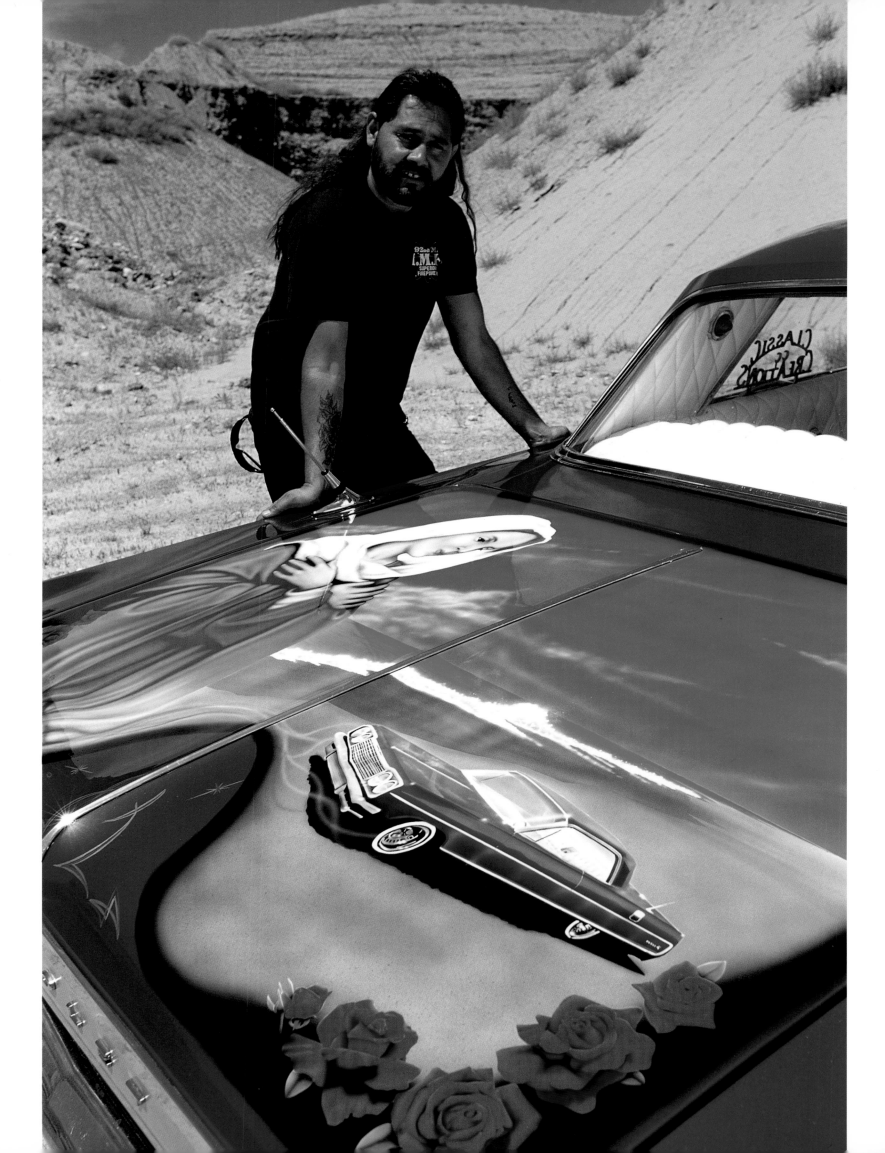

tion. Although the public's negative perceptions have only recently begun to seep into the political arena, unfavorable lowrider stereotypes go back as far as the cars themselves. Such stereotypes usually portray lowrider devotees as law-breaking, drug-dealing, gun-toting gang members whose profits from crime support their expensive hobby. While it is true that the lowrider is the vehicle of choice for some law-breaking individuals with gang ties, many lowrider enthusiasts are middle-aged, family-oriented, community-minded citizens who oppose negative social behavior.

Perhaps the most united effort to achieve respectability for New Mexico lowriders has been made by car clubs, informal lowrider organizations with names like *La Familia*, *Los Amigos*, the Imperial Car Club, and Touch of Class. Many car club members actively promote lowriding as a healthy alternative to gangs and drugs by taking their cars and their "Just Say No" philosophies to local schools and juvenile detention centers. In fact, many of them tell youngsters that they won't be allowed into a car club if they take drugs or are in a gang. Members of Española's Classic Creations, for instance, are required to sign a contract that says they will abstain from drinking and drugs. If they break the rules, they are out of the club.

Among their various activities, car club members convene regularly for afternoon and evening cruises. They meet at area parks and parking lots, line up wagon-train fashion, and commence their slow-going caravan along city streets, around villages plazas, and out onto rural roads beyond the towns. Unlike the hot-rodder, whose objective is to travel at breakneck speed, the objective here is to go as slow as possible, to

left
'64 Chevy Impala
Owner Eddie Gallegos
of El Llano

be seen and (stereos blasting) heard. Destination: nowhere.

Car clubs also cruise to lowrider shows in Española, Albuquerque, Denver, Phoenix, Los Angeles, and elsewhere. "Waxed to the max," cars are judged on everything from how "radical" their paint job is to how clean their engines are to how high they can jump off the ground. (Starting from a dead standstill, some 3,000-pound automobiles can jump more than two feet.) In an effort to further awareness about lowriders within their communities, many car clubs sponsor their own shows and donate large portions of the proceeds to area charities.

Besides winning the admiration of fellow lowriders, car-show winners take home trophies and prize money and occasionally are featured in the national magazines devoted to lowrider culture. One such venture, Orlando Coca's *Orlie's Lowriding Magazine*, is published out of New Mexico and has a monthly circulation of 130,000. To the dismay of club members, however, the competitive

nature of car shows has spawned another disturbing public perception that car clubs, like gangs, are oppositional bodies whose rivalries often result in violence. Car club members adamantly denounce such assertions as pure myth, stating that the only sparks that fly between opposing car club members are those during a "street fight," an impromptu hydraulics contest where two lowriders who find themselves side by side at a streetlight flick on their hydraulics switches and start their cars hopping.

Indeed, there is a strong familial feeling among car club members. It is not uncommon to see youngsters sitting alongside their parents during a club cruise, and in an interesting imitation of their elders, many lower and apply lowrider decor to their bicycles. During the warmer months, club members and their families get together for weekend picnics or camping trips, bonding with

Orlando Coca, Corrales-based publisher of **Orlie's Lowriding Magazine,** *and his classic cars.*

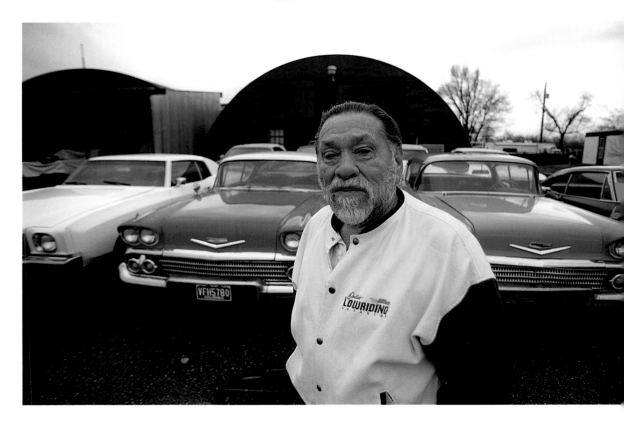

relatives in a collaboration of creativity and cultural pride. The lowrider tradition is passed on from father to son, aunt to niece, brother to brother, husband to wife. Like any other treasured family possession, these cars are heirlooms passed down through the generations. For many families, lowriding is more than a hobby; it is woven into the fabric of life itself.

Thus, when Española lowrider Fred Rael and his wife, Jovan, decided to marry, they did it lowrider style. On July 19, 1997, the couple gathered with family and friends at an Española church to recite their vows. The bride wore a traditional white wedding dress and veil. The groom, in the tradition of his old-time lowrider counterparts, dressed in a purple zoot suit. After the ceremony, the couple stepped outside the church into a parking lot filled with their buddies' low-built beauties.

While their friends got into dropped sedans, trucks, and even a lowrider limousine, the bride and groom climbed atop the back seat of Rael's '64 Impala convertible with purple paper flowers pasted around its pearly body. As the wedding carriage exited the parking lot onto one of Española's main streets, seventeen lowriders pulled out behind it in a line. Horns honking, the newlyweds waved to passersby as the wedding party made its way down memory lane.

Lowriders are motivated by the creative urge to take the most revered symbol of American progress and individualism—the automobile—and make it their own. In a kind of reverse cultural appropriation, New Mexico Hispanics have reinvented an originally Anglo status symbol to suit their own tastes and needs. The result is a repertoire of cars that captures both the timeless ideals of

traditional Hispanic culture and the creative expressions of life in a contemporary New Mexican Hispanic community. Like the Virgin of Guadalupe or the annual green chile crop, lowriders have taken a place within that community as essential symbols of cultural tradition, dignity, and, above all, pride.

Eddie Gallegos's story perhaps best sums up the lowrider life. Gallegos grew up in Española with eight brothers who raised him in the lowrider life-style; if they weren't working on or cruising cars, they were talking cars. One brother, Manuel, owned a sleek 1964 Chevrolet Impala that Gallegos dreamed would one day be his. Manuel promised the car to him when he grew up but wrecked it before Gallegos reached adulthood.

In time, however, Gallegos began assembling his own fleet of cars: first, a '68 Chevy Nova; then, a '68 Chevy Bel Air; finally, his first Chevy Impala, a green '64 that another brother sold him for $80. He added new steering wheels, rims, and other details to the vehicles, then somewhere in between it all, he discovered alcohol. After awhile, drinking began to mean more to Gallegos than lowriders.

Years of drinking would pass before Gallegos realized that alcohol was literally a dead end. For help, he turned back to his childhood dream, purchasing a dilapidated '64 four-door convertible Impala and vowing to get sober and fix it up. He equipped the car with a small white steering wheel and put gold-plated fixtures on everything from the wheels, bumpers, headlights, and taillights to the interior door handles and switches. Inside, he covered the seats in white vinyl embellished with a classic diamond-tuck pattern. He installed his own hydraulics system and painted the car bonzai blue with a little violet pearl mixed in. A

friend painted an image of the Virgin Mary shrouded in roses as well as one of Gallegos's own '64 Impala parked oceanside on a sandy beach. Finally, Gallegos put a chain frame around a license plate that says "Suave '64."

By the time the car was complete, Gallegos was finished with drinking. "All that money I was spending on drinking, I put into this car," he says. "I stopped drinking and put my heart into my car."

Then, in 1997, Gallegos's brother Nick suddenly died of a heart attack. Besides teaching him about mechanics, hydraulics, and other lowrider essentials, Nick had accompanied Gallegos to all of the area lowrider shows. "We were always together," he says. Gallegos, then the acting president of Española's Classic Creations car club, couldn't bring himself to attend any club meetings or lowrider shows after Nick's death. "It was just too hard," he says.

If there was a time that he was tempted to start drinking again, it was now. Instead, Gallegos looked at the prized 1974 Chevy lowrider truck that he had inherited from Nick and mustered the strength to cope with his loss. Gallegos asked an artist to paint Nick's portrait—an image of his brother floating in a cloudless sky above silvery ocean waters—on his Impala. When the portrait is completed, Gallegos plans to buy a zoot suit and stand for his own portrait next to his car with the image of his brother.

"I guess what it comes down to is that I was born a lowrider, I grew up in a lowrider environment, and I'll be a lowrider all my life," Gallegos says. "It gets hard sometimes, but when the hard times come, you've just got to say 'Dale gas, man. Dale gas.'"

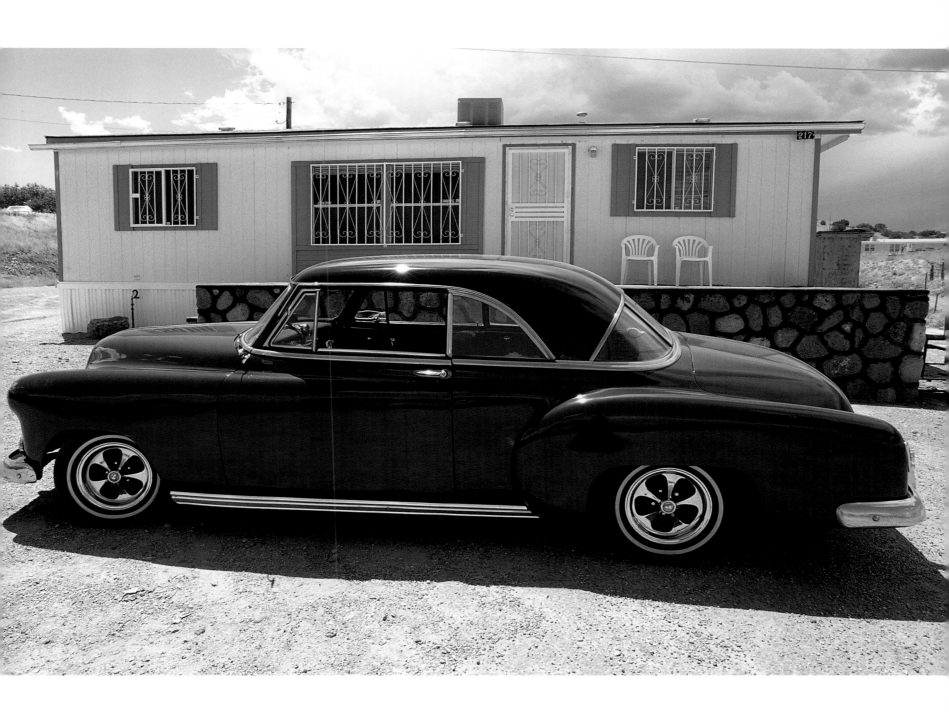

'51 Chevy Bel Air
Owned by the late Nick Gallegos of Española

following spread
'49 Chevy pickup
Owner T. J. Gutierrez of Velarde

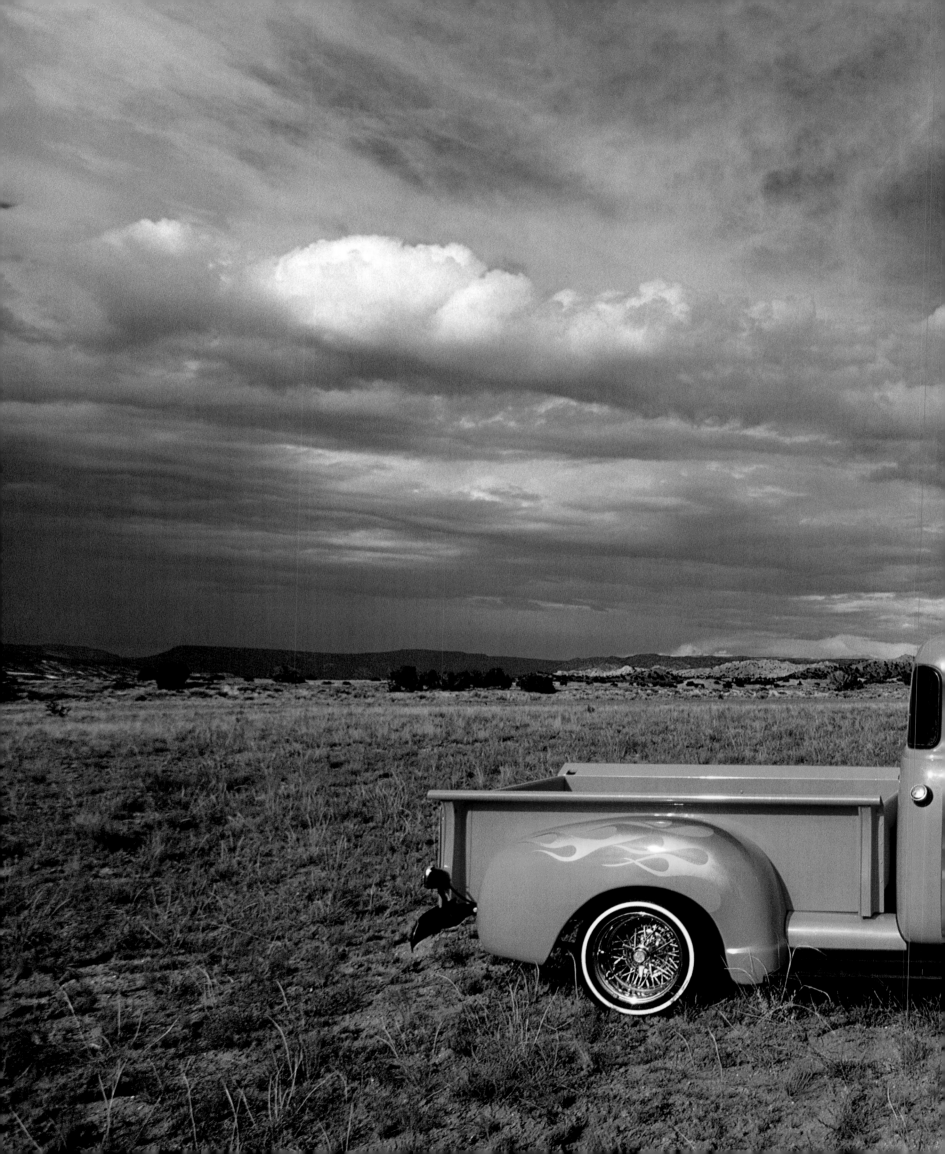

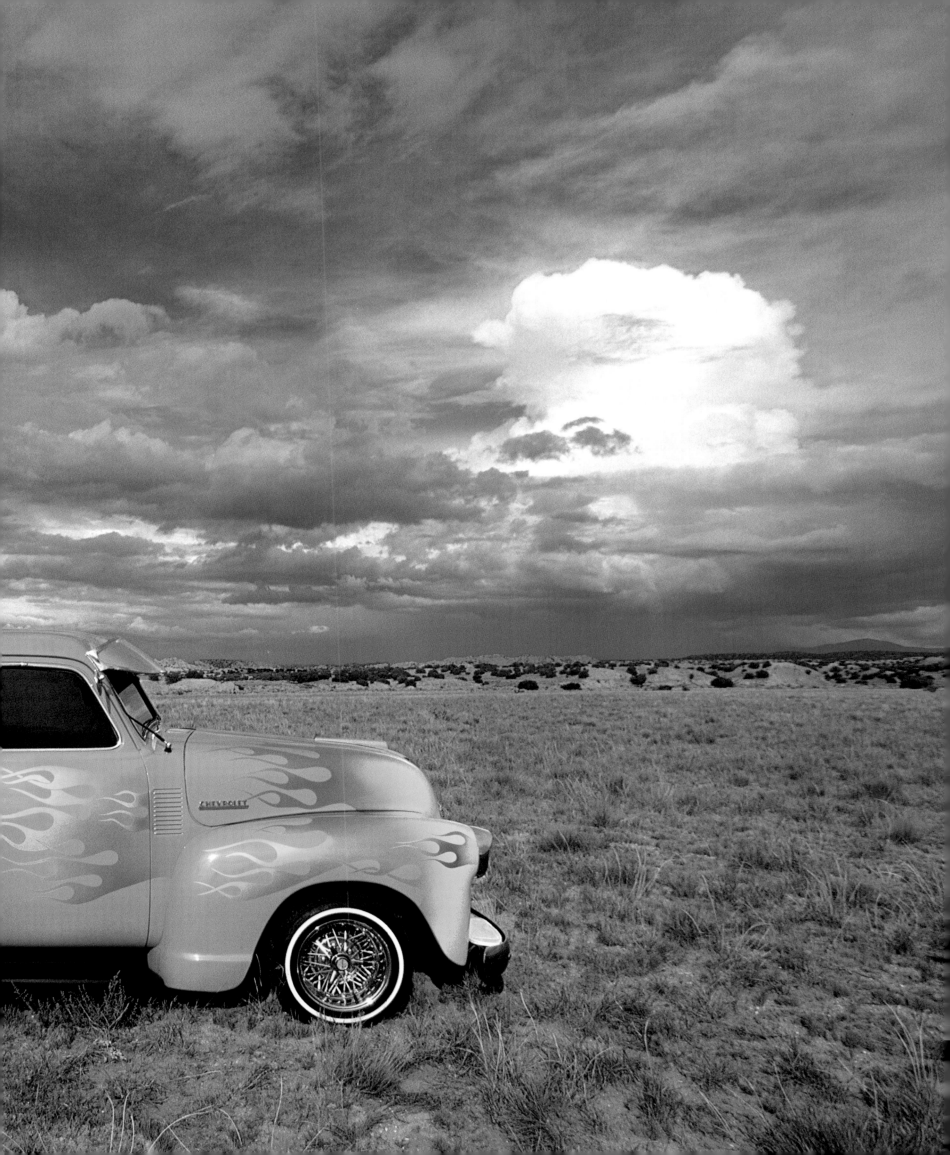

right
'50 Chevrolet Fleetline
Owner Jerome Reynolds of Alcalde.
Mural by Randy Martinez.

'63 Chevy Impala Super Sport
Owner David Lopez of Socorro

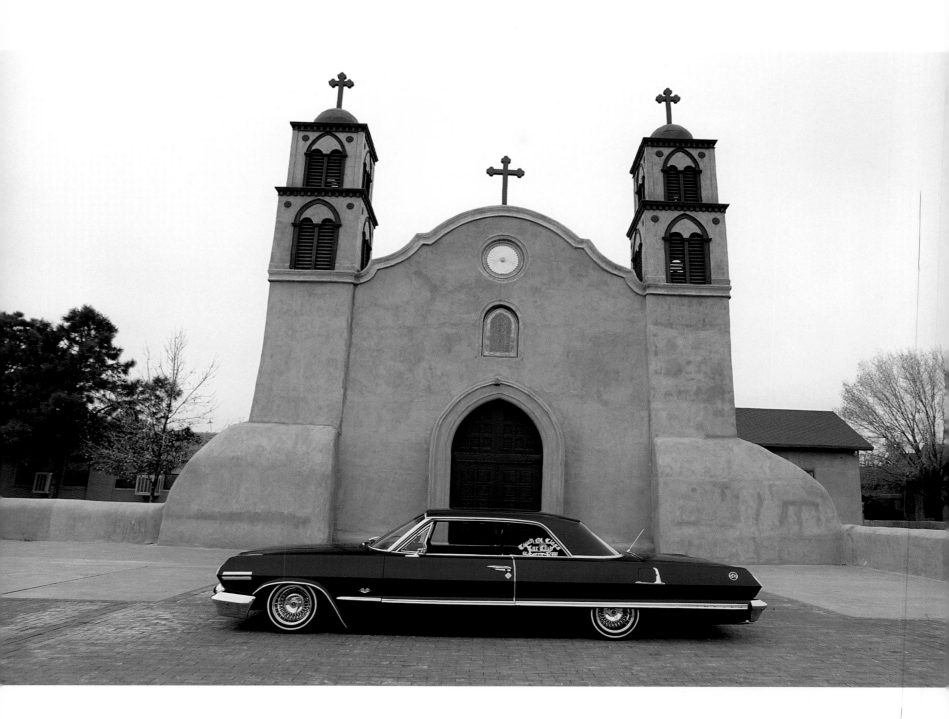

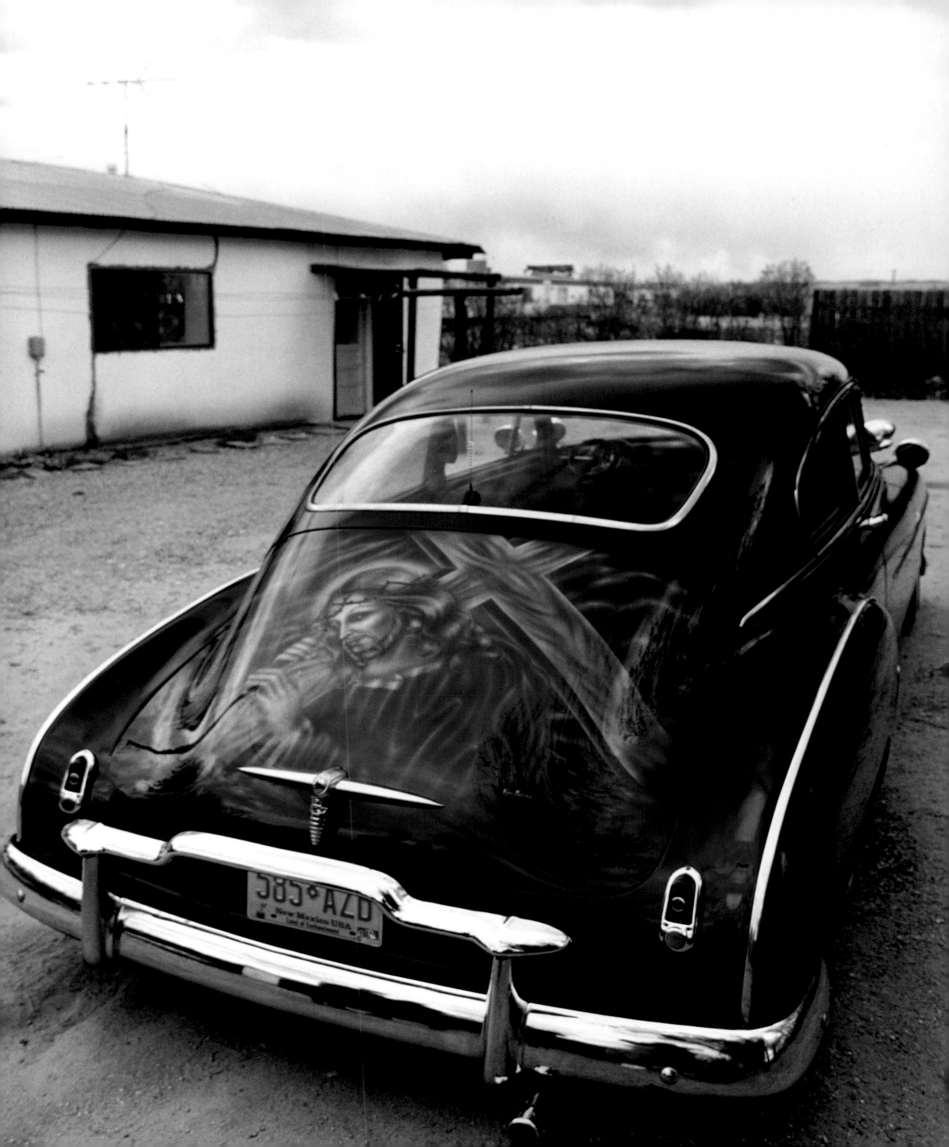

'51 Chevy Coupe (left)
Owner Leroy Trujillo of Chimayó

'52 Chevy hardtop
Owner Vince Trujillo of Chimayó

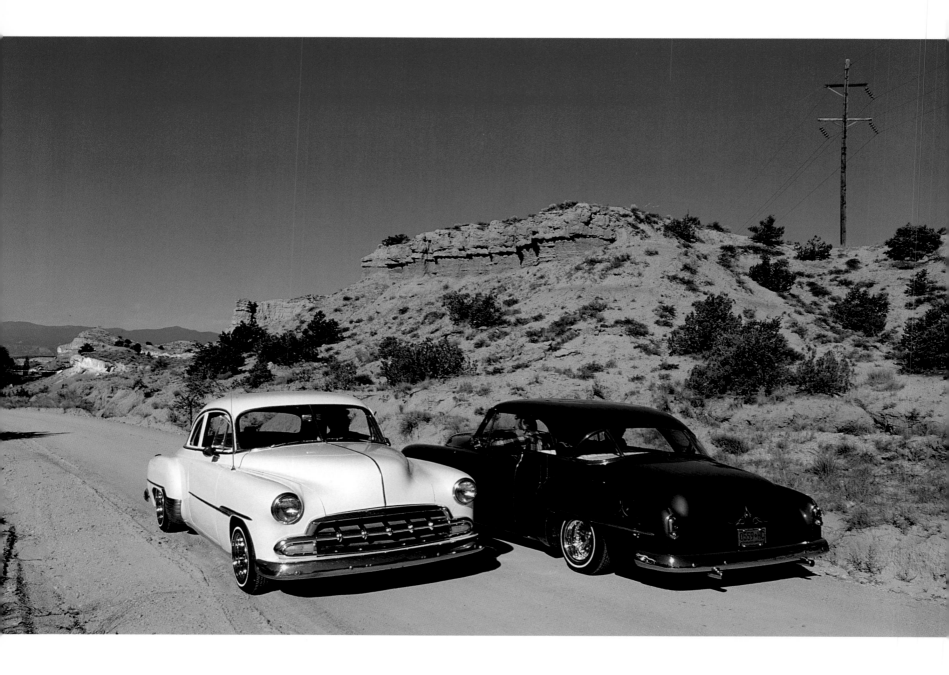

Interview with a Lowrider

Carmella Padilla
Juan Estevan Arellano

Northern New Mexico has a unique Spanish dialect that has been spoken and has evolved in our towns and villages since the late sixteenth century. It is kept alive and vivid in the "Spanglish" language of Northern New Mexico's lowrider culture, as expressed in the work of poet Juan Estevan Arellano.

PADILLA: *Orale*, Estevan. That's a term that I hear all the time among lowriders in Northern New Mexico. Can you explain it?

ARELLANO: *Orale* is a greeting, slang for "hello." In some senses, it can mean "pay attention." They use it here, but they use it in Mexico a lot, too. I've even heard it in Spain.

PADILLA: In your poem *La eché en un Carrito*—you refer to a *Carrito Paseado*. What is that?

ARELLANO: Oh, that comes from a song about lowriders. A *carrito paseado* is a "cruiser" that *la plebe, el vato loco*, or a *chavalo*—which all mean "young kid"—would be cruising in. Other kids are known as *cholos*, a term that came from California. In terms of young girls, sometimes they are called *chuquitas*, from the word *pachuquita*. In terms of adults, the word *cuerota* refers to a very sexy woman, while *guanga* means a fat, flabby lady. *Ruquito* refers to an elderly person; *jefitos* means parents. A married couple is one that's *enchanta'o*, meaning "to be at home." It comes from the word *chante*, a "house."

PADILLA: You also refer to a person in your poem as *el Colora'o*. What's that?

ARELLANO: That's a nickname meaning "redhead." *Colora'o* and *rojo* are "red."

PADILLA: What other words are used to refer to a car?

ARELLANO: Other words that are used for the automobile are *carrucha*, from the word "car," and *ranfla*, a word that came from the *Pachucos*, or the zoot-suiters, of the forties and fifties. Some real slow lowriders are referred to as *perrodos*, for a black insect that resembles a '64 Impala.

PADILLA: What are some other general terms that might be heard in an everyday lowrider conversation?

ARELLANO: When someone uses the expression *Chales*, it means to be quiet. *Tirando chancla* and *bolete* are both slang words for dancing. A *tecato* is someone who is hooked on heroin. A *marijuano*, on the other hand, is someone who smokes pot. The words *gallazo*, *frajo*, and *toque* are all slang for a marijuana joint. So are *yesca* and *grifa*.

PADILLA: Tell me some more.

ARELLANO: You know, a lot of lowriders like to enjoy a beer in moderation. Slang for beer is *bironga*, which is also sometimes referred to as *un seis*, a "six-pack." When someone talks about a *peda*, it refers to getting drunk. *Tirilongo* also refers to being inebriated; *carmelito* is when one has had too much wine to drink. *Turilailo* is someone who is a few sandwiches short of a picnic.

PADILLA: I've often heard the word *feria*. Can you explain it?

ARELLANO: *Feria*, in the way that lowriders use it, means "money." But it can also be a "fair."

PADILLA: There are a lot of other words I've heard that almost sound like they are English but that are definitely Spanish. What's that about?

ARELLANO: There are a lot of English words that have become "Hispanicized." Like the word *wachando* comes from "to watch," and *brecas* is derived from the "brakes" of an automobile. When someone says *trimear la greña*, they are talking about a "trim," a "haircut." Some Spanish words follow the same basic thinking. For instance, a *leñero* is someone who goes to gather firewood; it is an extension of the word *leña*, Spanish for wood.

PADILLA: What about *resolana, chasco, tapalo*? Also, what are some miscellaneous words used to refer to other people?

ARELLANO: A *resolana* is a place where the sun hits in the morning, usually with a southeast orientation, during the spring or fall, where men gather to talk about issues that concern the local community. *Chasco* is a mishap, and *tapalo* is a shawl used by old women. As for people terms, *manito* comes from the word *hermanito*, or "brother," as is the word *carnal*. *Paisano* is a fellow countryman. *Jura* is a policeman.

PADILLA: Somewhere in your poems you mention "Irundian." Who is he?

ARELLANO: He's the famous Spanish bike rider. The word *baique* is another Hispanicized English word that is derived from "bicycle."

PADILLA: What's a *chico*? A small person?

ARELLANO: It could be, but it usually refers to a form of corn that is cooked in an *horno*, a clay oven, when it is very tender. Thus the term *chicos*, the best variety of which is *maíz concho*. *Chicos* are put up for the winter in a *dispensa*, a kind of utility room. Beef jerky, or more specifically, *carne seca de alazan*—elk meat—is usually hung to dry in a *dispensa*.

PADILLA: It is commonly noted that the dialect of Northern New Mexico is an ancient one that can be traced back to Spain before its conquest of the Americas. Thus, Northern New Mexicans, and many lowriders, speak the oldest style of Spanish found in the Americas today. Can you give me some examples of words that best reflect the Old Spanish origins of the language?

ARELLANO: There are some words that we use that are definitely Old Spanish, such as *curre*, which means "to go." The more contemporary word for it, which we also use in Northern New Mexico, is *ve*.

PADILLA: What about some more contemporary words that definitely have their roots in more recent times?

ARELLANO: The words *catea'o* or *pajueleada*, which mean to be "beat up," are part of the modern *pachuco* language. Another commonly heard word is *pendejo*. In places like Mexico *pendejo* can be considered a dirty word. But here it has a much lighter meaning and refers to being "foolish" or "stupid." Well, *Hay te wacho*. That's slang for see you later.

right
'56 Ford pickup
Owner Benny Vigil of Española.
Son B. J. and mini lowrider.

Ode to "el mecánico"
by Juan Estevan Arellano

The garage, that strange cross between a *dispensa* and a kitchen, only that here you can have a *bironga* while you work on the "trannie," *"la transmisión,"* replacing the four on the floor with an automatic one.

"Tranqui," as *Tranquilino* is known, is one of the best mechanics in all of the Española Valley, especially when it comes to transmissions and lowriders and at times—in his spare time—he does bodywork; that is, besides the work he does in his *huerta de chile* and *milpa de maíz* during the summer.

When anybody asks for the best *"compónico,"* or mechanic, to fix a messed *"trannie"* or do "head" work, everybody says in unison, *"curre con el mécanico,* he'll give you a good deal, especially if you take him *un seis de Corona"*; and everybody knows that when they say *"curre con el mécanico,"* they are referring to *Tranquilino,* who was born in *Río Chiquito* between *Córdova* and *Chimayó.*

Today's garage or shop is not just a place to fix cars, to get them ready for a car show; it is more of a sanctuary, a holy place where *plebe* gather to talk about politics, about what's happening today *en el mundo,* sports, drive-by shootings, about the *viejitos y familia y más de todo pedirle a la Virgen que les ayude a todos los necesitados.*

To some, the garage or shop has replaced the *resolana* by the *corral,* where men and boys used to gather to talk about horses and the chores that had to be done, about the *matanza* that awaited them on Saturday, wood that had to be split, all the while munching on *piñón* and *carne seca de alazán.*

Now those same conversations take place around an old home-made *fogón de un barril* that burns discarded oil from the many oil changes he does daily; but the conversations have hardly changed though there is more English spoken today in the daily conversations of the *mecánico,* especially with the younger lowriders.

Huddled around the *fogón* the *plebe* warms up by putting one hand on top of the old stove while holding on to a Bud with the other hand, *de vez en cuando cambiando la birrea de una mano a la otra,* without missing a stroke, while pulling a *cécina de Carne Seca de los Rastrojos* from the brown bag and saying *"que cosas hace Dios cuando tiene tiempo"* as he pulls from a *cecina,* while at the same time noticing a young sixteen-year-old *vecina* pass by, *"la Rosa de Chimayó."*

"Tranqui," the new name that was pinned on him along with his job at Los Alamos, gave him the money he needed to set up his garage; "that place is bad!" say the *plebecita;* "Wow, look at those new toys!" muses another wannabe from the *Arroyo del tonto* as he examines all the new tools, or "toys," *Tranquilino* has on the wall.

Here he creates magic. Like any well-known magician it is the tools that make the man as he yells to his sixteen-year-old son to "give me a $^{9}/_{16}$, or a half inch," as if the mechanic's tools were a violin, making wonderful music as he puts the finishing touches on a 350 motor, reminding him of the 350 turquoise '67 Camaro he bought soon after he graduated from high school, when he worked construction for $1.75 an hour.

Hoy en día todos lo buscan, that he is the best mechanic and he also does bodywork, but mostly for himself. At present he is working on a Camaro similar to the one he owned, *nomás que está todo catea'o,* "but one of these days, this six seven will be cherry, like the day it rolled out of the Chevy garage in Española."

Then this 350 Camaro will be joined with his other newly revamped '71 Camaro, and his memories will waltz back to his senior year at *Santa Cruz,* when he used to go out with Joanie, a *chingona chavala* from *Córdova;* today she is married to *Faustino,* the butcher at Valley Meats, whose brother, who passed away about ten years ago, had his lowrider with the *Virgen* bought by the Smithsonian where it is today on display.

In this garage there have been more dreams of lowriders making it big, "maybe being in a movie," daydream some, while others imagine their "baby" on the cover of *Lowrider* magazine; *Tranquilino* has had several of his creations appear on the cover of *Lowrider;* he could be called a creator of "Super Models."

Meanwhile, others reminisce about *"la Ruby,"* to which *el pendejo de Ricardo* asks, "Your babe?" "No," answers Miguel, *"la Ruby, mi carro,* my lowrider, the '57 Chevy that used to belong to your *tío Melaquías, pendejo!"*
Melaquías named his '57 Chevy *"la Ruby,"* in memory of *"la que se fue y ni escribió,"* his babe that "hit the road Jack," and he never saw her again until a couple of years ago, at a dance at Red's. Only that now she is *"bien pajueleada,"* or as *Tranquilino* would say, "ya

está muy corrida sin aceite, ocupa un tune up."

Here, in this garage, which to the untrained eye might seem like an old *adobe dispensa*, he creates magic with his grease monkey hands, both in motors as with his bodywork, transforming a '64 Impala into a one-of-a-kind work of art, a classic lowrider. this one going to Japan, not Barcelona *como dicen los hermanos turilailos.*

Barcelona doesn't have any lowriders and here in *"el norte"* we don't know any Catalonian; here we prefer *el Spanglish, del español de Cervantes y el inglés de los* commercials.

El bajito y despacito would never be able to maneuver the medieval streets of Spain like the horse got accustomed to its new land *de "la Nueva México"* in 1598, low and slow as the lowriders could never make it Spain.

Tranquilino has never been to Spain, only to *"España,"* that is *Española,* and in *México* only as far as *Juárez,* but then only to *la Calle Santa Fe y la Avenida 16 de Septiembre,* to get some *tequila del*

Hornito o la de Don Julio, the real kind, and to get some upholstery for his first *ranfla,* a '53 Chevy coupe, the precursor to the lowriders.

From the '53 with "baby moons" he graduated to a '57 Chevy, two door, *con alas,* until he got his *'64 perrodo,* which eventually became his first lowrider; now it belongs to his *chavalo*—JR—the one with the baggie pants and a GI haircut, the type his dad would never have been caught with.

Now the *"mecánico"* has more work than he can handle, whether it be overhauling an automatic transmission or a 327, doing bodywork on his neighbor's '74 Monte Carlo, or redoing an old '64, from early in the morning to late at night, "eight days a week, fourteen months of the year." *Tranqui* is always busy working in his garage.

Sometimes at night, after everyone finally leaves, he and a couple of friends go to the back room, what remains of the old *dispensa,* where he has an old refrigerator, to have a couple of "six bangers" in his famous *"Cuarto Azul,"* where the subject changes from cars to politics to

sports and back to cars—not just any cars, but lowriders.

For it is here in the Española Valley where the lowrider cult was born with the '53, '55 and '57 Chevys, then came the '64s and finally the Monte Carlos in the '70s and now even the foreign cars and pickups are turned into works of art with *"La Guadalupana"* painted across the trunk.

"The lowriders," interjects *Tranquilino,* "are our traveling galleries; wherever we go, we take our art with us, the same as our *carnales* wear their art in the form of tattoos. The only canvases we have are our cars and our skin; we can't afford to buy fancy papers or inks."

"Nuestro arte es del pueblo, para los que no tengan dinero ni educación todavía puedan apreciar el arte, y más de todo, seguir con la fé, la fé que nos hace quienes somos sin parecernos a nadie," dice *Tranquilino* as he explains his philosophy and why he has made the art of lowriders his life's vocation.

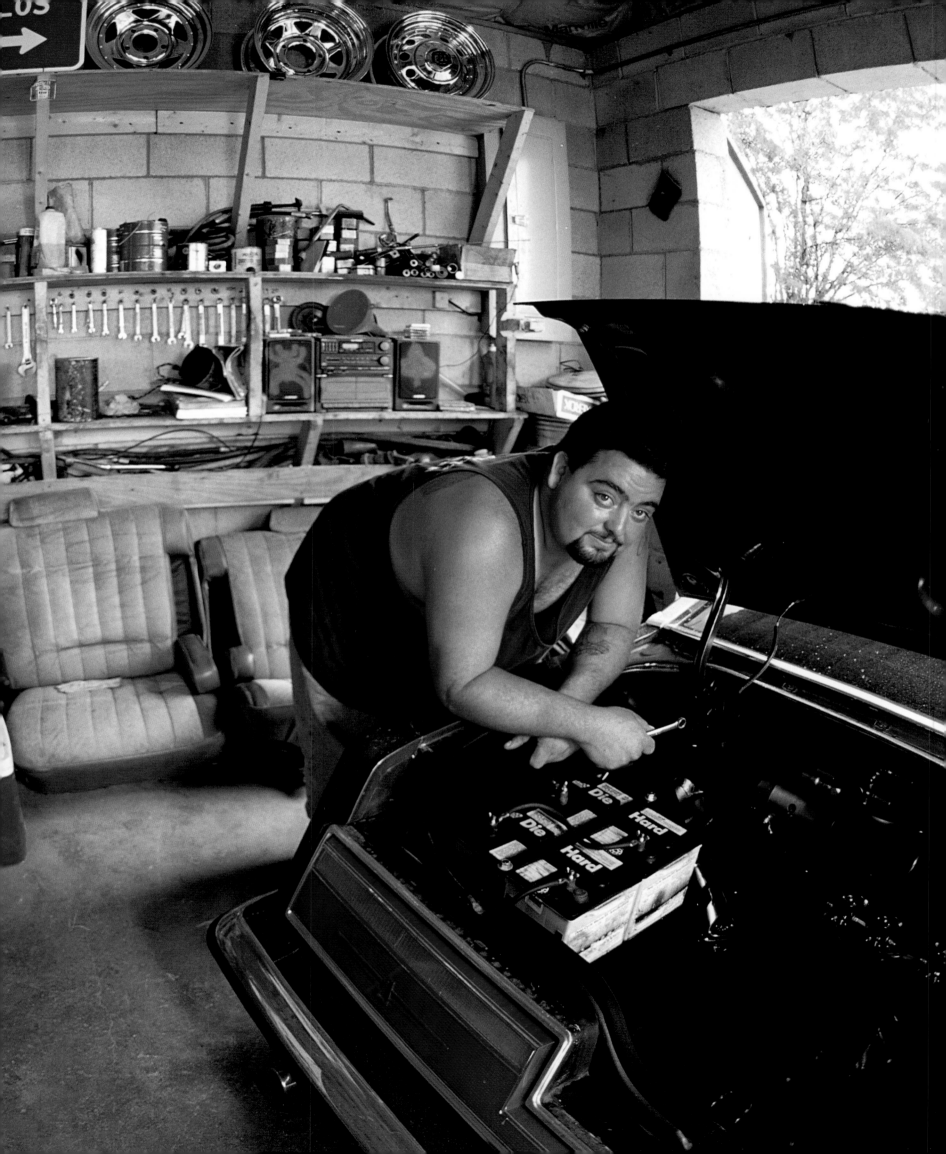

Car
Choreographer

Wille Trujillo, hydraulics specialist, of Chamita

A sign that hangs on the wall of Wille Trujillo's garage says "Do it in my lowrider."

"You're cruising down the road real slow, you flip on a switch, and the car comes to life," Trujillo says. "Making the car dance up and down, front to back, side to side: That's doing it."

The owner of Wille's Hydraulics at Chamita is the car choreographer of choice for many Northern New Mexico lowriders. A certified mechanic and welder, Trujillo says he specializes in hydraulics—a complex combination of wiring, batteries, and pumps that can propel a 3,000-pound automobile off the ground—because "they are an attention-getter."

"I like the up and down of it, the cars, the competition," he says. "When people turn to look at your car hopping down the street, their eyes get real wide. It's like a high, a real rush."

Ranging from $2,000 to $3,000 for a basic two-pump, six-battery, ten-switch setup, hydraulics are an expensive lowrider extra given that their use on public thoroughfares is generally illegal in most cities. But except for the inherent dangers of car-hopping—"Seat belts are required," Trujillo says—it's worth the entertainment cost.

"I've made cars walk behind me, turn in circles, or hop up so that all four tires are off the ground," Trujillo says. "There's nothing that I haven't been able to do with a car except make it turn a flip, and I'm working on that."

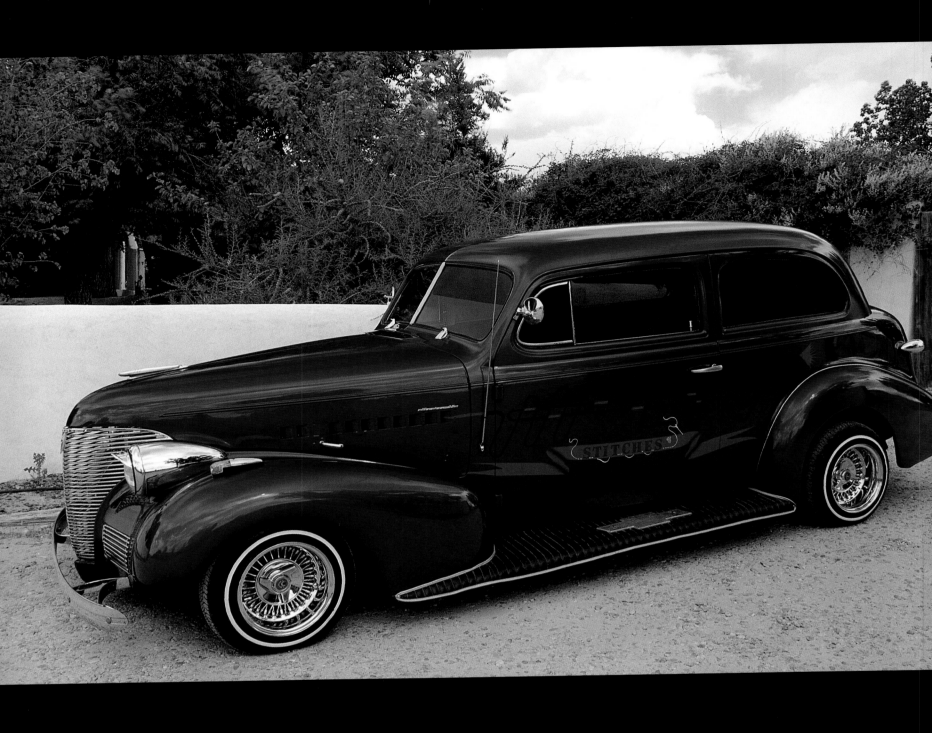

Stitches

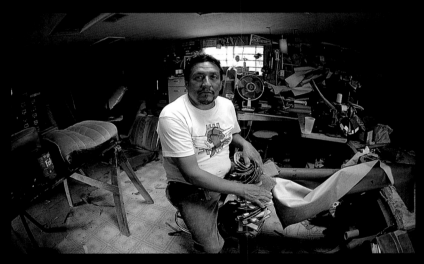

'39 Chevy ("Stitches")
Owner Julian Quintana
of Sombrillo

"I've been hooked on lowriders since I was seventeen," Julian Quintana says. "I got my first car, a '48 Chevy Coupe, and lowered it. Then I got some vinyl and stapled it to the door panel so it looked real nice. I guess I've never grown up."

Quintana is crouched behind a sewing machine at his Sombrillo-based business Julian's Upholstery, stitching to strains of oldies on the radio. After learning to upholster furniture in high school, Quintana turned his talents to cars. Today, three-quarters of his business is in lowriders. His masterpiece—a 1969 Ford LTD called "Dave's Dream"—has thousands of black buttons hand-sewn onto the diamond-tuck seats and red-and-black velvet under the hood. The car is on permanent exhibit at the Smithsonian in Washington, D.C.

The diamond tuck, the tuck-and-roll, the square pleat, the ruffle—such are the tricks of Quintana's trade. Working with leathers, velvets, vinyls, and velours, he sews everything from headliners to visors, from seats to door panels to floors. "Stitches," his prized '39 Chevy sedan, sports swivel seats swaddled in a silky shade of charcoal gray. Thread, needle, and a thimble are painted on the doors, whose locks are thread spools.

"When I'm finished with a car, it's like a piece of art," Quintana says. "Everybody asks if I make dresses, too."

35

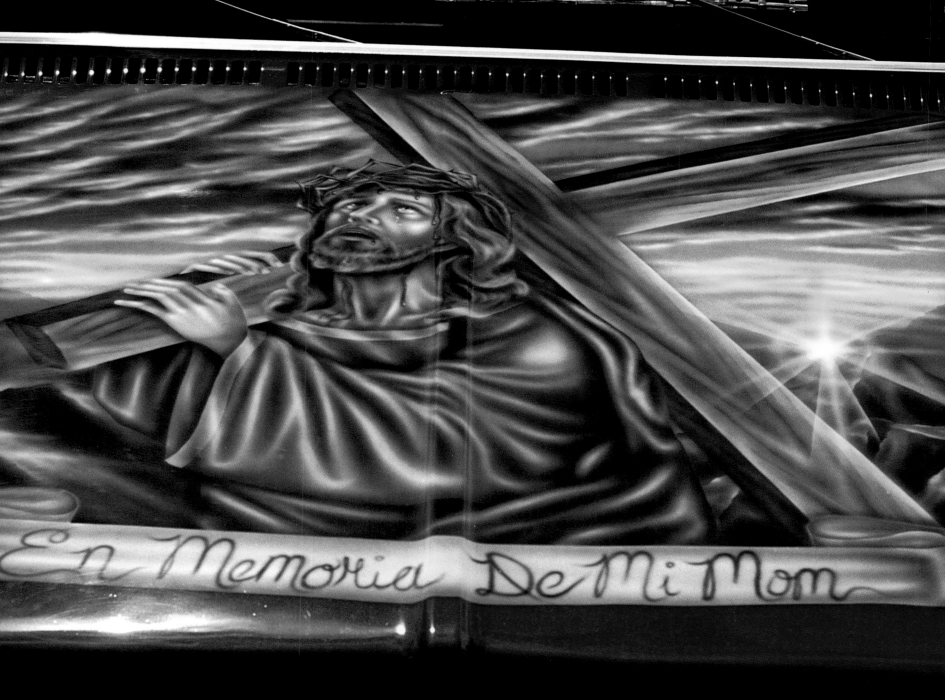
En Memoria De Mi Mom

'73 Chevy Stepside
Owner Luis Garcia of Española. Mural by Randy Martinez.

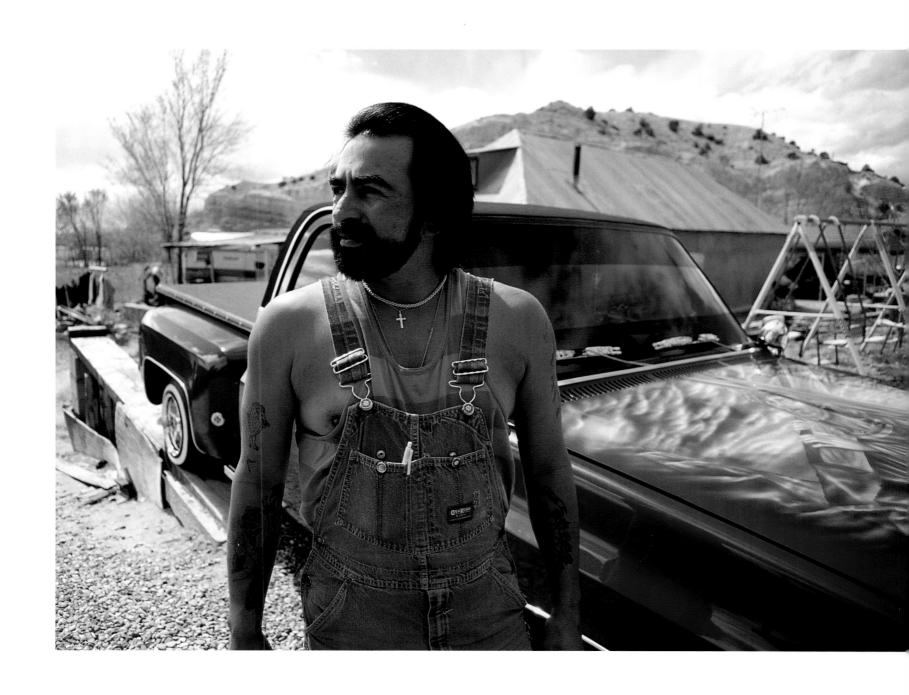

'75 Chevy Caprice
Owner Atanacio "Tiny" Romero of Chimayó

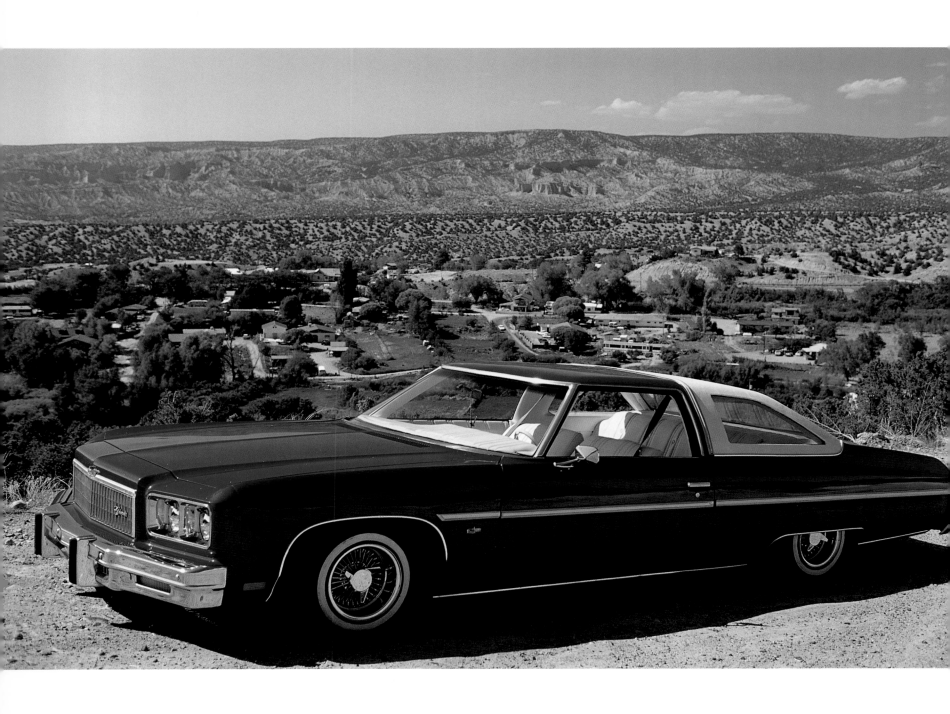

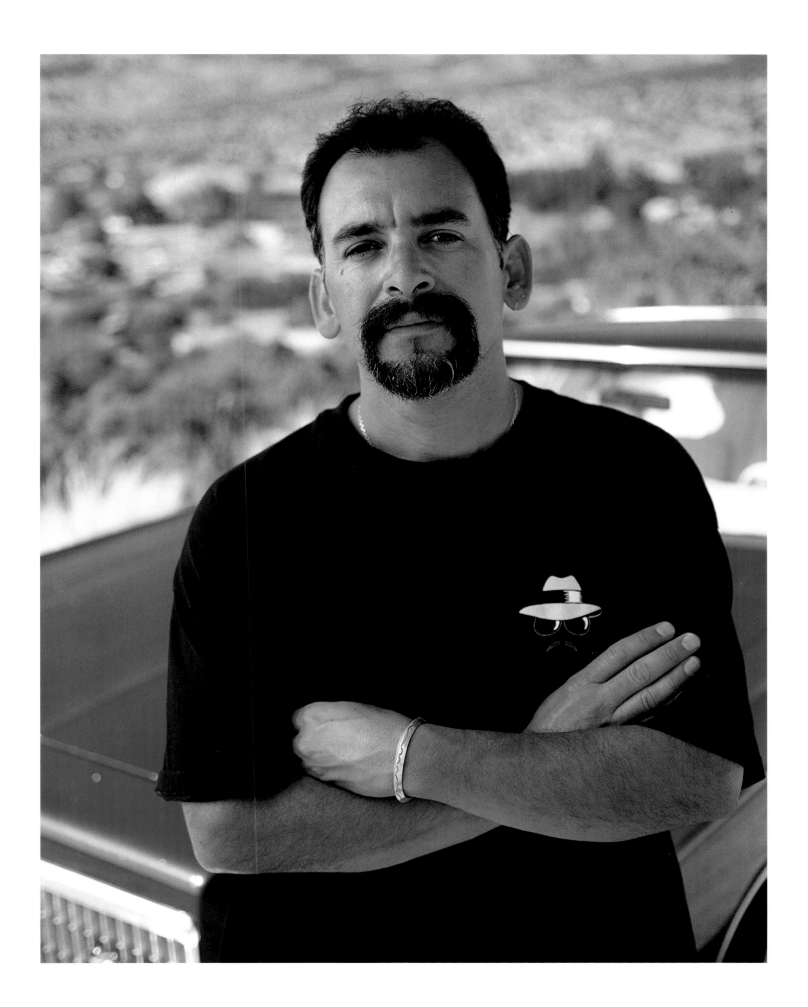

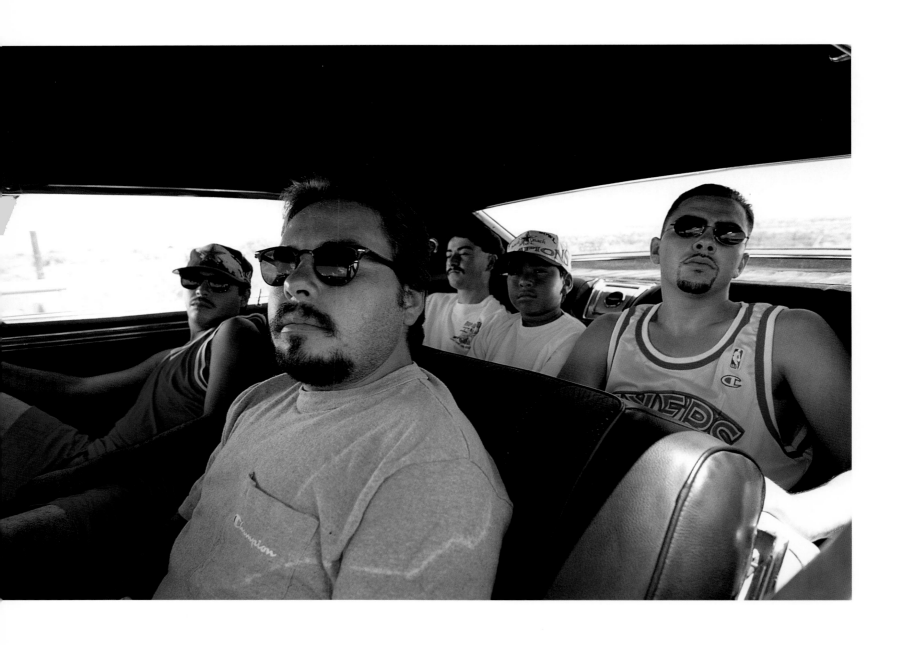

'66 Chevy Caprice
Owner Andreas Vigil of Fairview

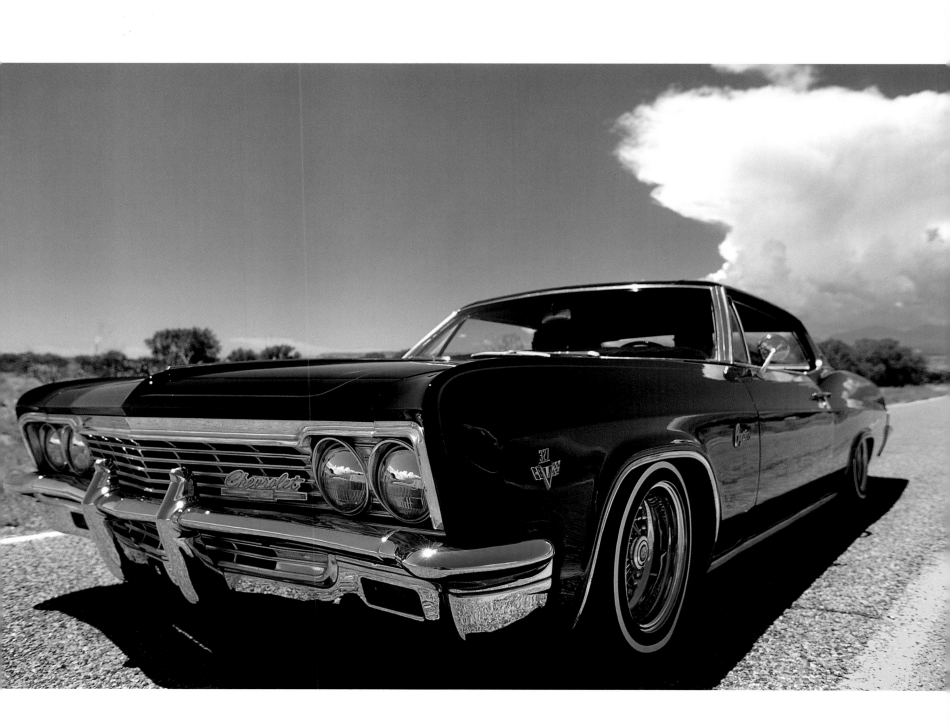

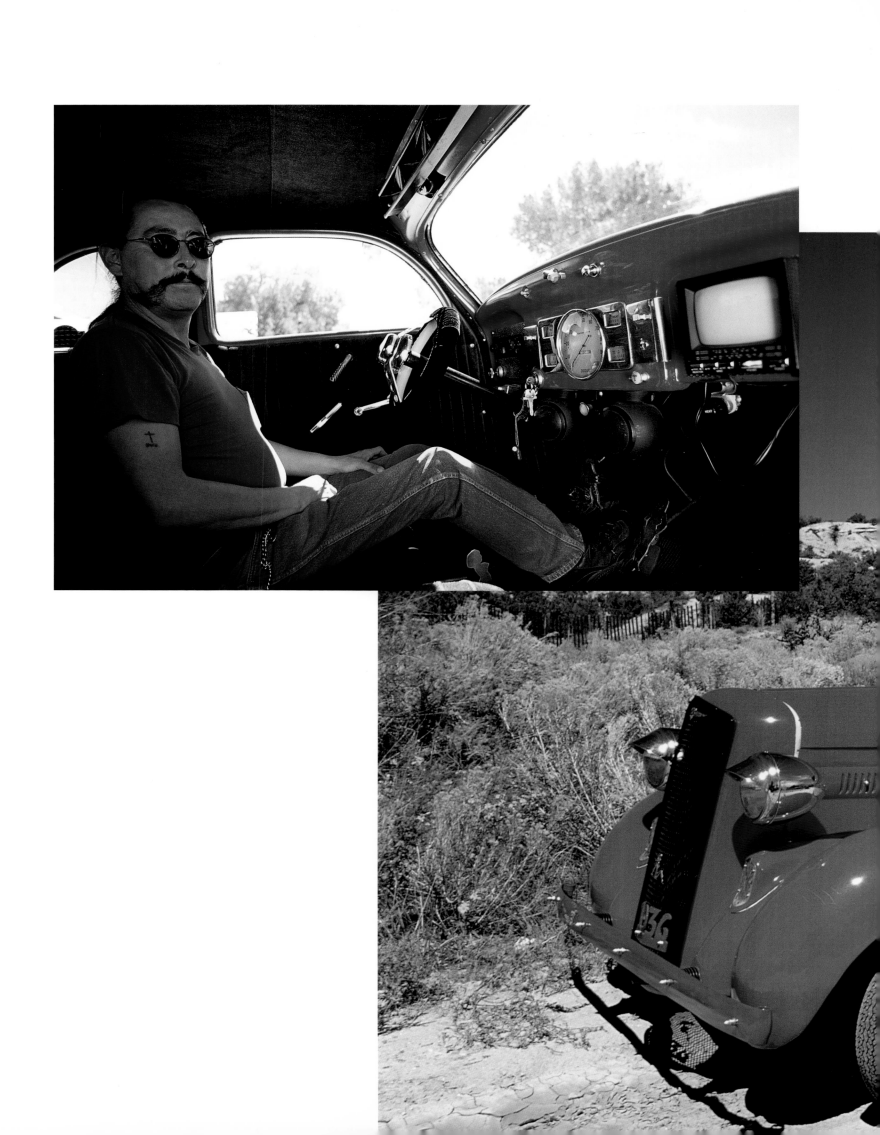

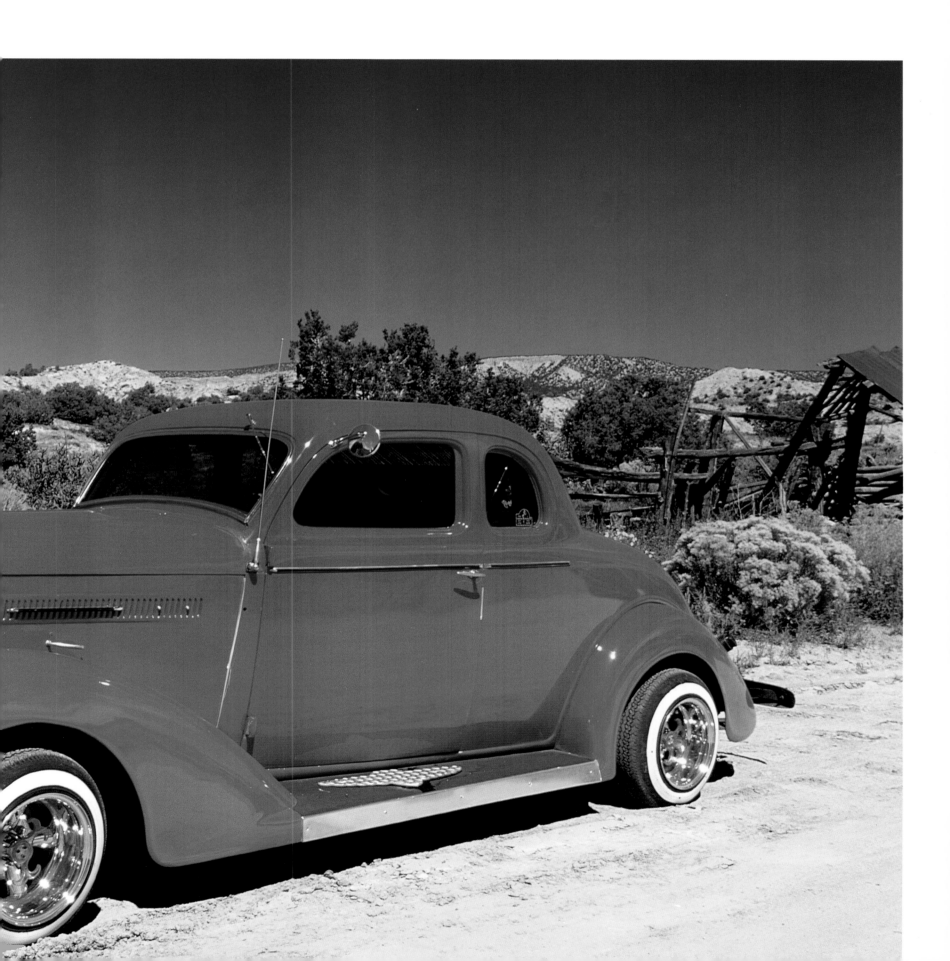

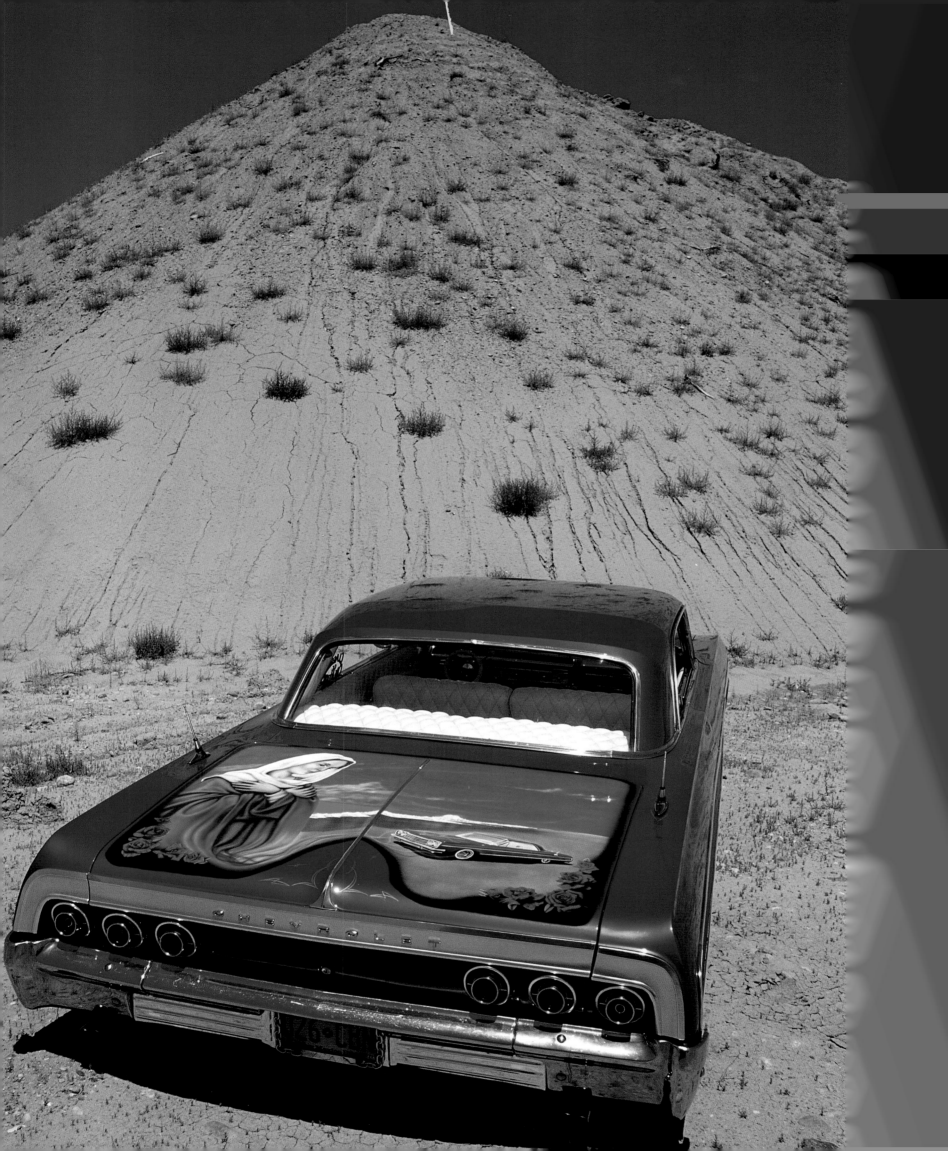

Dream Car

When Eddie Gallegos first brought his 1964 Chevrolet Impala home to El Llano, his wife, Barbara, dismissed the beat-up vehicle as junk. But after watching Gallegos restore the car from the inside out, his wife won't even let him drive it to the grocery store for fear that it will be hit.

"My wife was always telling me, 'When are you going to grow up?'" Gallegos says, "but even she likes the car now. She calls it her 'dream car.'"

Now, Gallegos has made the car the object of his eight-year-old son E. J.'s dreams as well. Ever since he was old enough to hand his father a wrench, E. J. has understood that if he stays out of trouble the car will one day be his. Gallegos also plans to buy another car to pass on to his nine-year-old daughter, Teresa.

"I tell my kids, 'I'd rather have you here fixing cars than out making trouble or fighting,'" Gallegos says. "They have to give me good grades and finish school. They have to be good and help me out here at the house. I remind them every day."

Gallegos, a former alcoholic, credits the car for keeping himself on a straight path in life. And his own example, he says, is the best life lesson he can give his children.

"To me, being a lowrider means being out of trouble," he says.

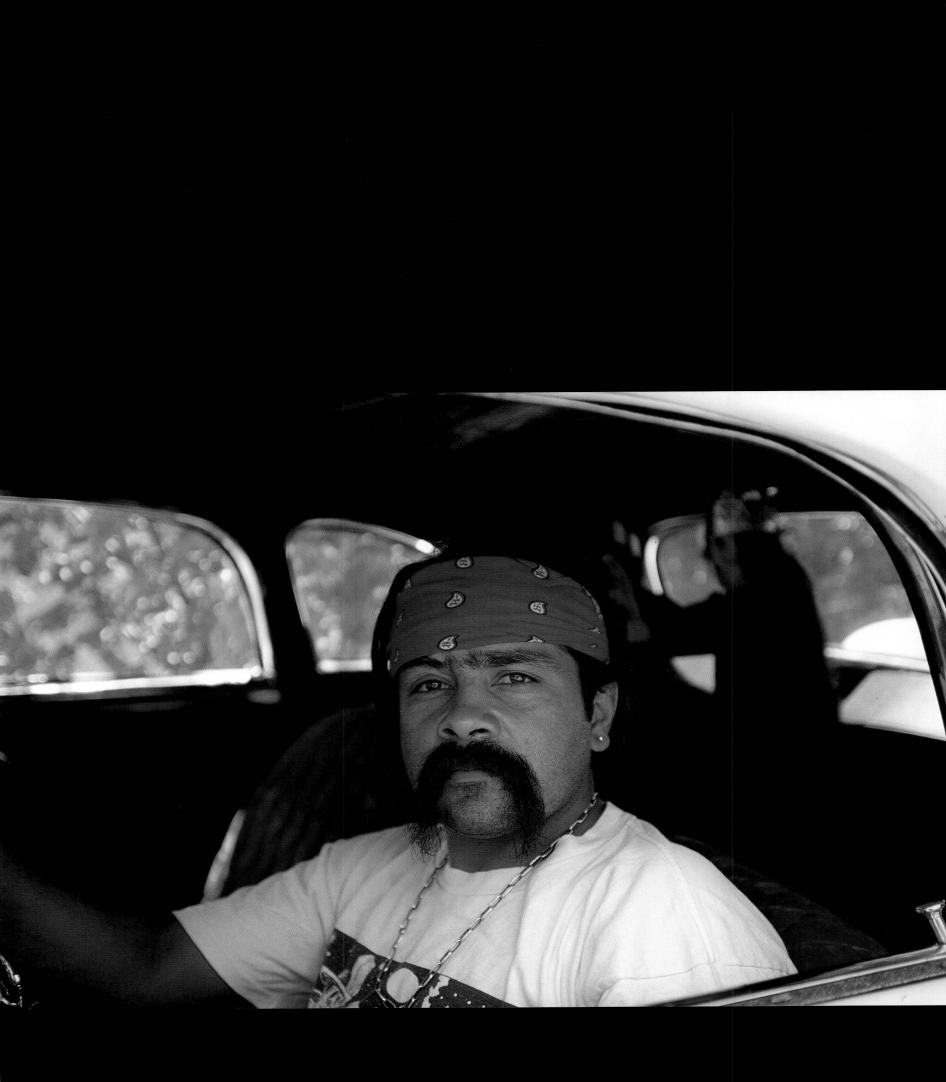

\mathscr{R}*esurrection*

The body of the abandoned '39 Chevy sat in a dry arroyo bed in Ojo Caliente like an eggshell on the compost heap. Its exterior was pitted with bullet holes from all the times the locals had used it for target practice. The car had long been left for junk.

But as soon as Nicholas Herrera rescued it, it began the transformation to art. Herrera, a *santero* (a maker of religious images), saw sculpture in the weathered mountain of metal, and he hauled the dirt-filled hull to his El Rito home.

"I used five cans of WD-40 just to get the doors open," he recalls. "One guy bet me a thousand bucks I could never make it run."

Using a host of salvaged car parts, Herrera pieced the car together like a giant jigsaw puzzle. Mixed within his mobile hodgepodge were the front end of a Ford Mustang, the back end of a Camaro, a Barracuda steering column, and a 327 engine from a '67 Corvette. Herrera painted the car pearl white, and a friend adorned it with images of some of Herrera's favorite saints. Five years and more than $20,000 later, the resurrection was complete.

"That guy who bet me, I cruised up to his house one day just to see the look on his face," Herrera says. "If you want a bad-ass lowrider, you build it from scratch."

'39 Chevy Coupe
Owner Nicholas Herrera
of El Rito. Artwork by
Desi Lopez.

47

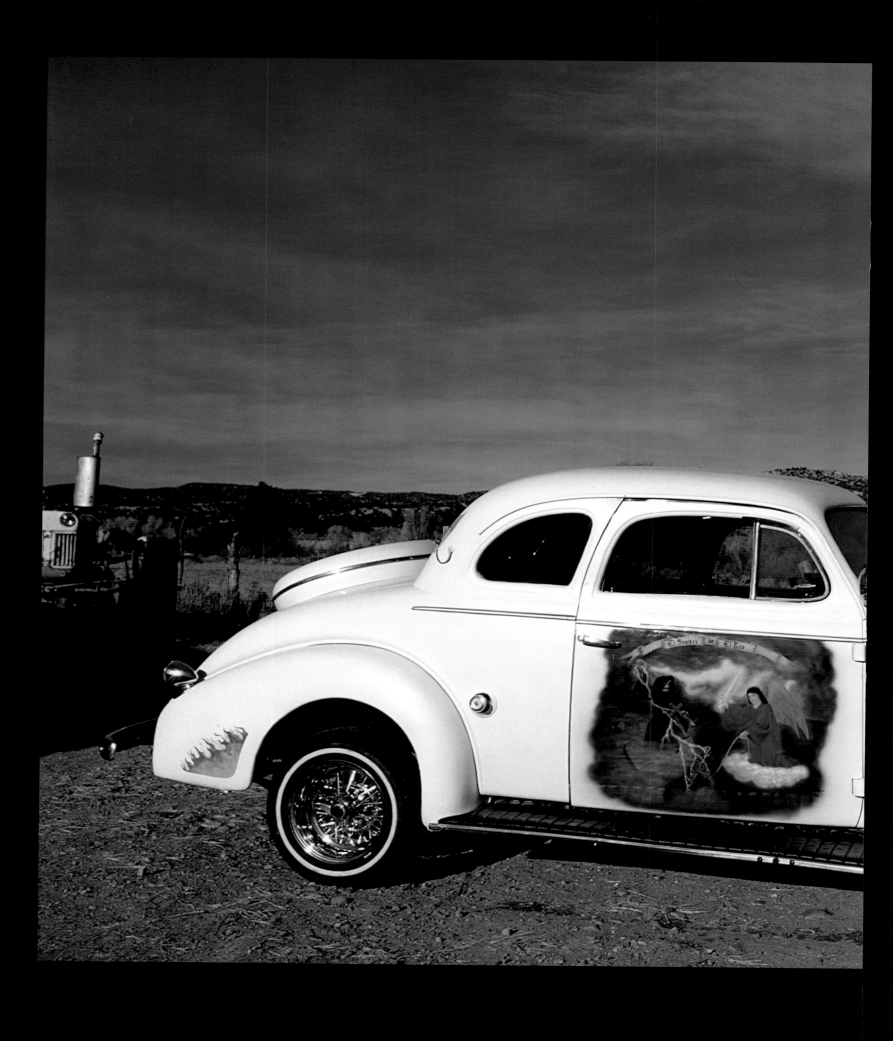

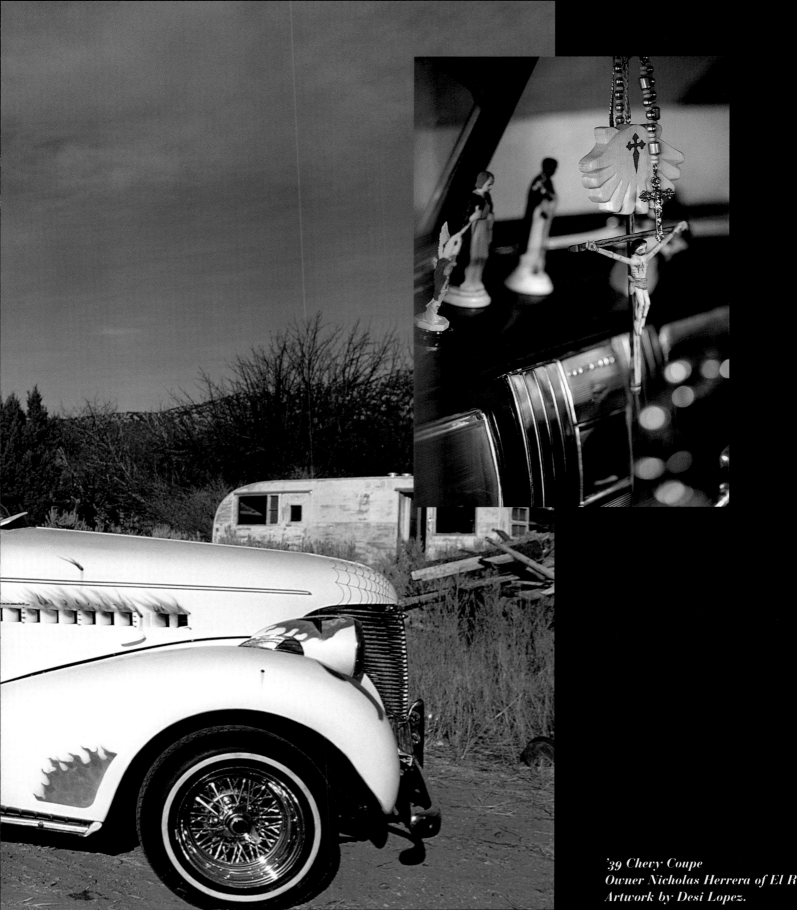

'39 Chevy Coupe
Owner Nicholas Herrera of El R
Artwork by Desi Lopez.

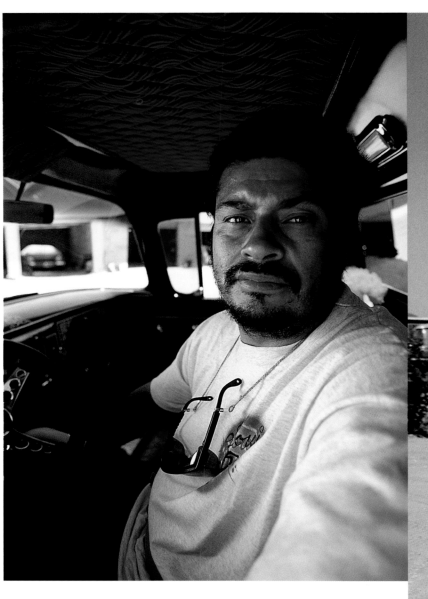

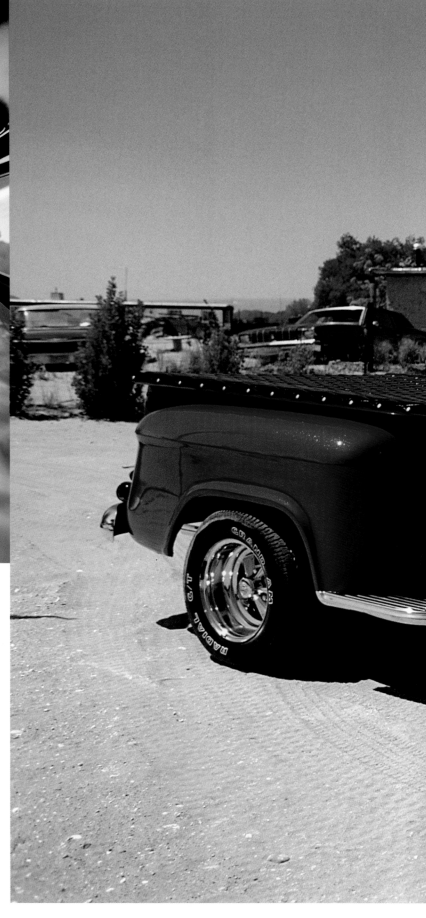

'56 Chevy pickup
Owner Louis Martinez of
Hernandez

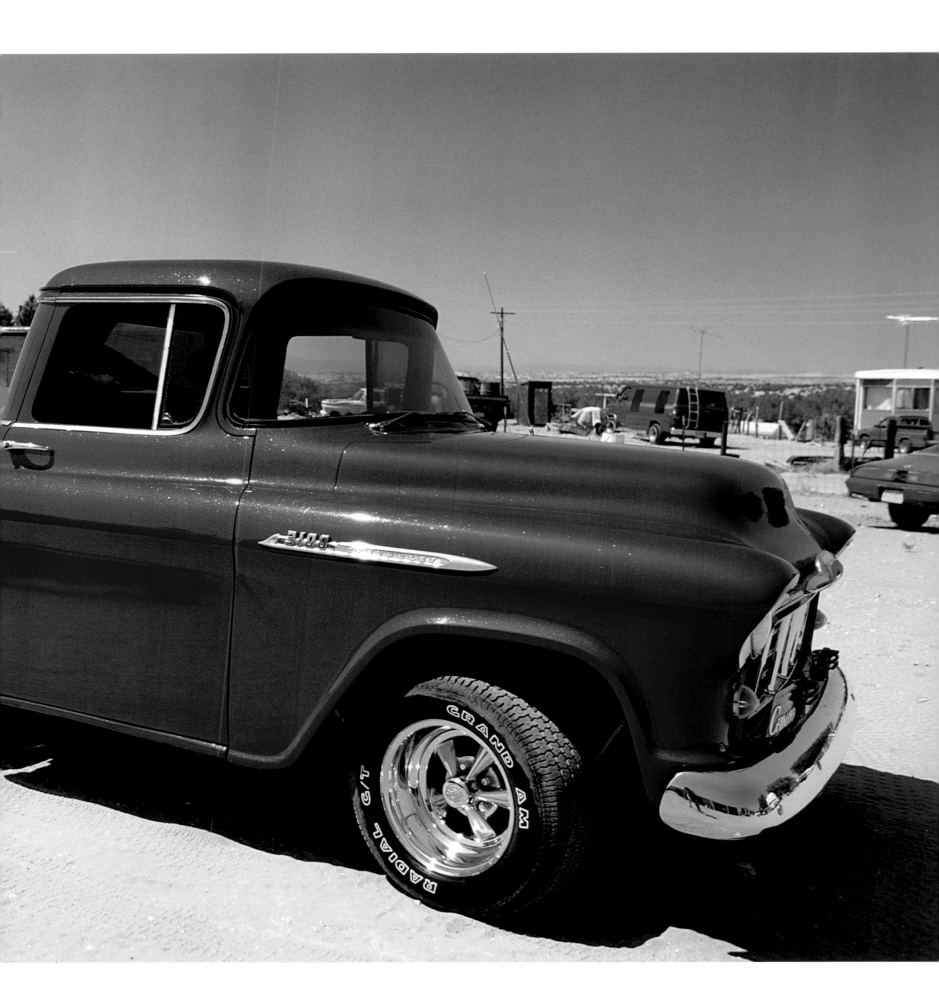

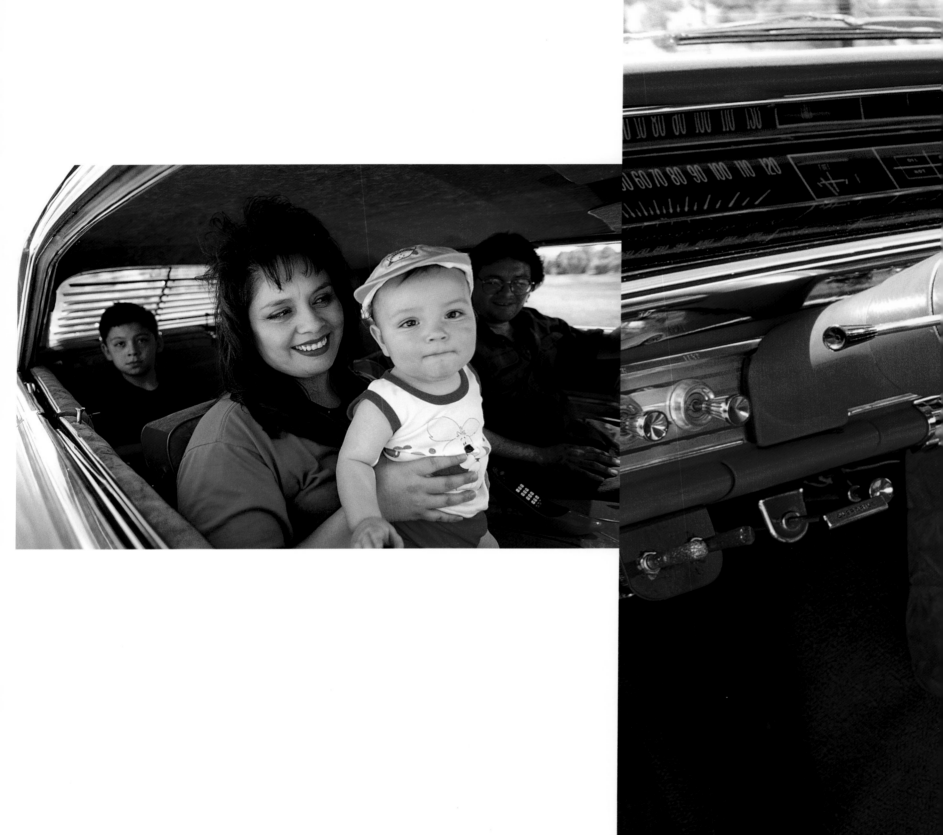

'63 Chevy Impala
Owner Jerry Gurule (shown here
with family) of Peñasco

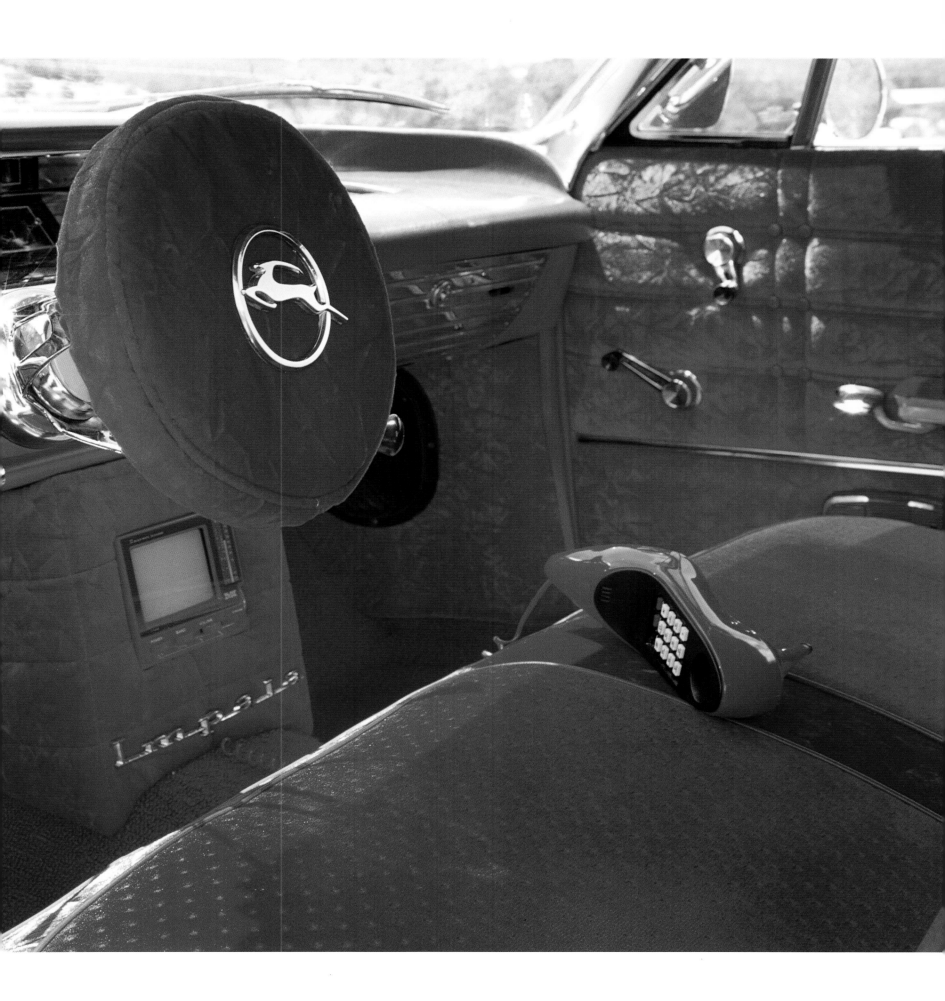

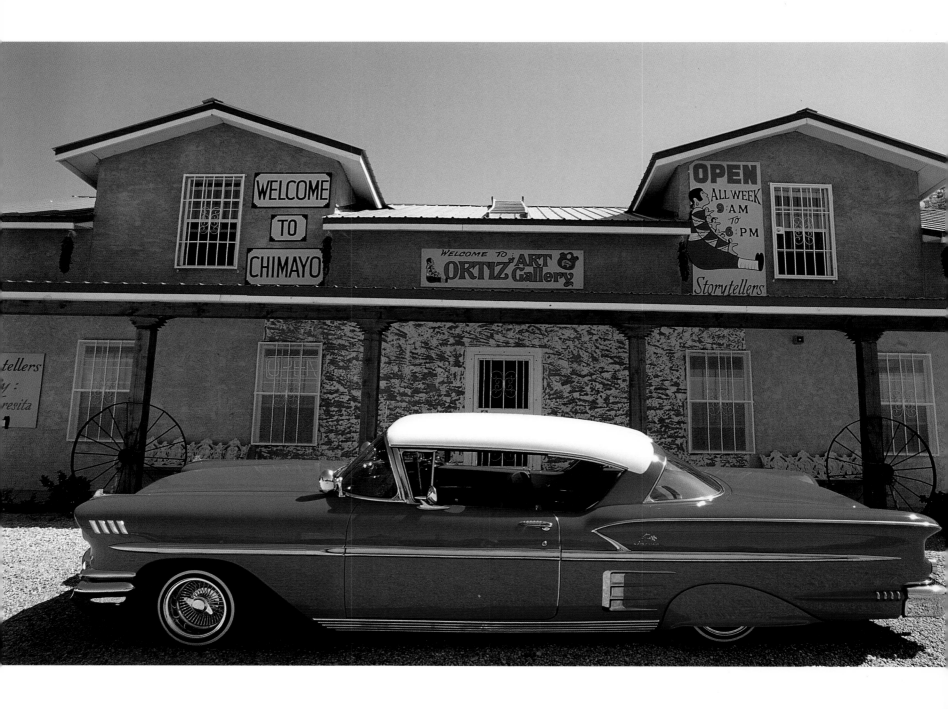

'58 Chevy Impala hardtop
Owner Wray Ortiz, Jr., of Chimayó

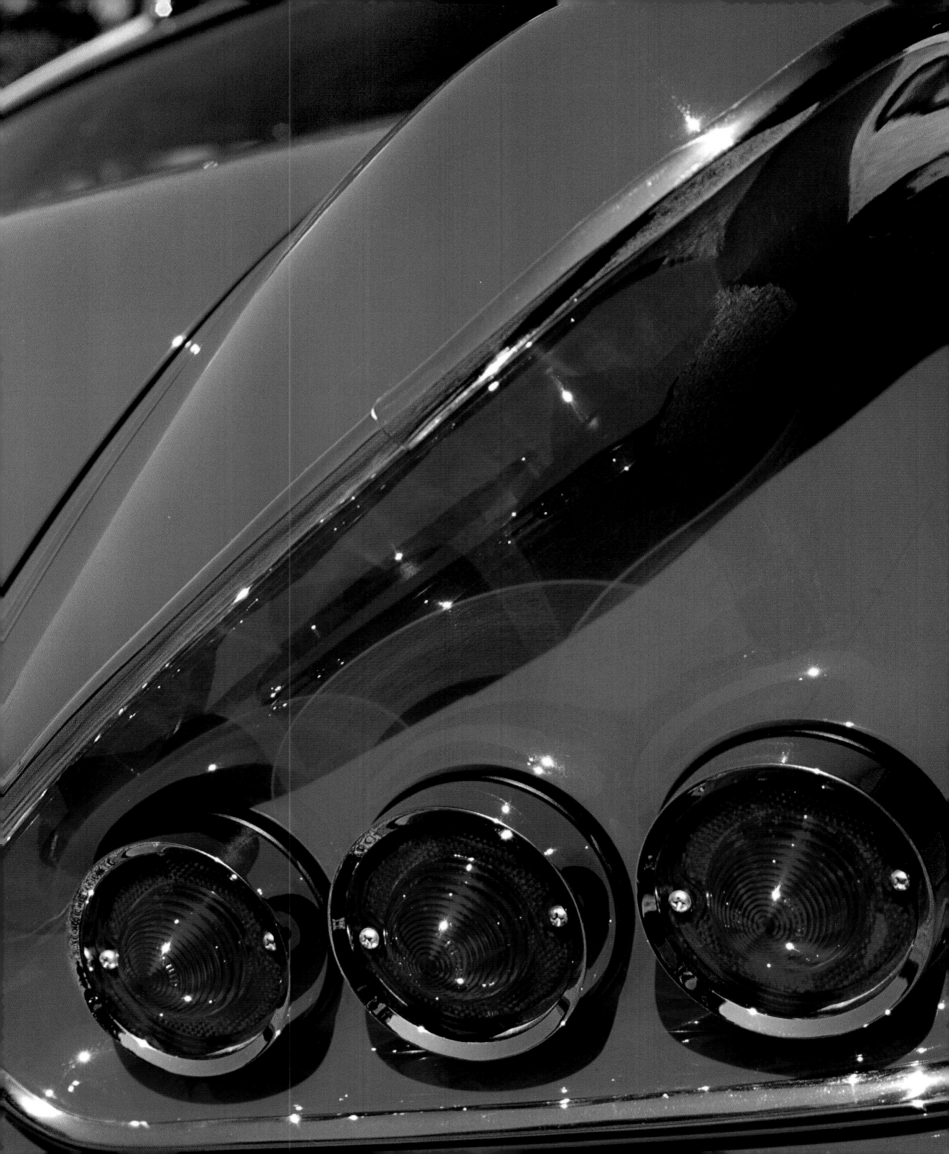

'58 Chevy Impala hardtop
Owner Wray Ortiz, Jr.,
of Chimayó

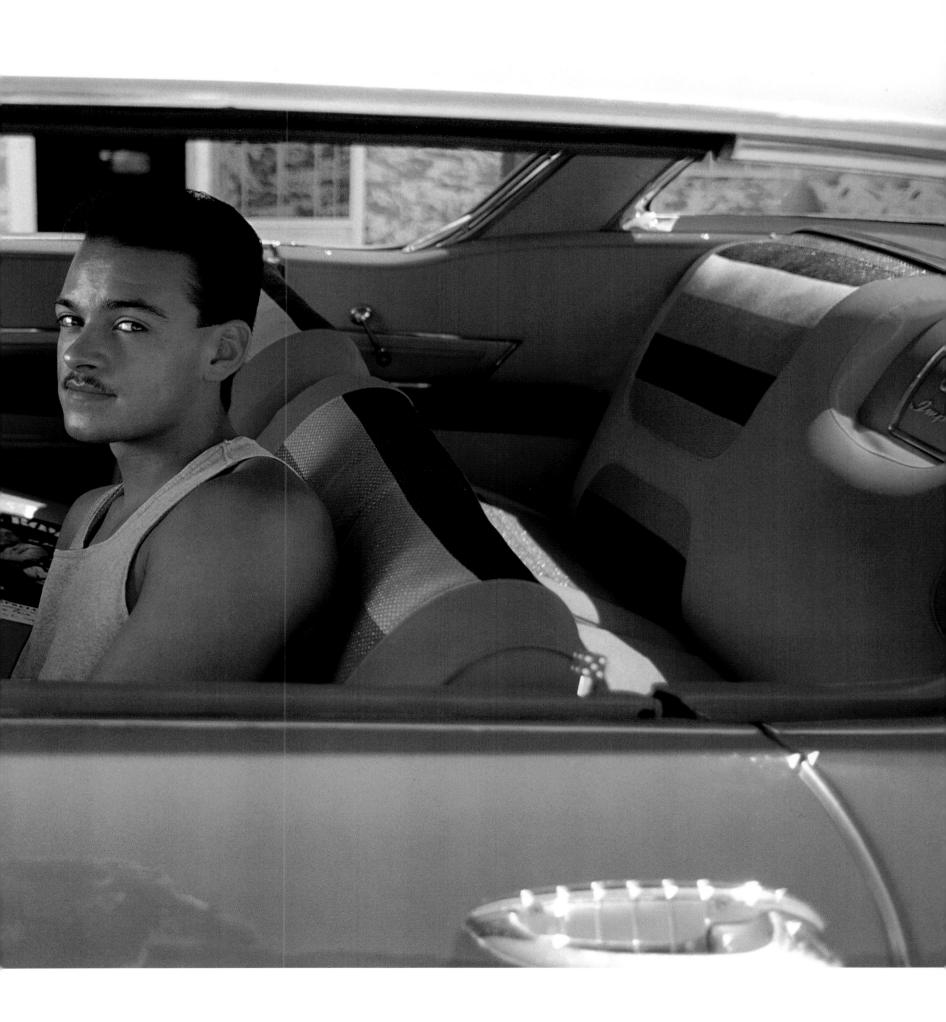

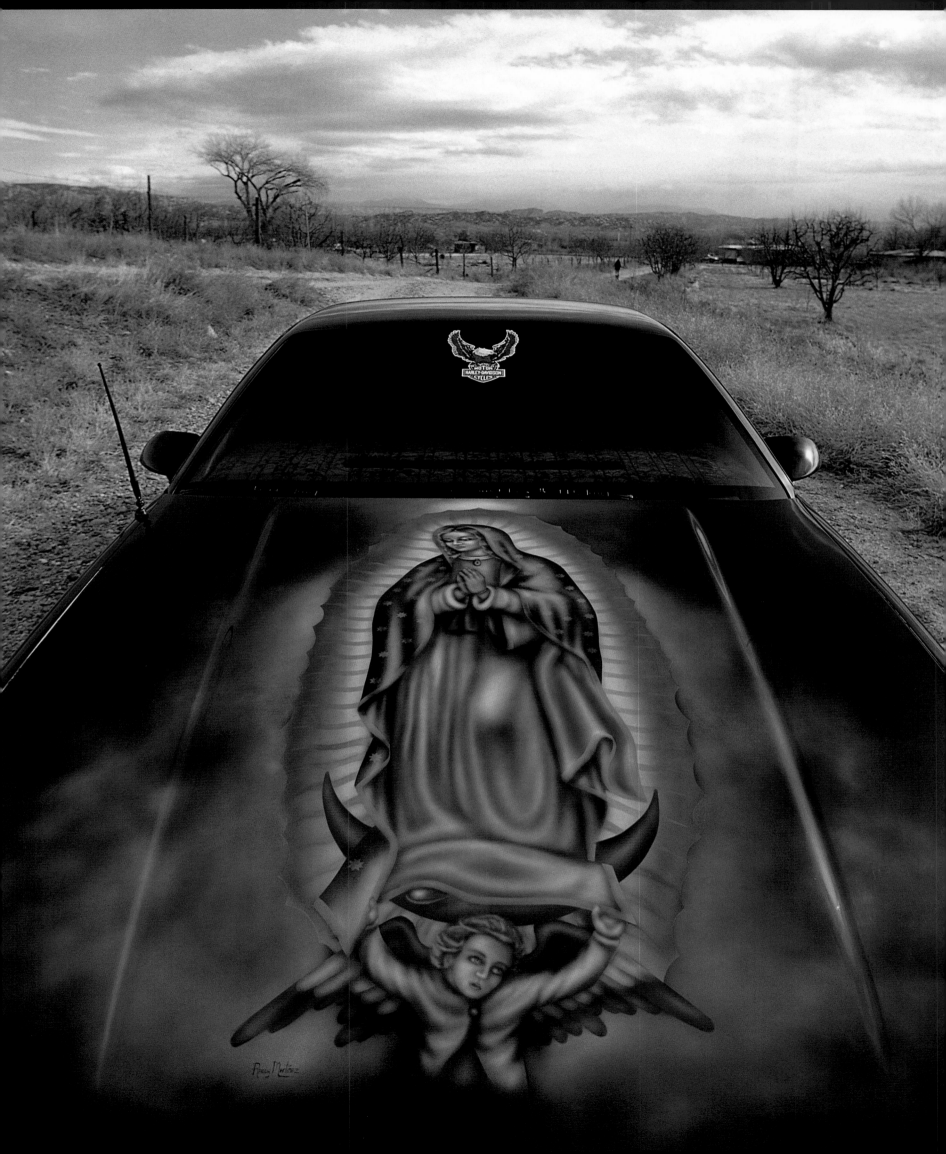

Four-Wheel Faith

'79 Ford LTD
*Owner Leroy Martinez
of Chimayó. Mural by
Randy Martinez.*

left
'84 Chevy Camaro
*Owner José Velarde of Velarde.
Mural by Randy Martinez.*

In the gray dawn of morning, on a cloudy Sunday after a night of rain, a parade of cars cruises into the center of Chimayó. Giant puddles of water and mud fill the parking lot of the Santuario de Chimayó. The drivers swerve to avoid the muck as they park in front of the church.

One by one, as their engines fall silent, they gather around their distinctive driving machines. Our Lady of Guadalupe glistens on the dark blue hood of José Velarde's 1984 Camaro while Christ's Resurrection and Ascension are played out in brilliant blue-green hues on Norman Sanchez's '73 Monte Carlo. Leroy Montoya's 1990 Nissan pickup features Jesus in a flowing robe, and Victor Martinez's '79 Cadillac broadcasts a panoramic view of Chimayó with its legendary santuario painted alongside other village landmarks.

The men have come to Chimayó this morning from Peñasco, Española, and points north to worship at the chrome altar of a new Chimayó religion. Randy Martinez, the self-taught Chimayó artist who painted the cars, is the acknowledged master of that religion's new art form. Using the automobile as his canvas, Martinez paints devotional

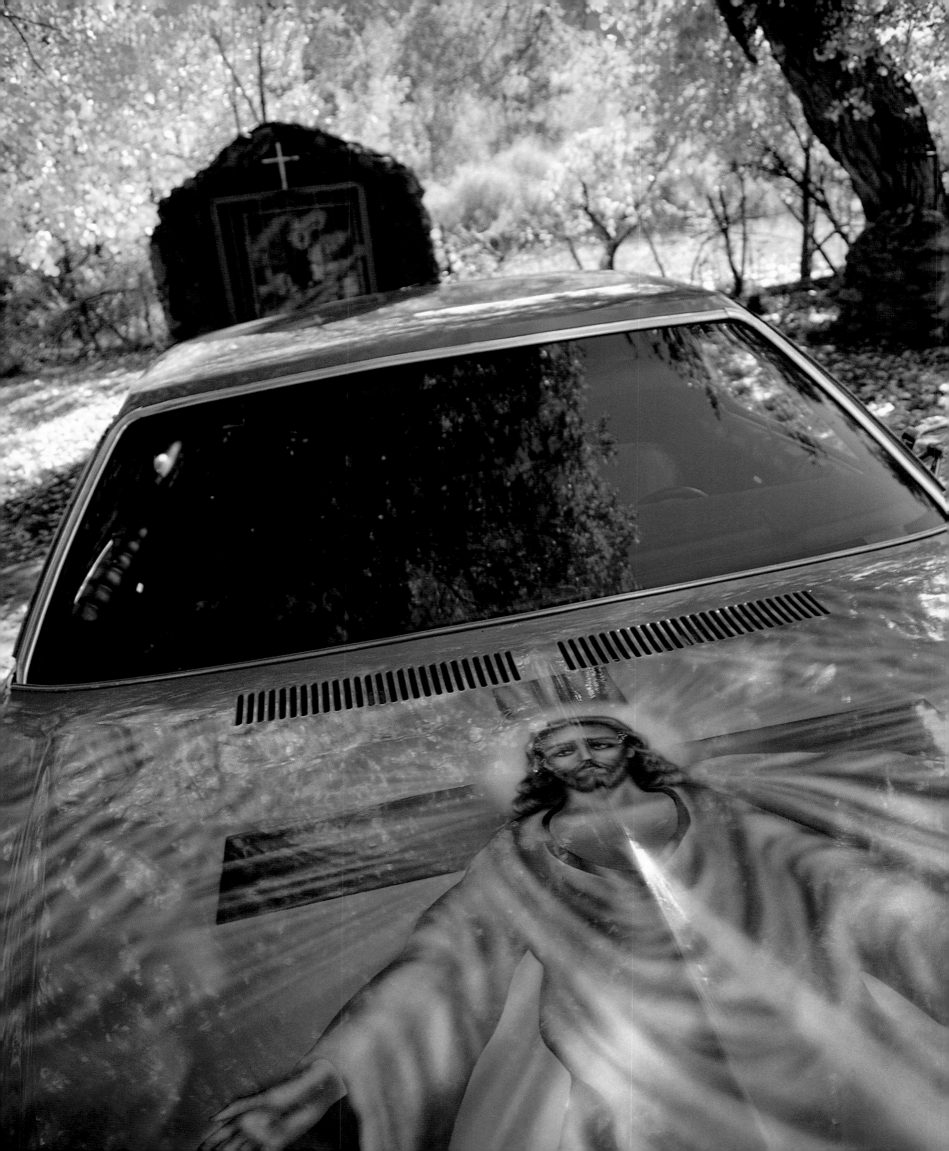

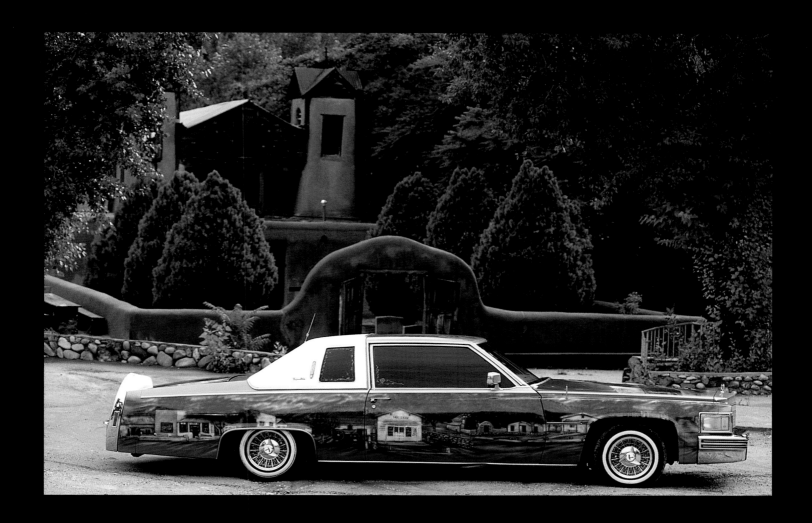

'79 Cadillac
Owner Victor Martinez of Chimayó.
Murals by Randy Martinez.

left
'73 Chevy Monte Carlo
Owner Norman Sanchez
of Española.
Mural by Randy Martinez.

images usually reserved for church and home onto car hoods, trunks, rooftops, wheel covers, and other exteriors. His luminous and detailed works merge the region's traditional religious iconography with contemporary car culture. In his hands, ordinary cars become grand objects of faith to idolize and to drive. "Cars," Martinez says, "are an extra way of communicating without the words."

During the warm months, Victor Martinez often parks his Cadillac just outside the santuario, where it has become as much a local land-mark as the church itself. "I could have already built a good house with that car," Martinez says, referring to the thousands of dollars he has spent on his creation. "But in this town, what you drive is more important than where you sleep."

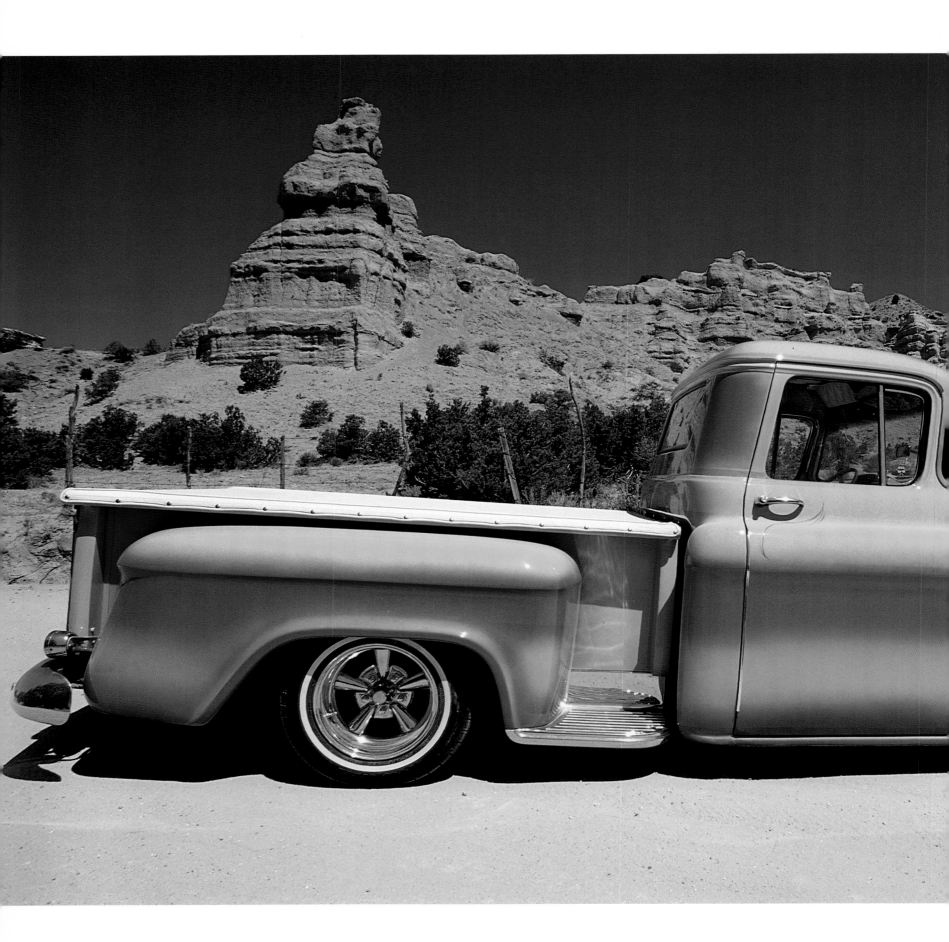

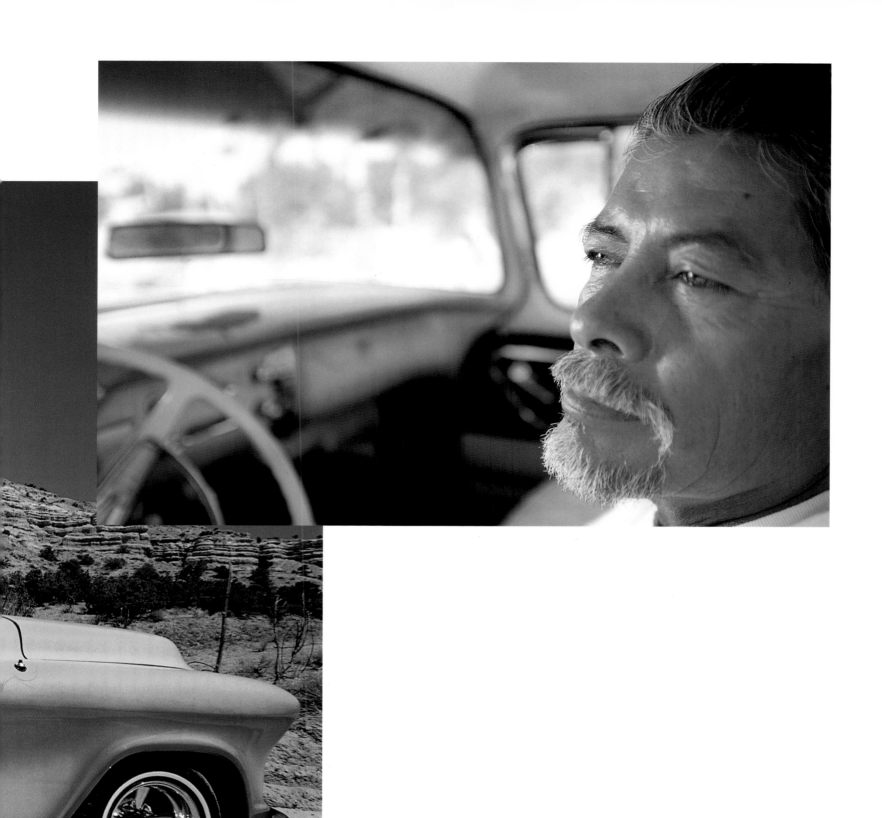

'56 Chevy pickup
Owner Joseph Martinez of Chimayó

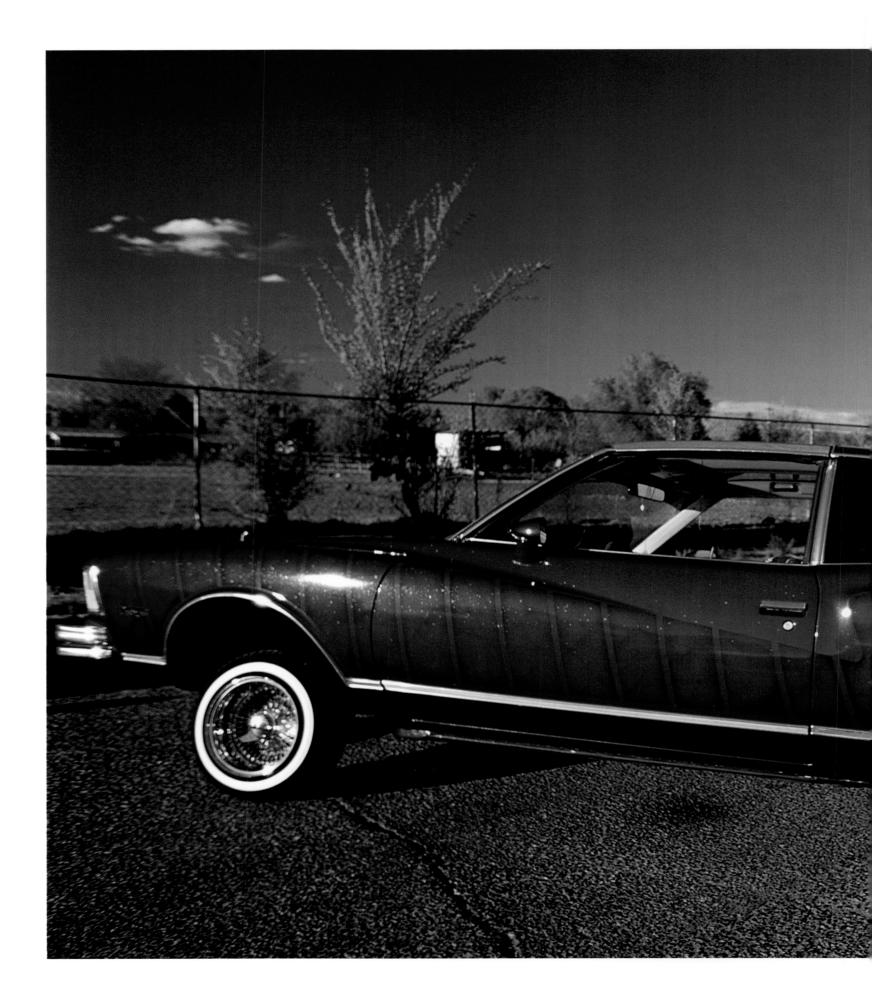

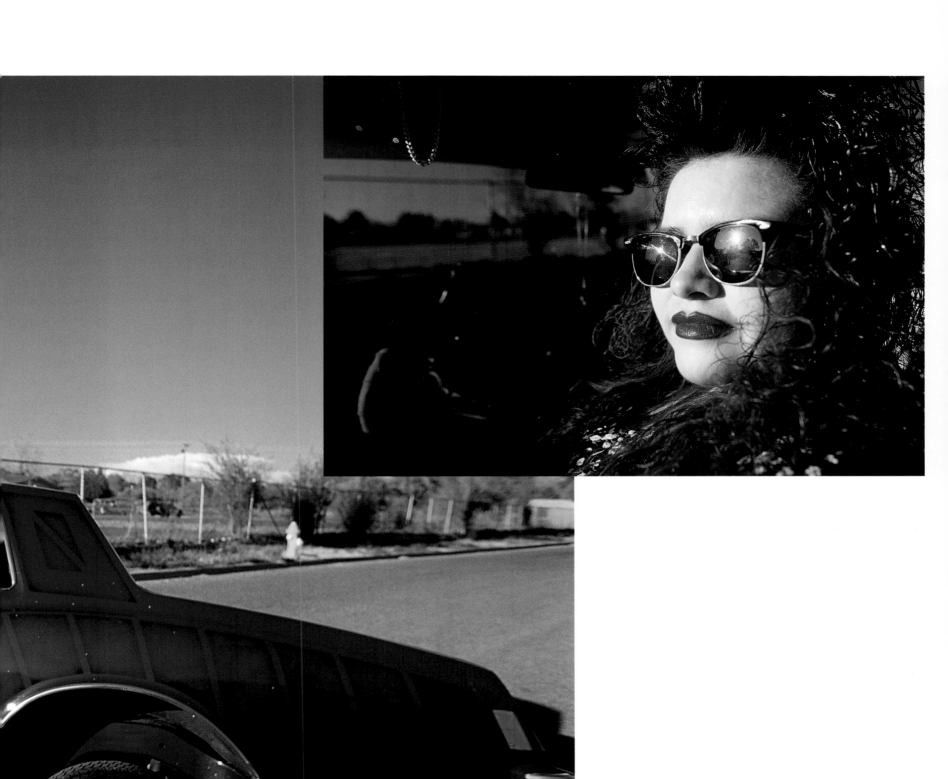

'81 Chevy Monte Carlo
Owner Rhiannon Montoya of Española

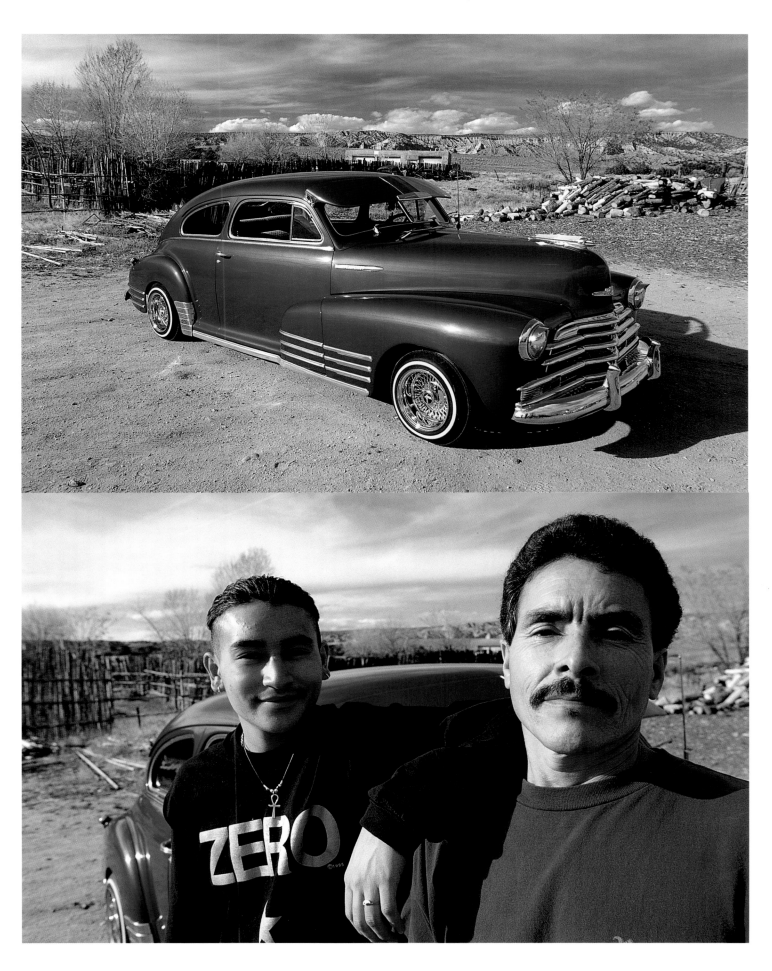

'47 Chevy Fleetline
Owner Joseph Romero
(shown here with son) of Chimayó

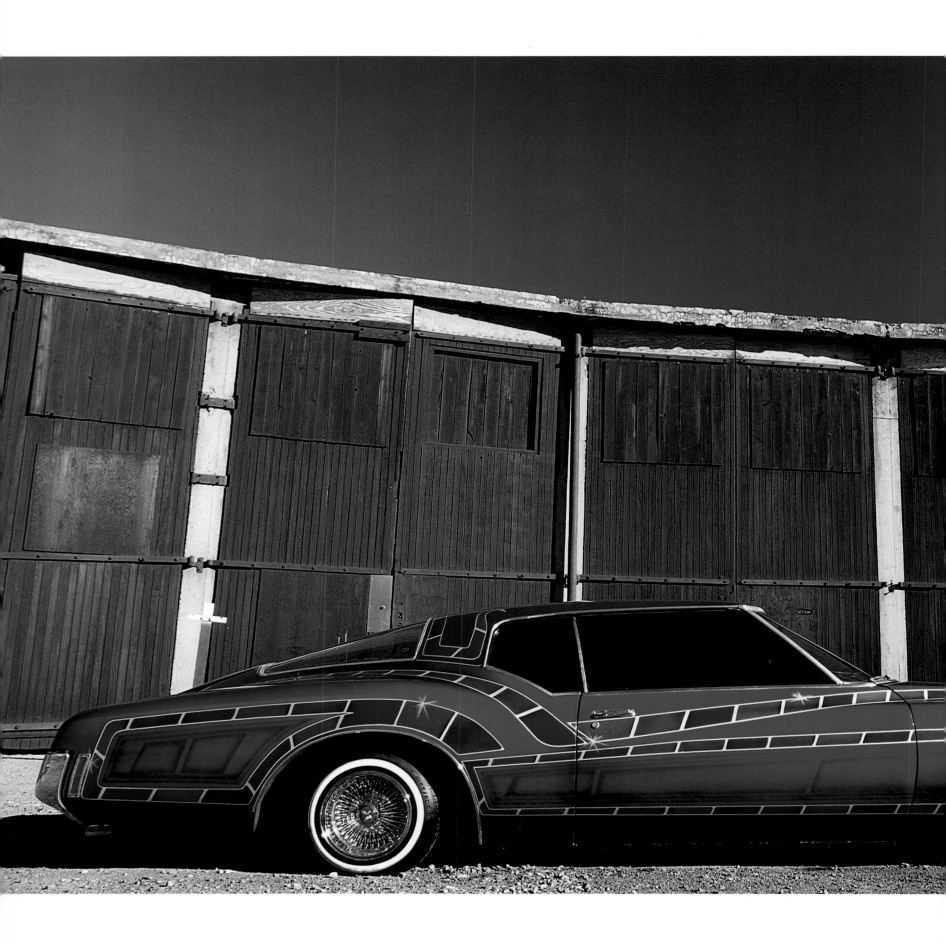

'72 Buick Riviera
Owner Adam Garcia of Las Vegas, New Mexico

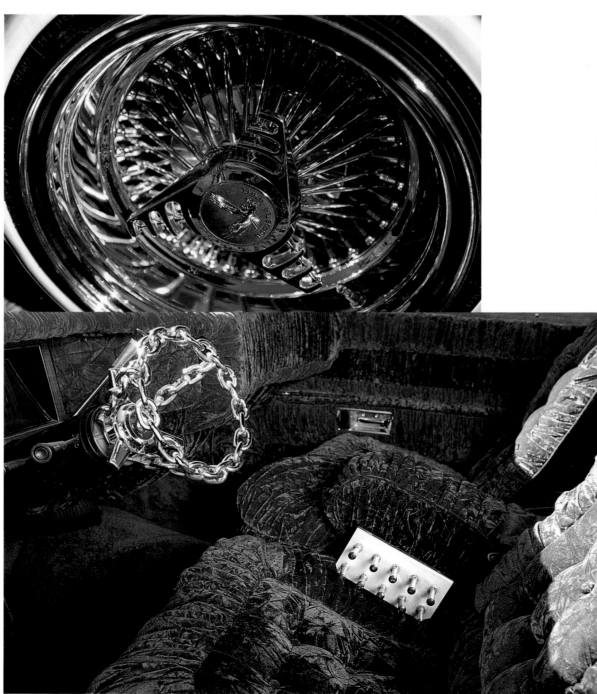

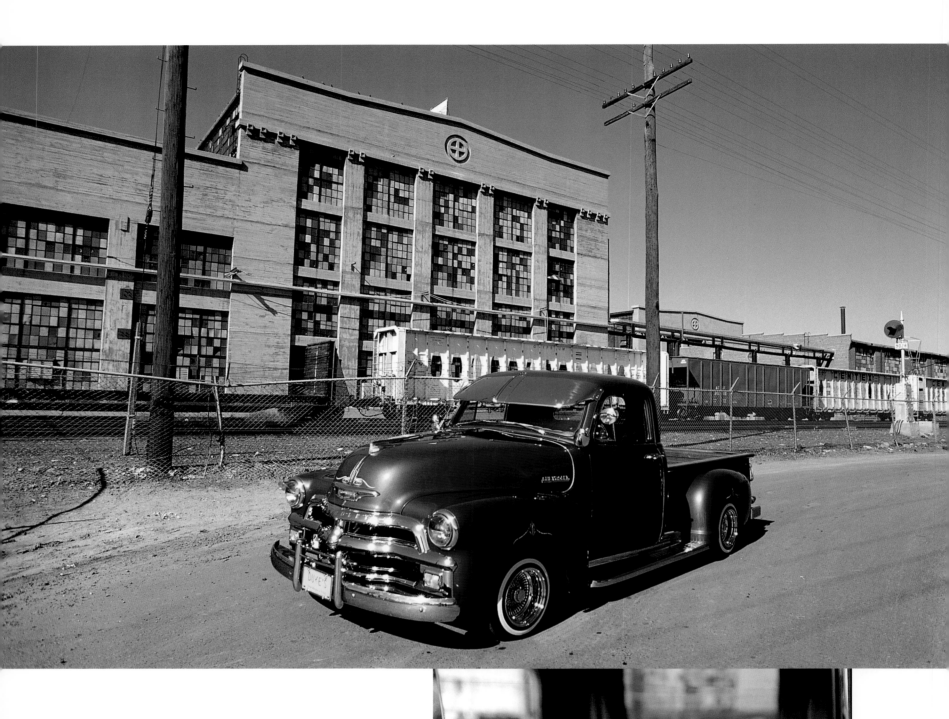

'41 Chevy pickup
Owner Frank Chavez of Albuquerque

right
'91 Plymouth Colt
Owner Eddie Tafoya of Española

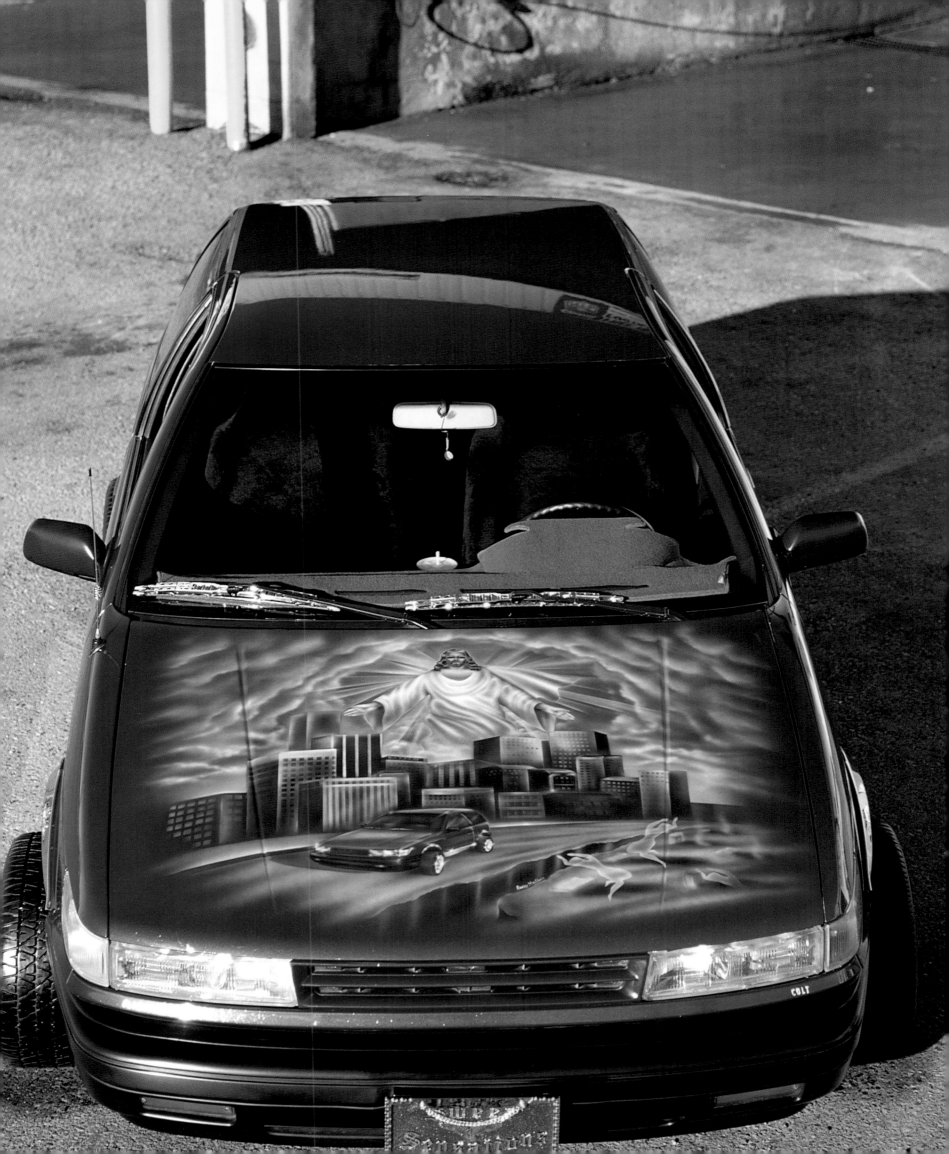

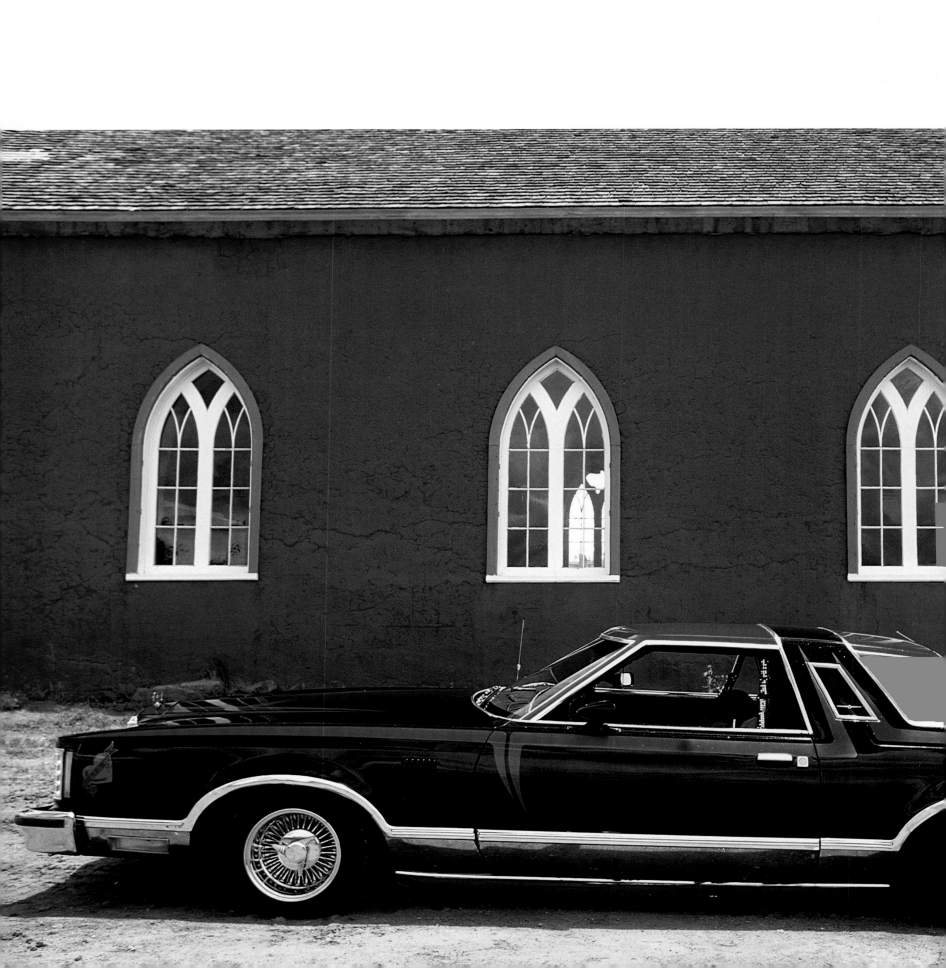

'78 Ford Thunderbird
Owner David Maes of Cleveland, New Mexico.
Mural by Freddy Olivas.

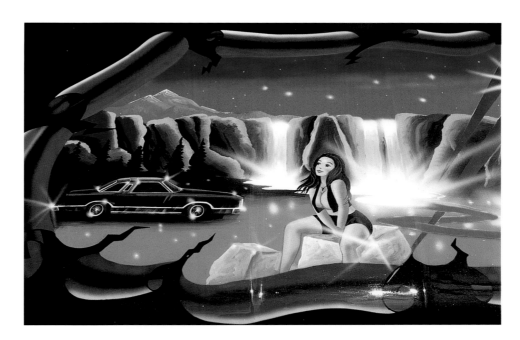

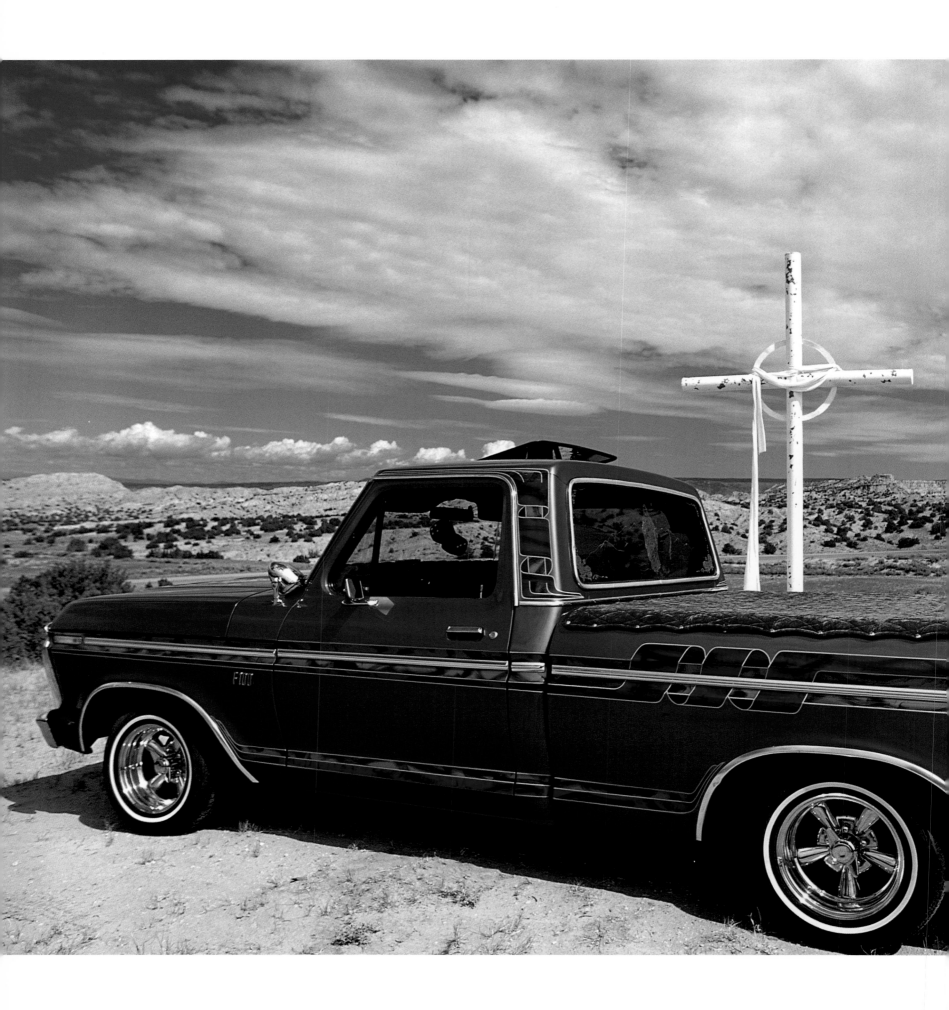

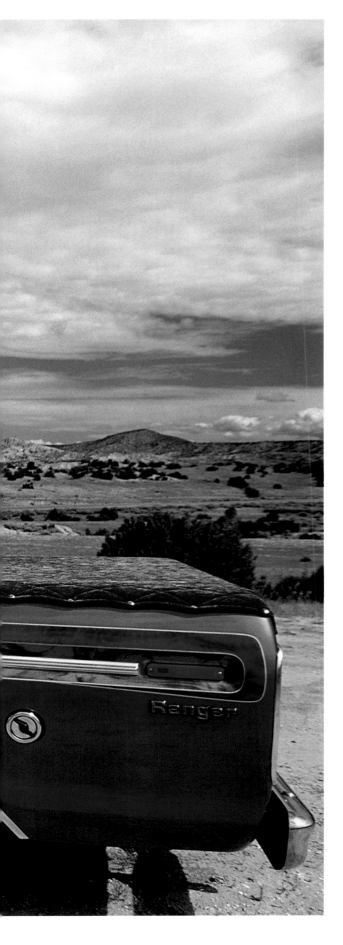

'73 Ford pickup
Owner Dennis "Chicago" Chavez
of Chimayó

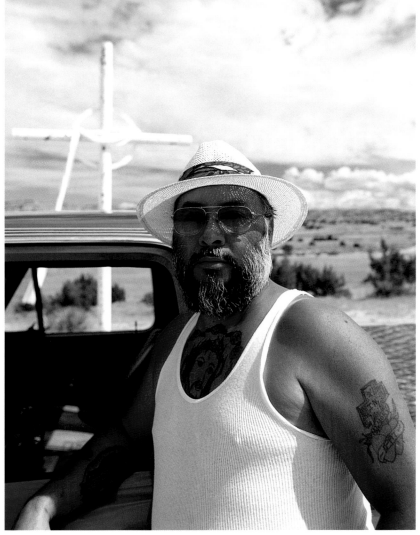

La Virgen de Guadalupe Cruising down Chimayó

by Juan Estevan Arellano

La Virgen for years has been floating above the *Río Grande*, where the *Río Fernández* joins the cold waters of the north on their journey south to Brownsville, *el Bravo del Norte se vuelve el Río de las Palmas*.

Like a sentry overlooking its flock below, the *Virgen del Pilar* watches over her people going *a la leña en* Carson, *en sus* pickups *viejitas*, and once in a while an old lowrider sputters down the gravel road.

Who etched *La Virgen del Pilar* on the huge basalt rocks of the mighty *Río del Norte* no one knows, *"nomás Dios sabe," decía mi mamá*; but like the Mexican ballad echos, *"solamente la mano de Dios,"* the hand of the almighty was what carved the *virgen* on the stone, and it used the softest of tools to do the work, *agua bendita*, for it was the water from a nearby *arroyito*, as it traverses the *llano* on its way to the river, over time sculpted *la virgen de los lowriders* on the west side of the gorge.

This is where all the *leñeros*, and now the lowriders, stop to gaze at the *virgen*, finish off a six-pack, roll a *gallazo*, *tirar el chorro*, and discuss metaphysics and philosophy, *de dónde, y quién hizo esa Virgen*, that everybody says has been there for eternity; *"mi abuelito y mi bisabuelo platicaban que sus bisabuelos se acordaban de la Virgen de la Cieneguilla,"* according to the philosophers of *la resolana*.

The old-timers would always refer to Pilar as *"la Cieneguilla,"* since the town today famous for rafters, when it got a post office, became *Pilar* in honor of the wife of the postmaster.

La Virgen Morena, la Señora de Tepeyac, it's still recognized by all as *La Virgen de Guadalupe*, *"la Upe,"* as some call her jokingly, *pero cuando se les atora un chasco*, that they have to pray to someone, it's always to *"La Virgen de Guadalupe," que todos aclaman*.

The *viejitas* with their *tápalos* and their icon of *"la virgen"* held tightly in their shriveled hands, the *cholos* with their tattoos all over their backs, some awesome works of art on skin, others so-and-so, but none compare to the master works of art of *"La Virgen de Guadalupe"* on the hood, or trunk, of the lowriders descending from the various villages—*hechos línea como hormigas*—as they march towards Española and the annual lowrider car show.

There's *Pedrito*, also known as "Pete," or "Peter"; he's from Chimayó, from *"el Arroyo del Medio,"* that for a long time he wasn't able to drive his *ranfla*, *su carrucha aplanada*, to his house because of his car being so low and slow—many a night his '74 Monte Carlo had to spend the night alone at his *camarada's* near Highway 75.

Every night he would pray to *"la Virgen,"* a la Señora de Tepeyac, a la Virgen Morena, to take care of his priceless car, the one with the most beautiful painting of *"la Virgen,"* done by the famous painter from *Córdova*, the one who had only done *bultos* of *"la Virgen." Siempre rezándole a la Virgen Morena.*

To his surprise, *"la Virgen"* that he painted on the *"Monte"* turned out to be a masterpiece; everyone who has seen it can't believe their eyes, that an uneducated *santero "de los chicos"* had painted the best portrayal of *"Upe"* that anyone had seen. It was incredible, the colors superb, the draftsmanship out of this world.

Another Don Diego, uneducated, *pero con fé; "no hay nadie que tenga más fé que Fulano de tal,"* the people from *Córdova* had been saying for years, for eternity it seems like, now everyone knows about his hidden talent. Always praying to *"la Virgen."*

She who was born from *maíz*, from the south, unlike Moctezuma who was born from a *piñón*, making him a *norteño*. *Nuestra señora de Tepeyac* never imagined herself cruising from Sonic to Sonic in Española with a bunch of *cholitos* and a couple of *chuquitas* from Río Chiquito.

Never would the *virgen* have imagined herself venerated by the *"vatos locos"* from the north, appearing in murals, paintings, poetry, or in a *bulto* form, from studio tours to the Spanish Colonial Market, and even on *pinto* art, *en los paños*, that is, handerchiefs.

Virgen Morena, virgencita querida, siempre en nuestros apuros y afanes nos acordamos de ti, it's only in our tribulations that we remember you, it seems, but you are always in our thoughts and prayers, "Brown Mother" of the Americas, mother of the *mestizo*, the *chuco*, the *cholo*, the *hispano*, *latino*, *chicano*, *nuevomexicano*, *manito*, *paisano*, *mulato*.

Whether riding on the back seat of a Monte Carlo, adorning the trunk of a '64 Chevy, on the back of a *vato loco o pinto*, wherever you are, *Virgen Morena*, protect us and guide us, same as when we are on *la peda, o poco tirilongo* that you intervene for us and drive us home safe.

Only *hispanos, chicanos, la raza plebe*, can be cruising and hopping, bouncing like a jumping bean, drinking and driving while praying to *"la virgencita, por favor que no me tuerza la jura,"* as the sheriff zooms in the opposite direction with its siren on as he finishes with the sign of the cross.

"Virgen Morena, perdóname," forgive me *Virgencita de Guadalupe*, but I promise you that on Dec. 12, for your birthday, we'll throw a big party. Everyone will be there, Johnny, *la* Janet, *la* Joyce, *el Chuey, la Presiliana, Juan de la Cruz.*

Virgencita, you who have cruised in more lowriders than anyone, you who have appeared mysteriously on more bare backs than a *vaquero* has mounted *mesteños*, don't ever forget your people because *la raza* will never forget or abandon you; if not stoically keeping guard over an *abuelita's altar* you are partying with *la plebe* at the Double-L.

Virgen querida, tú eres de la gente y la gente es de ti. Amén.

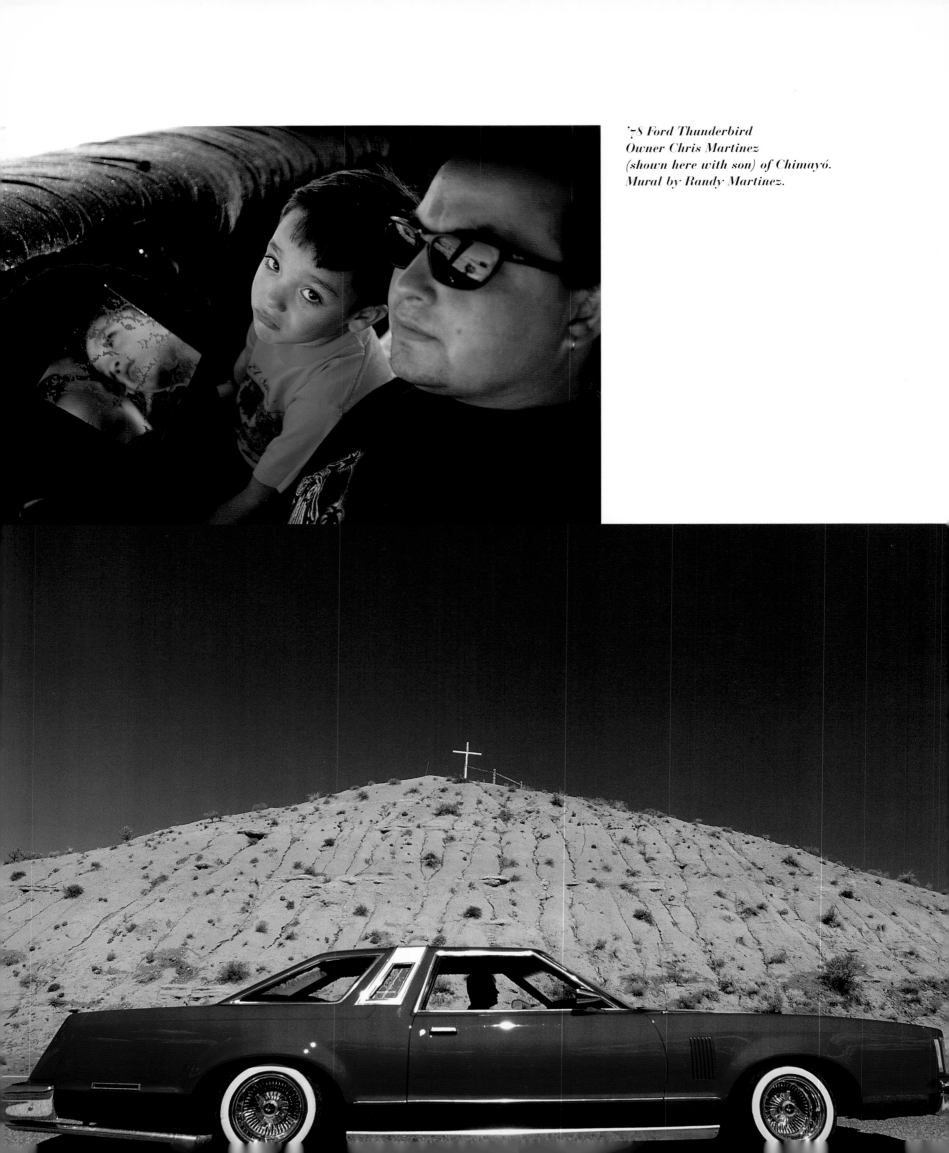

'78 Ford Thunderbird
Owner Chris Martinez
(shown here with son) of Chimayó.
Mural by Randy Martinez.

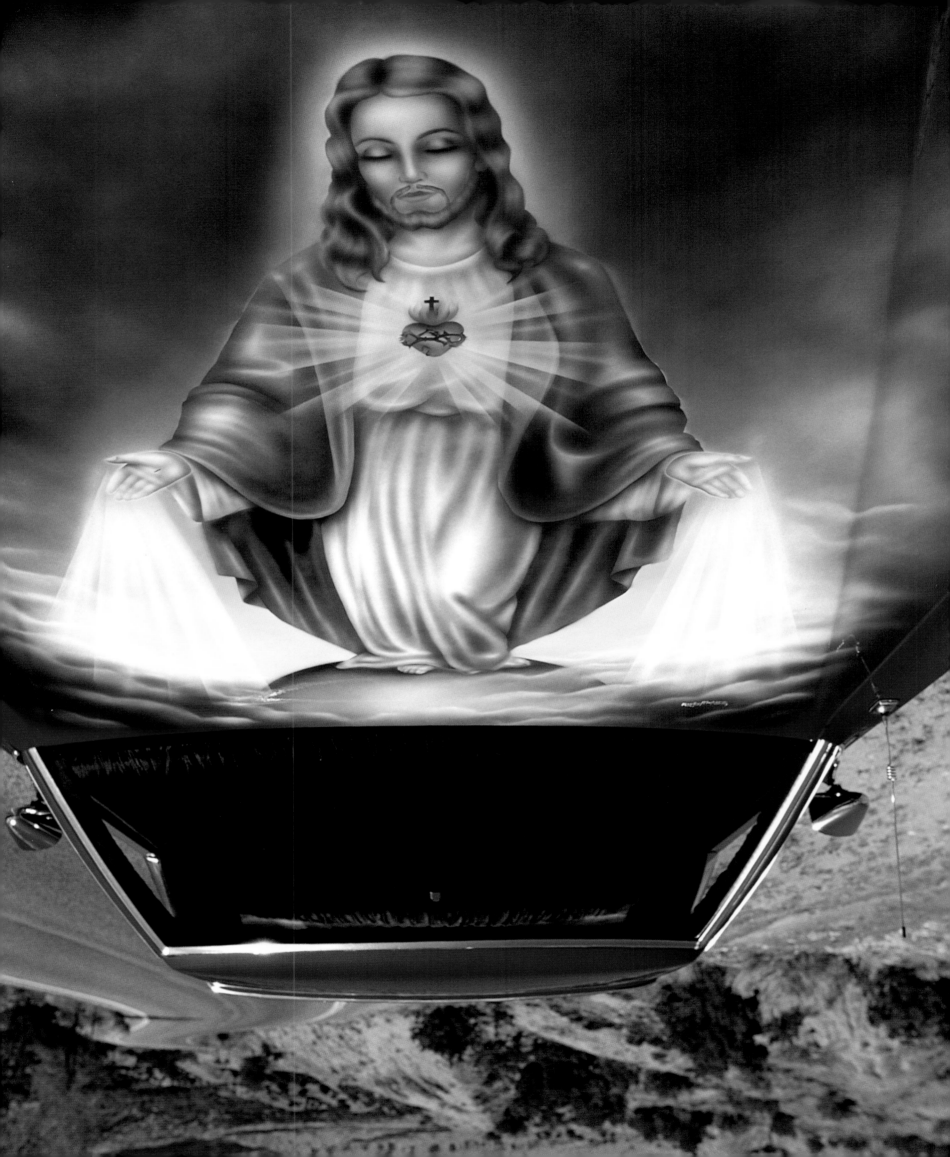

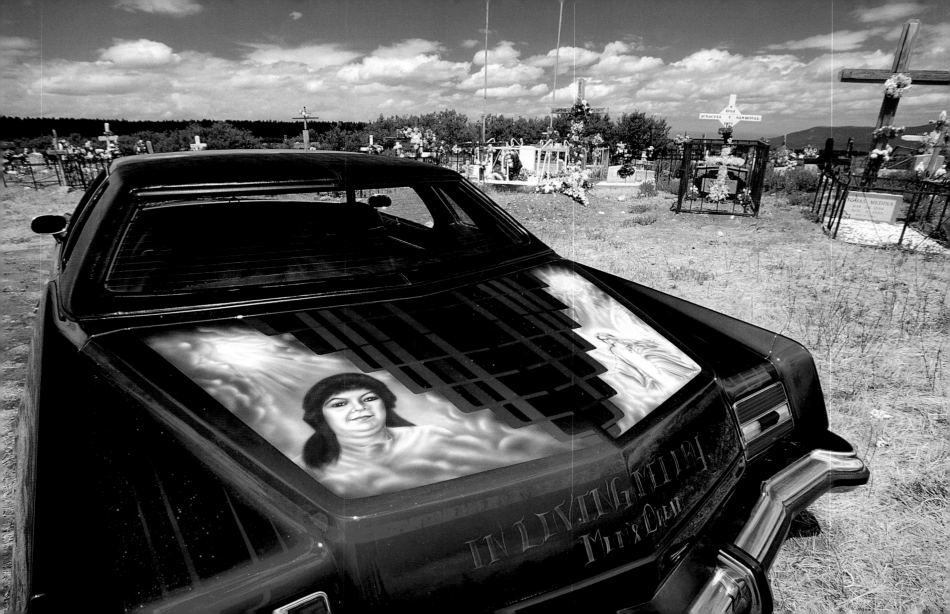

Rest in Peace

*'73 Pontiac Grand Prix
Owner Eloy Sandoval
of Peñasco*

It was the 26th day of January in Chimayó, 1991, the day thirteen-year-old Eloy Sandoval's world was frozen in a storm of gunfire.

"It was my mom's ex-boyfriend," Sandoval recalls. "She was moving her stuff out of their trailer. He showed up with all kinds of guns and started shooting everybody." Dead were Sandoval's mother, Ignacita, his two sisters, a nephew, brother-in-law, and two policemen. Eloy Sandoval took a bullet in the chest. The media dubbed the event "the Chimayó Massacre," the worst mass murder in New Mexico history.

Eloy went to Peñasco to live with his father. About the only things he had left of his mother were the painful flashbacks of her murder and her 1973 Grand Prix. "She had always wanted a nice paint job and nice wheels. I always wanted a lowrider," he says. "I decided to fix up the car in memory of my mom. Whenever I worked on it, I felt peace."

Today, the car is candy organic green with a cloud-shrouded portrait of Ignacita Sandoval painted on its trunk and the words "In Loving Memory: Mom's Dream." Sandoval has his own dreams for the car. "I'm not going to stop working on it," he says, "until it's the centerfold of *Lowrider* magazine."

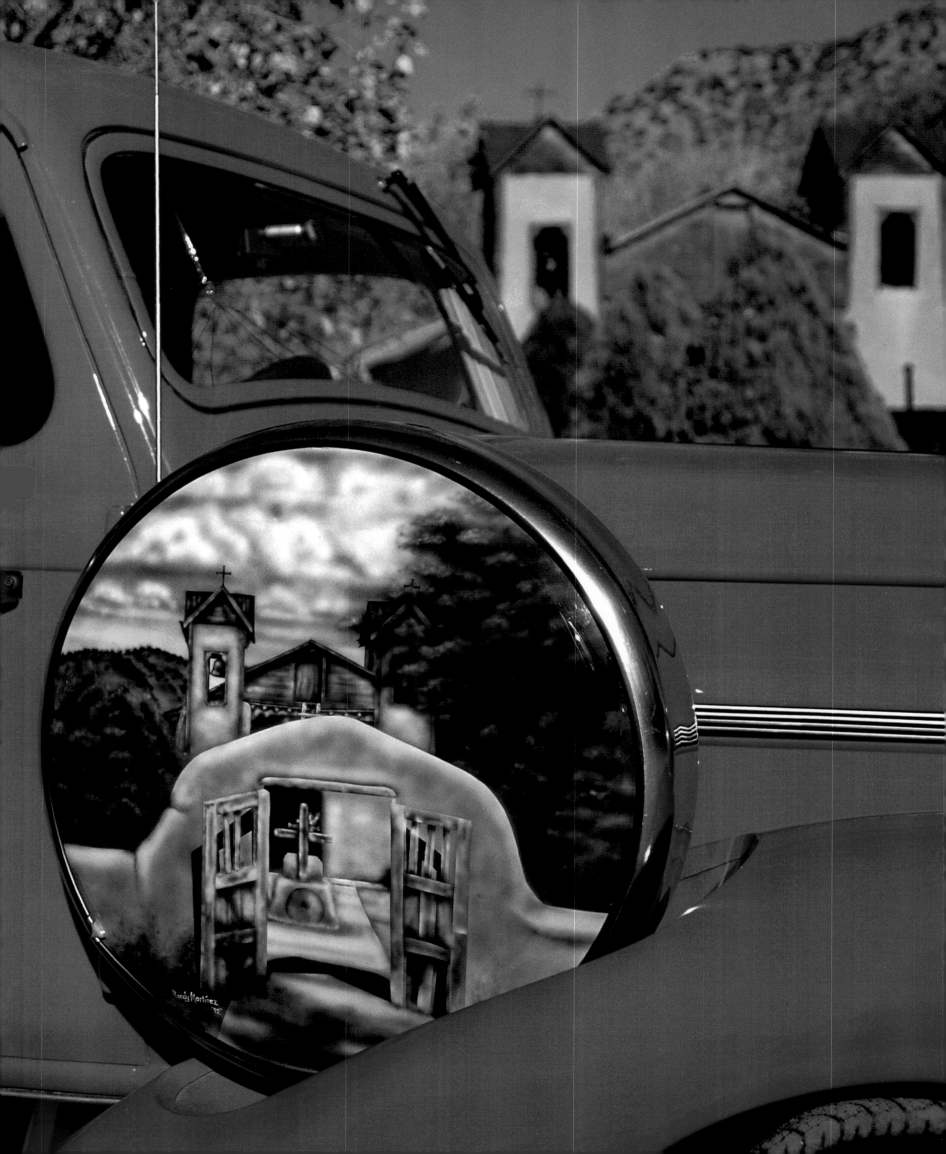

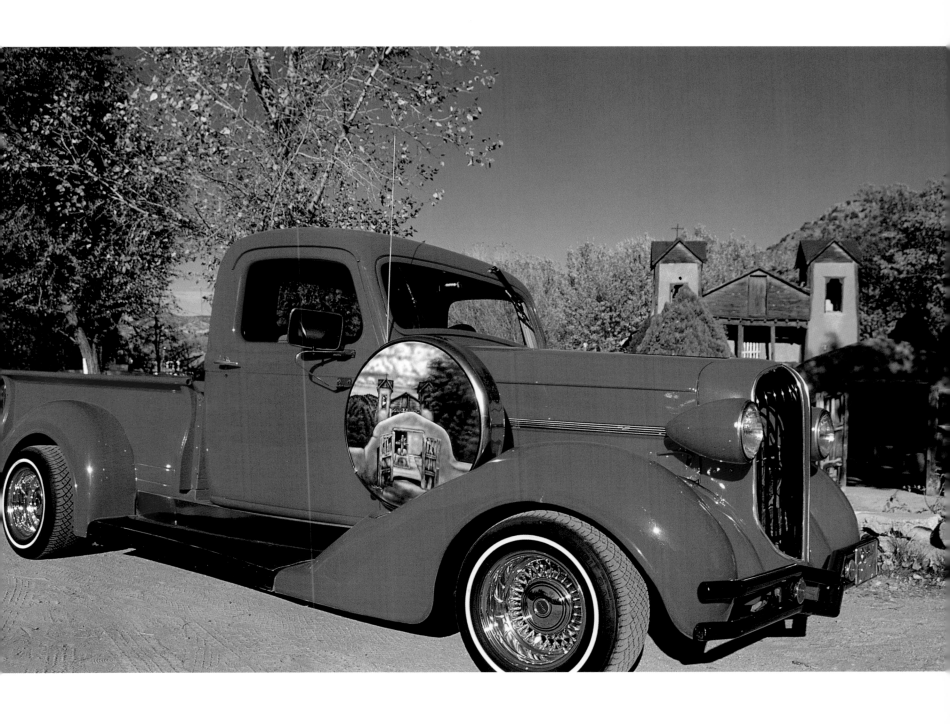

'37 Plymouth pickup
Owner Willie Sanchez of Chimayó.
Artwork by Randy Martinez.

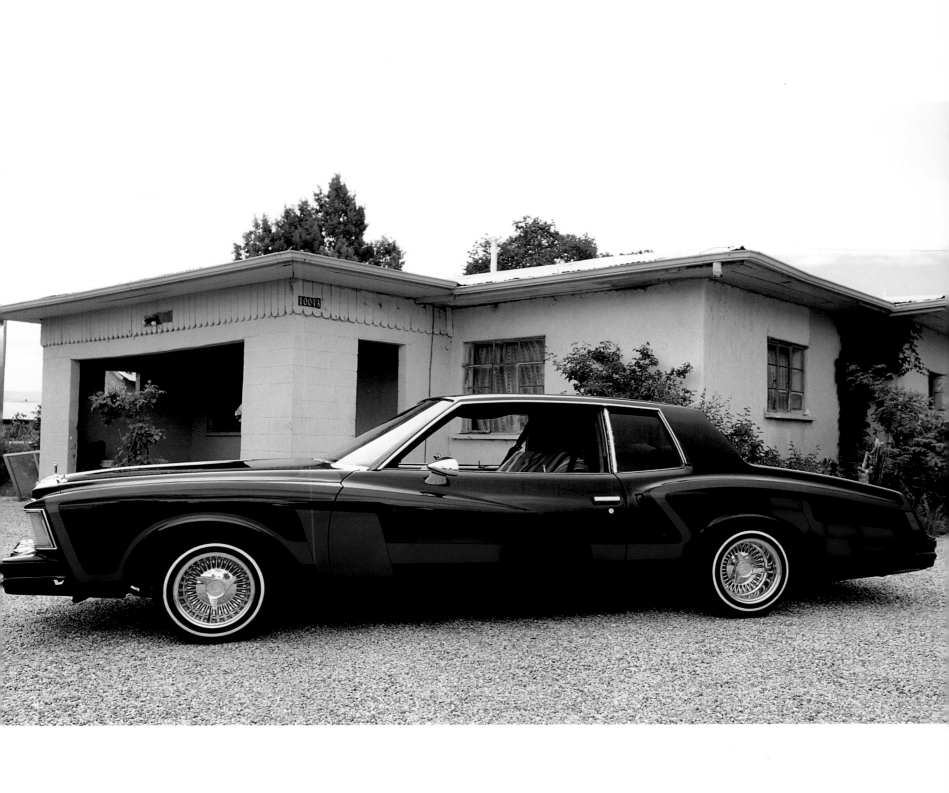

'78 Chevy Monte Carlo
Owner Annette Gonzales of Fairview

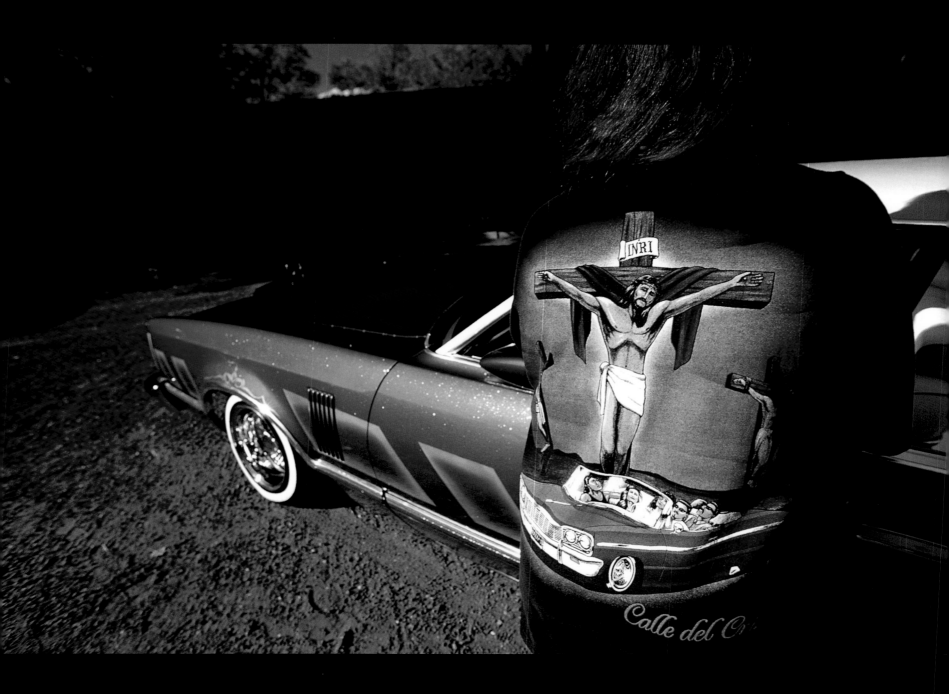

Lowriders in Love

When Lee Córdova met Bettie Martinez in 1984, both had a thing for cars. The only problem, Lee recalls, was that "she liked to go to the lowrider car shows, and I liked the drag races. Lowriders didn't interest me at all."

But the Alcalde couple liked each other enough to accept their differences. When Bettie got her 1978 Ford Thunderbird and began transforming it into the teal-green lowrider of her dreams, Lee gave his support. When the two married in 1989, he accepted that lowriders would always be a part of Bettie's life.

Yet Bettie wanted lowriders to be part of their lives together. Driving home from Santa Fe one day, she convinced Lee to check out a '63 Impala. She loved the car. He wasn't impressed. A few weeks later, though, Bettie persuaded him to ask the car's owner to reduce the price. Lee talked the man into taking $2,000 off and was so pleased that he agreed to buy the car with Bettie.

Suddenly seeing the car's potential, Lee began sinking all of his spare money into building a lowrider. He quickly went from spending $150 a week on parts to $600 every two weeks. He worked Saturdays to make extra money, and at Christmas he put his entire $2,000 bonus into the car.

license
'63 Chevy Impala
Owner Lee Córdova of Alcalde

'78 Ford Thunderbird
Owner Bettie Córdova
of Alcalde

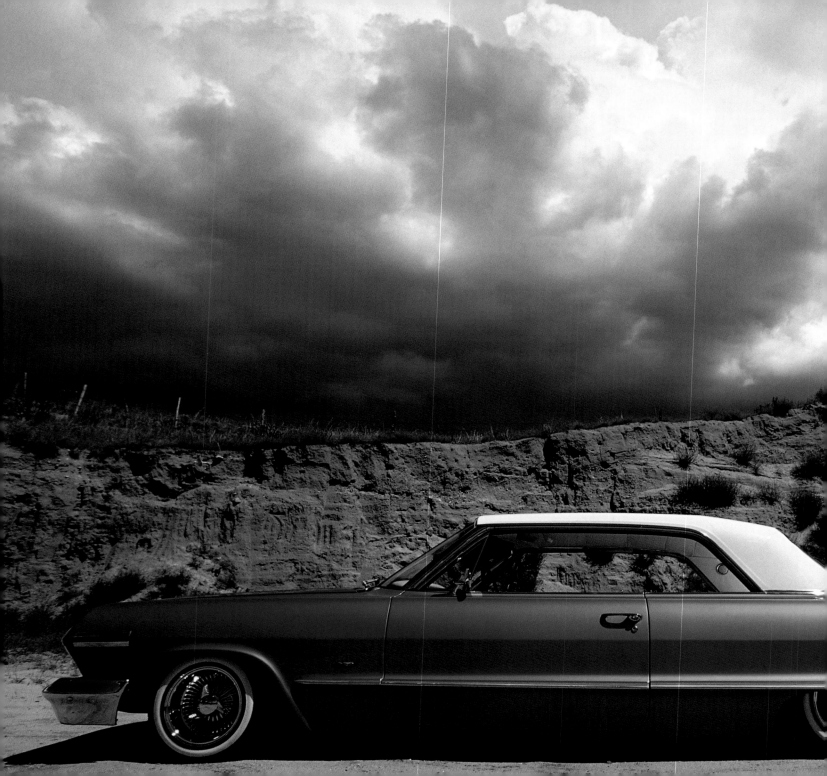

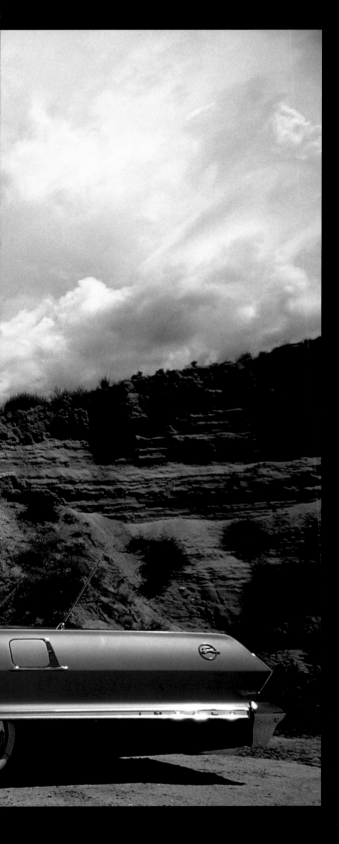

"It got to where I hated to see the UPS man coming," Bettie recalls.

"I got extremely carried away," Lee concedes.

Still, Bettie wasn't about to put a damper on Lee's enthusiasm. She suggested they join Classic Creations, a local car club, and begin exhibiting their cars at area car shows. In 1997, their Impala placed first in its category at an Albuquerque show. But the best prize, Bettie says, is the special bond the car has created between them.

"The car has made us closer in our marriage," she says. "We're lowriders in love."

'63 Chevy Impala
Owner Lee Córdova of Alcalde

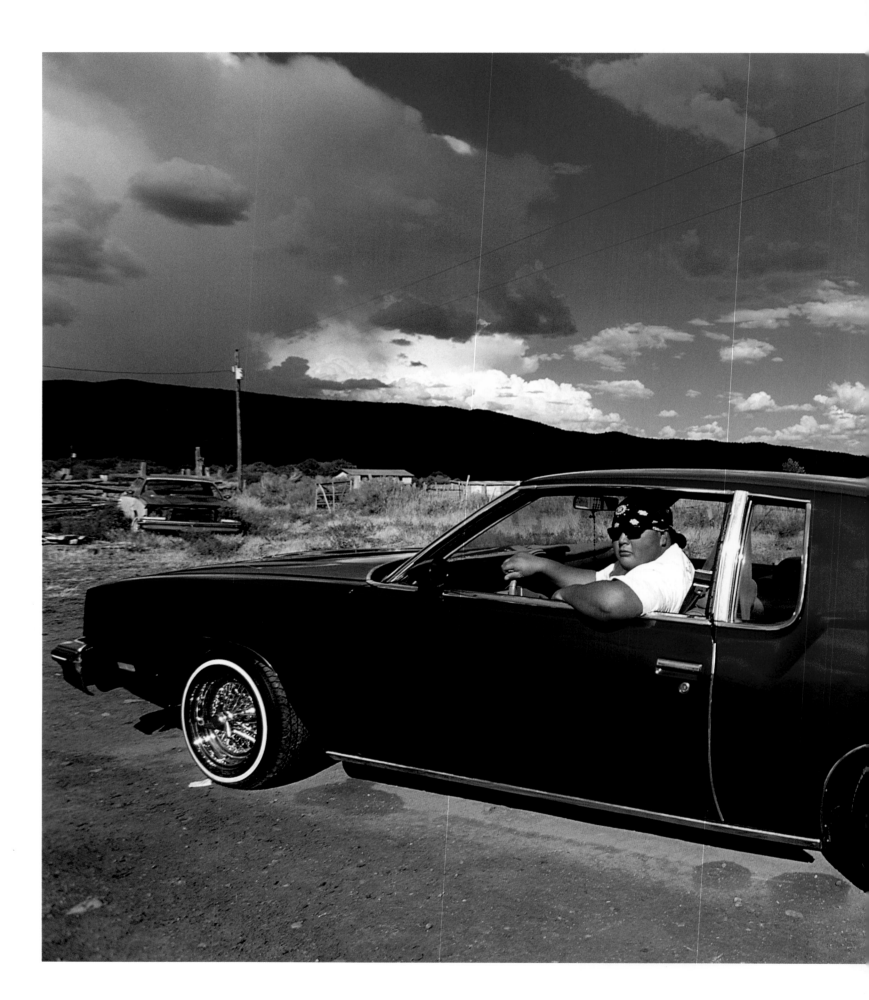

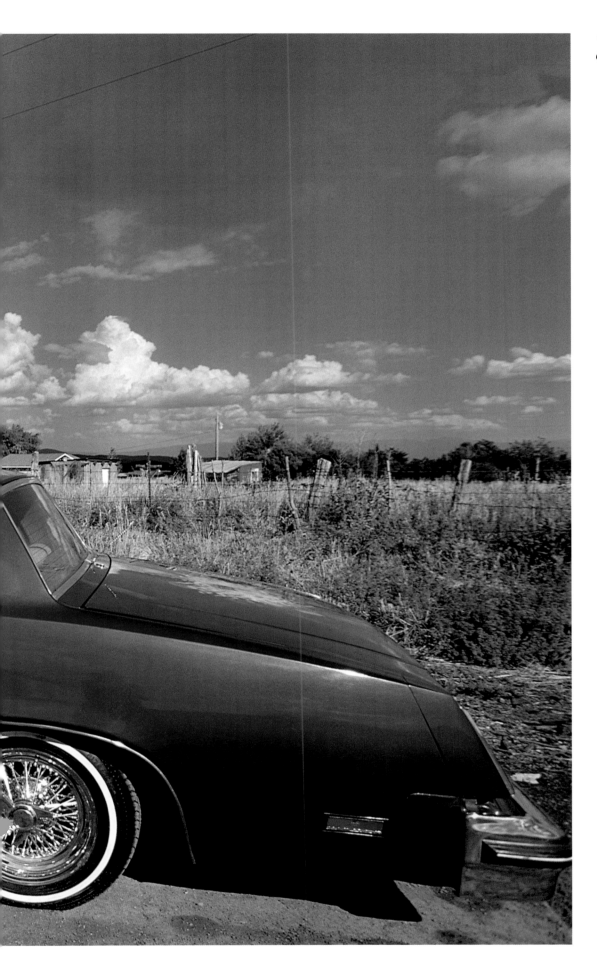

'78 Olds Cutlass
Owner Adam Alire of El Rito

La eché en un Carrito
by Juan Estevan Arellano

"Don't you worry," *retumba la radio del "Carrito Paseado" as la plebe, el vato loco del arroyo del rutututú* puff on their Camel, *soltando "rueditas de amor."*

As they huff and they puff the '57 Chevy jumps up and down and sways from side to side up Riverside Lane in *"España,"* after driving down from *"Chima,"* the Capital of Lowriders *en el norte.*

Chimayó, the village known to historians and folkorists for its pilgrimage during *Semana Santa,* and to the cops in *el norte* as the heaven of *tecatos* and overdoses. Chimayó, famous for its *chile* and *manzanas,* now also famous for its wrought iron windows and doors so the *tecatos,* not the lowriders, can't enter.

But who's a lowrider, *el chavalo de la Molly* in his '64 Impala *de la llantas peladas* in his low and slow rider, with the torn seat covers and the *rosario* hanging from the rearview mirror, or the *vato que no está tan loco* who works in Los Alamos as a machinist and is already a granpa?

Birdie, *el "Colora'o" de la* Tonie (she worked at the Motor Vehicle for years in *Santa*), is a lowrider and a biker, a Harley *ese, de esas chingonas,* like the horses his *abuelo* used to own. In fact, there would be no lowriders if the *jefitos* would not have been so *aficionados de los caballos.*

The people in *Cañoncito* still remember *"Lalito"* and his *yegüita la "Nellie,"* whom he had decorated with all kinds of reflectors and pieces of chrome all over the saddle and *freno.* In fact when "Nellie" was burned inside her corral by some wise-ass who was never caught he would get upset *si no le dabas el pésame!*

Then he got himself his first lowrider bike, back in the late '50s before *Lowrider* magazine; he decorated his bike like he did "Nellie," with chrome and reflectors all over. *Lalo* the Irundian of the Chicanos could be seen all over *el norte,* at times he was peddling to Taos, or he would be seen by the Opera by *Santa* or in *Abiquiú,* resting in the shadow of *"el Pedernal,"* the vagabond mountain on the *Río Chama.*

It was with *"Lalo,"* that my *cuñados,* brothers-in-law—or "cunnies," as Casías would say—got their initiation into the lowrider *movida,* modeling their *baiques* on his twenty-six-inch cruiser, then when they came back from Nam and *Lalo* had gone to a nursing home, they would always evoke his name as if he was a saint, the saint of the lowriders, as they would reminisce about *"Lalito's"* bike and how he used to decorate it and how that idea came from his horse "Nellie" and the many "nellies" the *jefitos* used to take pride in and their *frenos y sillas flamantitas y bien arregladitas.*

That same culture of always making the horse something to be proud of, of having the most *chingón caballo* somehow transferred from their *jefitos'* and *abuelitos'* generations to their Model A and Model Ts and later to the '57 Chevy or the '64 Impala, '72 Monte Carlo and so on. The *carro aplanado,* had replaced the *caballo paseado,* but the pace was still low and slow.

Today the lowrider holds on to his culture through his lowrider car, *la ranfla de ayer, descendiente de los primeros caballos* that Oñate brought with him to the Española Valley in 1598, *el carrito pasea'o* has become his traveling art gallery, his museum on wheels, with his

Virgen de Guadalupe on the hood of his "Monte" and another one tattooed on his arm, by his first tattoo from junior high where he crudely scribbled "Mom + Dad" and "l-o-v-e" on his knuckles and the faded letters of his first girl, *"Linda,"* now married to the sheriff, the one who gave him a DWI about ten years ago, when he used to drink *bironga.*

Hoy todavía le caen sus gallazos, sus buenos toques, todavía es miembro de la sociedad del cartucho aunque ya no está activo en la sociedad del corcho. "Drinking was getting me into a lot of trouble, but a little *'yesquita'* in moderation is *fregón.* I can't afford to drink and go cruising in my lowrider. *Me costó mucha feria.* I have about $20,000 invested in my 'mean machine.'"

Before lowriding became a fad, it was the cruisers who made the rounds from burger joint to burger joint in Española, *mirando a las chavalas en su "pantalón blue jean" bien apretaditos, wachando aquellas curvias de bajada y yo sin brecas, la Rachel, la Margo, la Maggie,* and all the rest of the *chulas de Chima, Truchas, 'l Alcalde, 'l Dique, de todos los* towns.

On weekends you find most of the *vatos,* now some of them are getting to be *rucos,* well, not really *rucos* like *los abuelitos o los tíos,* but the reality is that they are now "granpas" and *tíos;* not too long ago they were *estudiantes en el* "community college" *en El Rito y en el TVI en 'Burque.*

La Maggie, te acuerdas, she was *cuerota, que cuerpito tenía* and now she is all fat, *pobrecita, con las nalgas sueltas y guangas* and when she walks her twenty-four-inch waist of the early '70s now moves ("*chacualea*") like a jello hula hoop.

But today she is no longer *la chuca de* Taos she was then, when she would dance away the nights at *Los Compadres* and *La Cucaracha* drinking *Cuba Libres* and chasing them down with Coors, from the land of clear blue waters, *ella y la* Black Widow *tirando chancla toda la noche esperando la movida, en la espeta mientras tocaba el Silas, pobrecito ya murió,* and he would say, "Is everybody happy?" then as he got ready to play the last *rola* he would blurt out, "Motel time, motel time, *plebe!*"

That night, *el último bolote, lo bailó bien pegadita con el* Tom, she danced like she had never danced before and after the dance they went for a cruise in his '57 Chevy with four on the floor, with its brand new 350 engine, *la* Black Widow *también fue con su camarada el "Rock,"* they had a couple of more six bangers and two homegrown *frajos de la morada y se pusieron bien carmelitos, ni pa' que te cuento.*

In the *movida,* between kisses, they realized they were both students en El Rito, he was studying auto mechanics and auto repair—a double major, *ese*—and she was in cosmetology. That Monday he went so she could *"trimearle la greña"* and the rest, as they say, is history. Now they've been married for twenty years, though they have a twenty-four-year-old *chavala,* who has two kids. Oh *ya,* they also "shacked up" for four years. The *ruquitos* of the generation said they were *"amancebados"* and the ones that used to bathe the *padre,* the *"padreras,"* as they were called, said, *"están viviendo en pecado,"* though everyone in the community knew about their *movida* with the *cura.*

"El Padre Jesusito es muerto," they would say, in reference to an old *chiste de la plebe* about this lady that used to

have an affair with the village priest, and one day as Carmelita was walking to town she found a penis, full of sand by the convent, and she became hysterical and started lamenting, *"el Padre Jesusito es muerto,"* before she realized the penis belonged to an old haggard dog.

A quarter century later *todavía están enchanta'os aunque* both have played around, that is, both had lovers during the early part of their relationship, *él con la* Peggy who is now a nurse in Española—she is still single and beautiful—*y ella con el compadre Tacho,* but now they're all *"chales,"* very quiet, married, devoted to their families and their lowrider lifestyle.

On two different occasions Tom's car (though his real name is *Tomás León*) has graced the pages of *Lowrider* magazine, *con unas chavotas casi encueradas untadas como mantequilla sobre la pobre Virgen de Guadalupe,* and he has won countless trophies for his souped-up car.

In a way one could say that his car was salvaged from the boneyard at his *primo's.* He bought it from him while he was still in high school and started fixing it up until it became his *"carrucha,"* or *"ranfla,"* as *la plebe* would say. First thing he did was get some "mags *de puro chrome"* and for a long time he had it primed, all through high school, then one fateful day, a few days before graduation *de Santa Cruz,* he got a letter from the Selective Service telling him to report for duty in Fort Bliss—his lottery number had been thirty-nine—and he had been expecting it for some time. From '69 to '71 he was in the service and spent nine months *"en el infierno,"* as he called Vietnam.

He came back *"todo chinga'o"* and got worse when he realized his babe

Priscilla had married his best *camarada Felipe*—he was devastated *y le entró a la peda, grifa y coca,* well, he came hooked on *"la soda, de aquel la'o,"* as his parents would say.

Maggie, she was a cheerleader for the Peñasco Panthers during her freshmen year and a varsity cheerleader for the Taos Tigers during her sophomore, junior, and senior years, that is, she moved to Taos with her mother after she divorced her father the summer of '70. Her *jefita* was from *Ranchos,* that summer her mother, two brothers, and herself moved into an old mobile home her granpa owned in the middle of the *vega* where his father at one time used to plant wheat, then later on he used to plant white corn, *"maíz concho,"* el propio para chicos.* But as he got older he stopped planting and the *rastrajo* eventually returned to *vega.*

The old '57 is now on four piñon stumps out back, while the second '57 he bought after he returned from Nam is his son's, Manuel or "Manny," the one he now uses to cruise his dad's old stomping grounds in Española, Santa, and Taos. His dad, now that he is middle aged and a granpa, has two lowriders, a pickup '51 Chevy all "cherried" out for show and a '74 Monte that used to belong to an old retired lab worker in Los Alamos.

Not much has changed *"en España"*; the kids still cruise from Sonic to Sonic, their boom boxes awakening even the dead *en el Campo Santo,* here in the valley *de los españoles-mexicanos,* where the first *fregones caballos* were nurtured by Oñate. Today his descendants fix up old cars and turn them into works of art, *del modo que los abuelitos engordaban un potrillo flaco hasta que lo hacían el mejor de todo el atajo.*

'59 Chevy Bel Air
Owner Fred Rael of Fairview

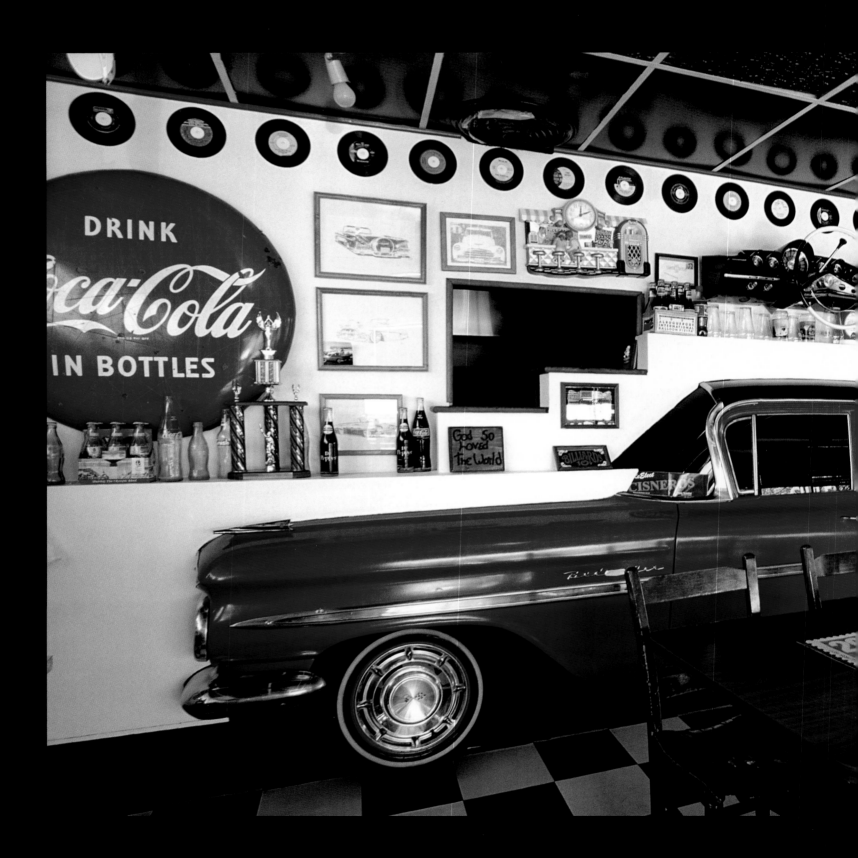

Eat at Ol's

"**W**hen he first told me he was going to be a lowrider. I cried." Olivama Rael says. motioning across the table to her son. Fred. "I went to my prayer-book leader and said. 'I need prayer. My son's going to be a lowrider.'"

It is just before the dinner rush at Ol's Diner in Española. the Rael family business. The Raels are remembering when "lowrider" was a dirty word in their home. It was 1977. and Olivama and her children had just moved back to their native New Mexico from Los Angeles. Mom took a job as a waitress. and thirteen-year-old Fred began showing an interest in cars.

"When we came to Española. I heard that lowriders were really bad. and like everybody else. I believed it." Olivama continues. "But my prayer-book leader asked me if I'd rather Fred spend his money on liquor and drugs. He said if he spends his money on his car. it's a blessing in disguise."

As Fred immersed himself in the how-tos of bodywork. mechanics. upholstery. and other lowrider luxuries. Olivama slowly converted to the lowrider faith. By 1983. when she bought Ol's Diner. a 1950s-style burger joint. she was so enamored with lowriders that she had Fred install one in the dining room. He sawed a 1959 Chevy Bel Air lengthwise in half. painted it cherry red with a black top. and bolted it to the wall. "A lot of people think lowriders are immature." Fred says. "but they're an art form."

Situated on Riverside Drive. Española's main drag. Ol's is now a popular hangout for lowriders who come from all over Northern New

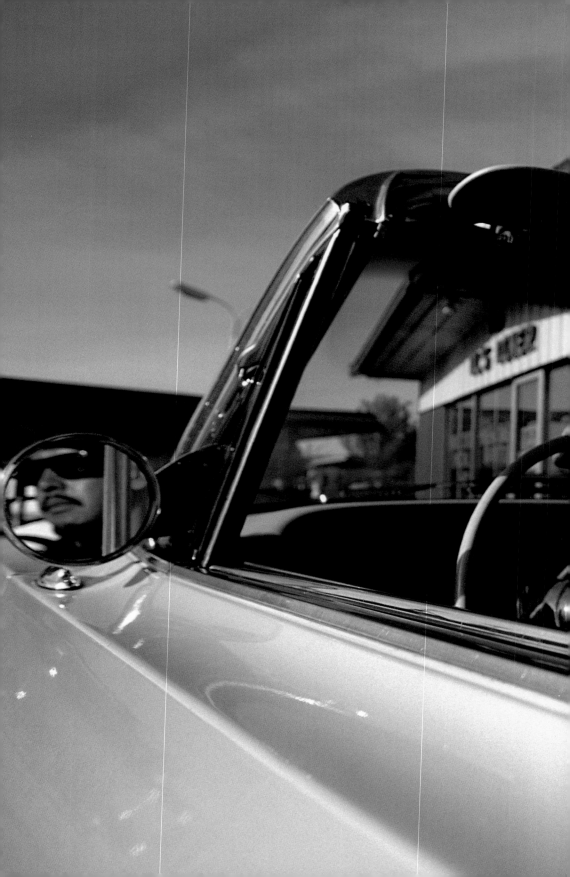

Mexico to cruise. When Fred's not navigating his '64 beige Impala convertible—complete with 24-carat gold rims—through city streets he and Olivama are at the restaurant enjoying the view.

"When I see a nice lowrider pass by, it makes my day," Fred says. "But if it doesn't scrape the pavement, it's not a lowrider. It's just another car with rims."

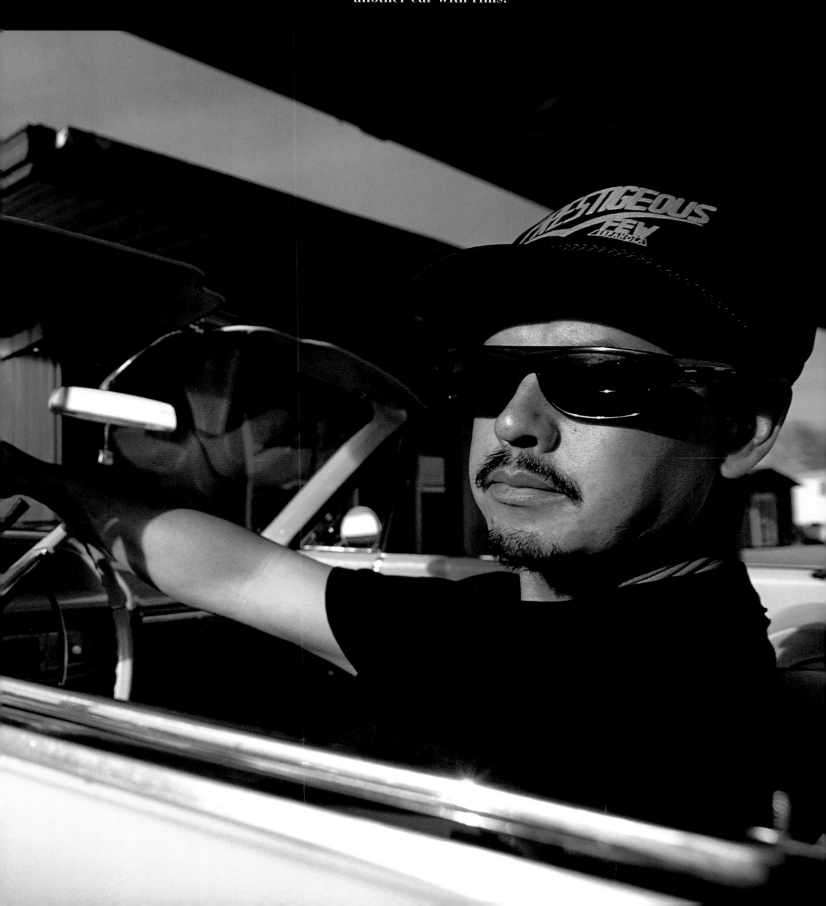

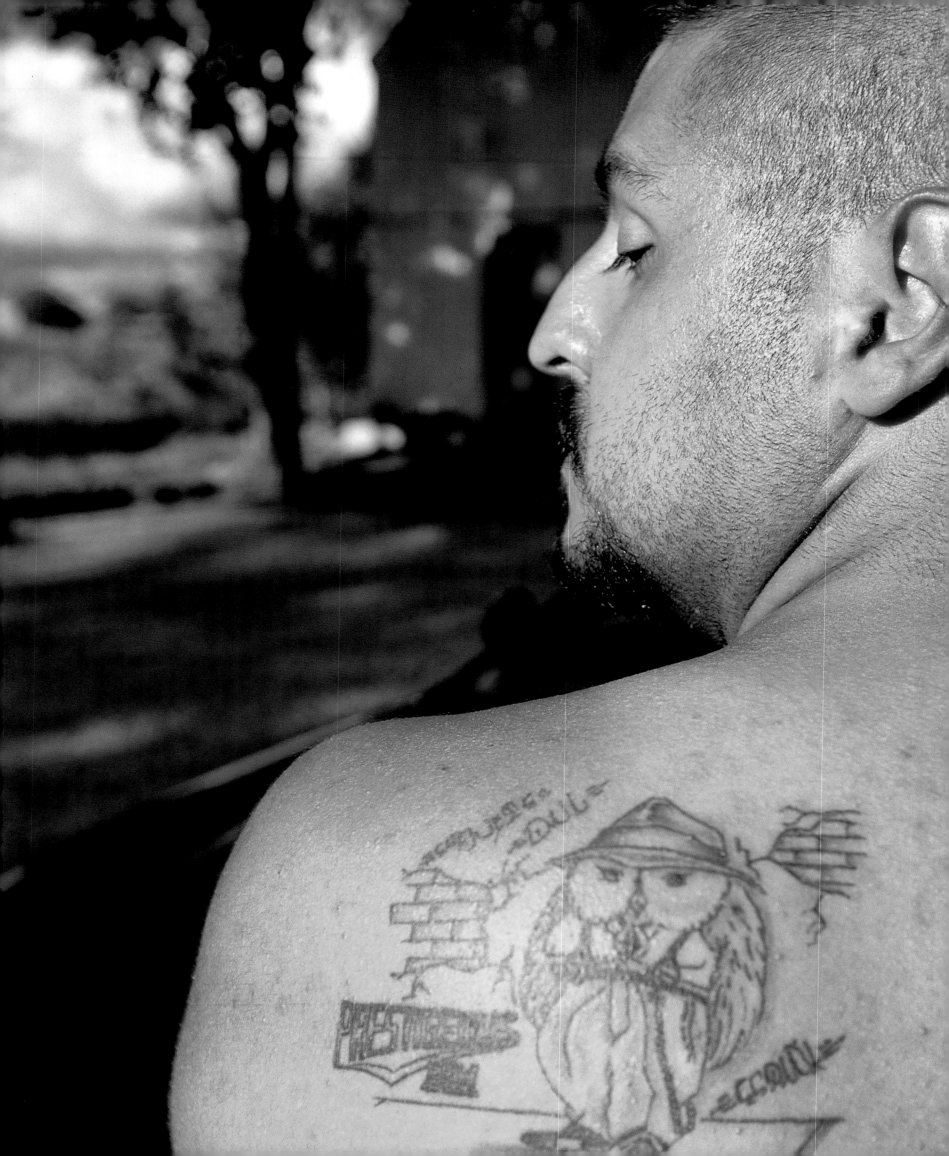

Night Owl

*'95 Honda Civic
Owner Carlos Sanchez of Española*

As a kid in Los Angeles, Carlos Sanchez was known as "the Night Owl" because he often snuck out of the house at night to roam city streets. Sanchez and his late-night companions weren't out to cause trouble, but the fact that they were young Hispanics made them prime candidates for the "gangbanger" label. Their love for lowriders set them up for the stereotype even more.

When Sanchez later moved to Española, he was thrilled to see its flourishing lowrider culture but disappointed that the lowrider–gangbanger stereotype still prevailed. Thus, in 1993, after cofounding the "Prestigeous [*sic*] Few" car club, Sanchez set out to change the community's negative views.

"We decided to market ourselves as a community-oriented club," Sanchez says. "We wanted to show people that most lowriders are good people. Most of us are hard workers who have two or three jobs just to stay above water."

Club members organized a car show to raise money for area charities. Convincing city officials to allow the one-day show was difficult at first, but after the charity donations had been made, they welcomed the following year's show. Today it is the largest lowrider show in Northern New Mexico.

"We're more than just a car club that cruises on the weekends; we're like a business," Sanchez says. "But the best part of what we do is show kids that the best way to stay out of trouble is to get into this."

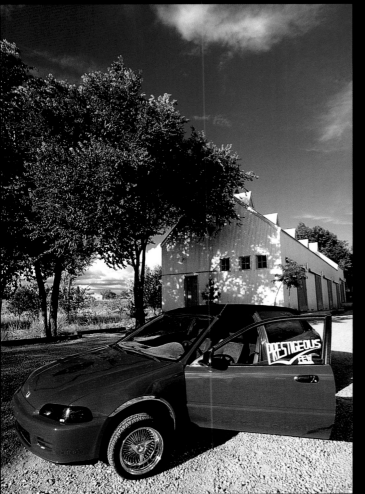

'75 Chevy Monte Carlo
Owner Joseph Jaramillo
of Vallecitos

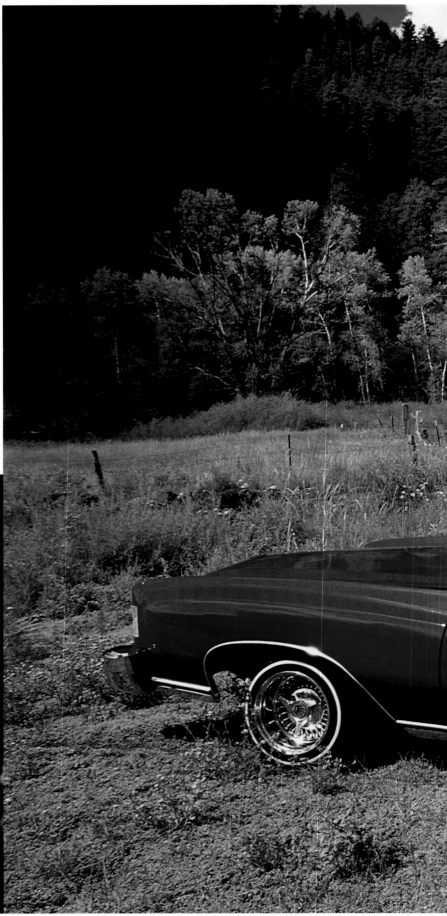

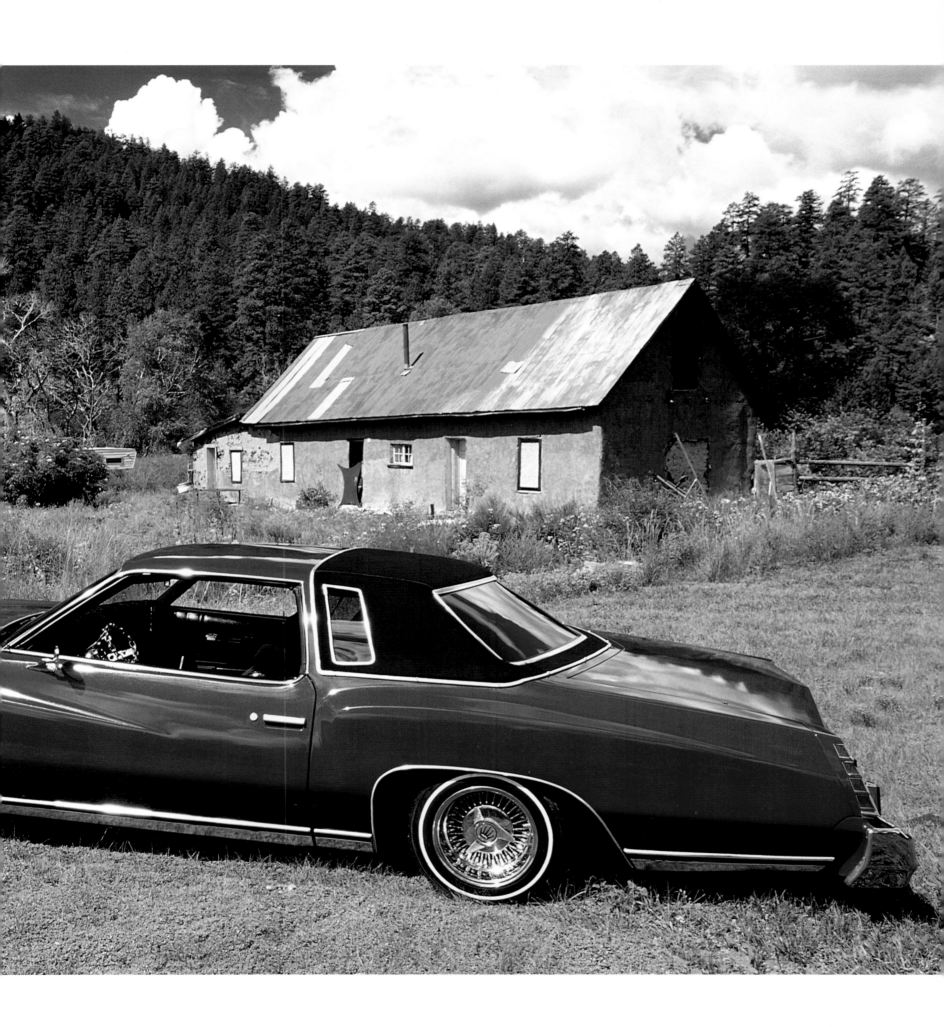

'67 Pontiac
Owner Arthur "Lolo" Medina
of Chimayó

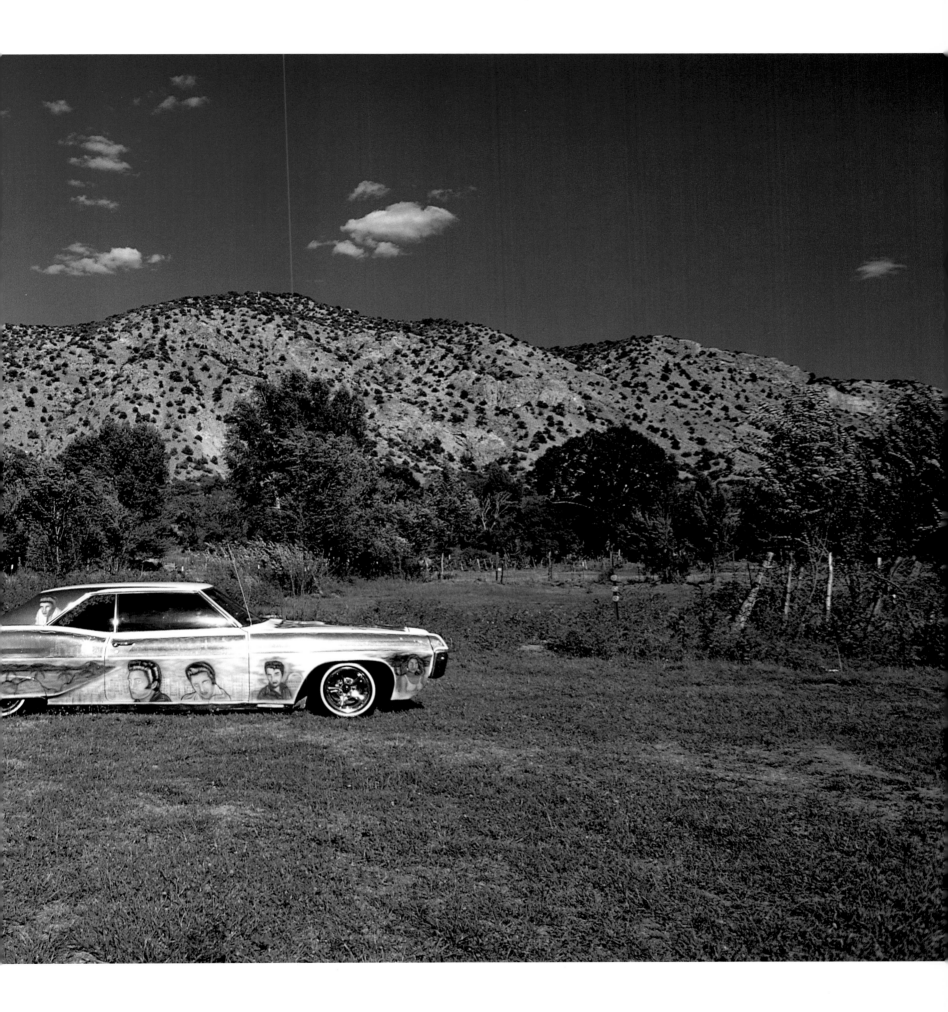

'41 Ford
Owner Melecio Martinez of Santa Cruz

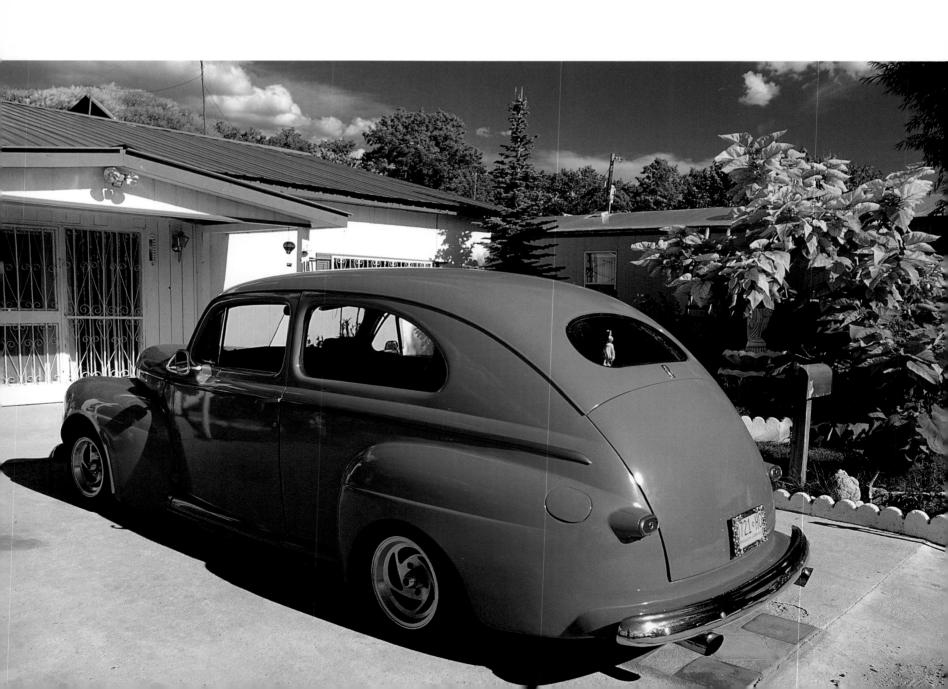

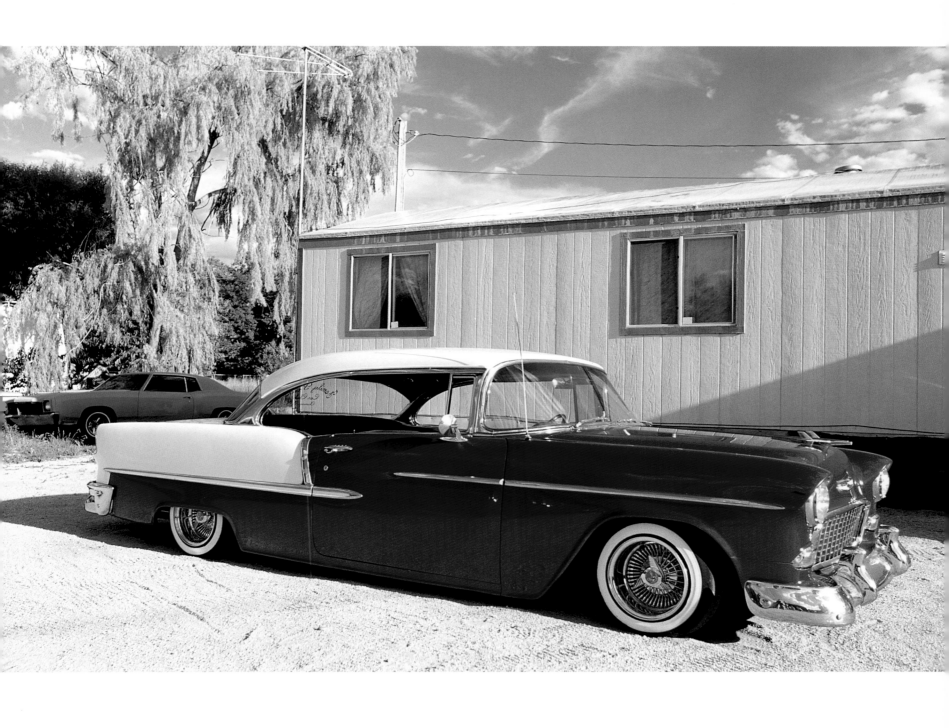

'55 Chevy hardtop
Owner Tony Martinez of Santa Cruz

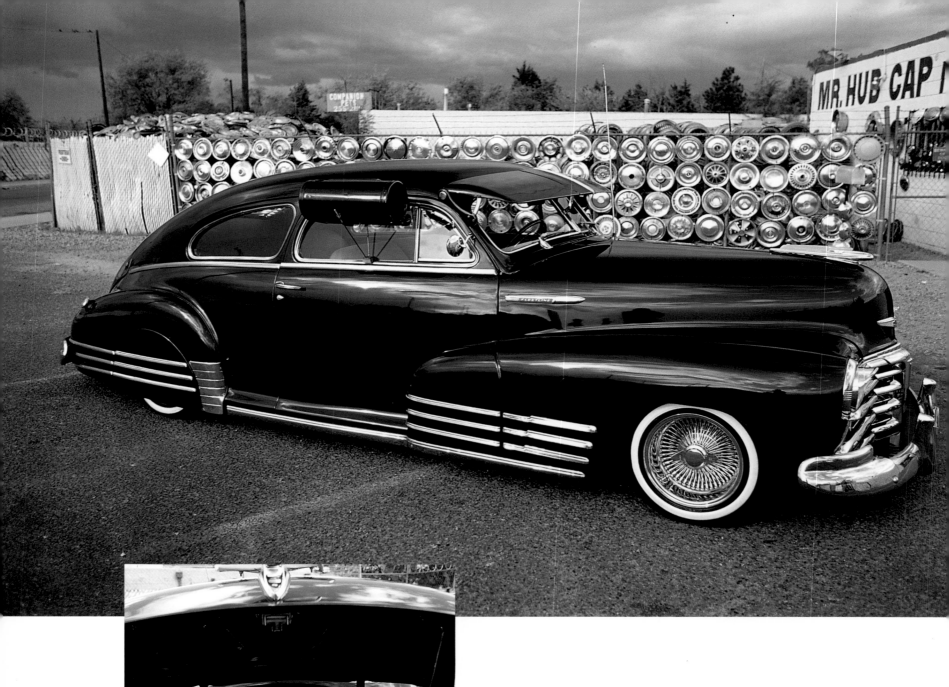

'48 Chevy Fleetline
Owner Jerry Leyba of Albuquerque

'62 Chevy Impala Super Sport
Owner Antonio Gonzales of Socorro

following spreads
'77 Lincoln Continental Mark V
Owner Joe Maestas of Rociada

'59 Ford pickup
Owner Eddie Salazar of Española

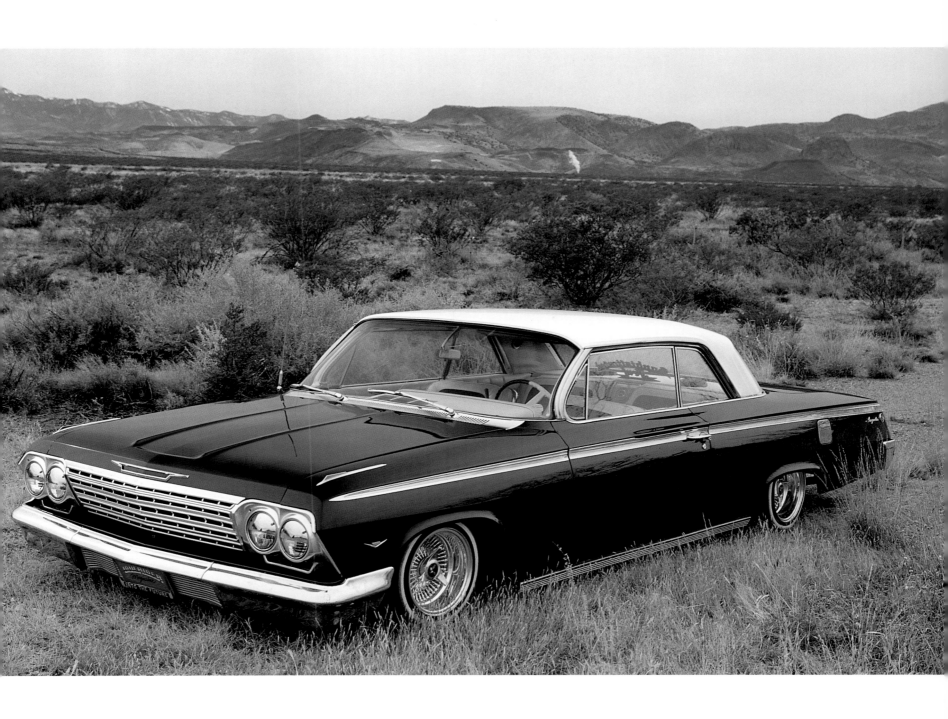

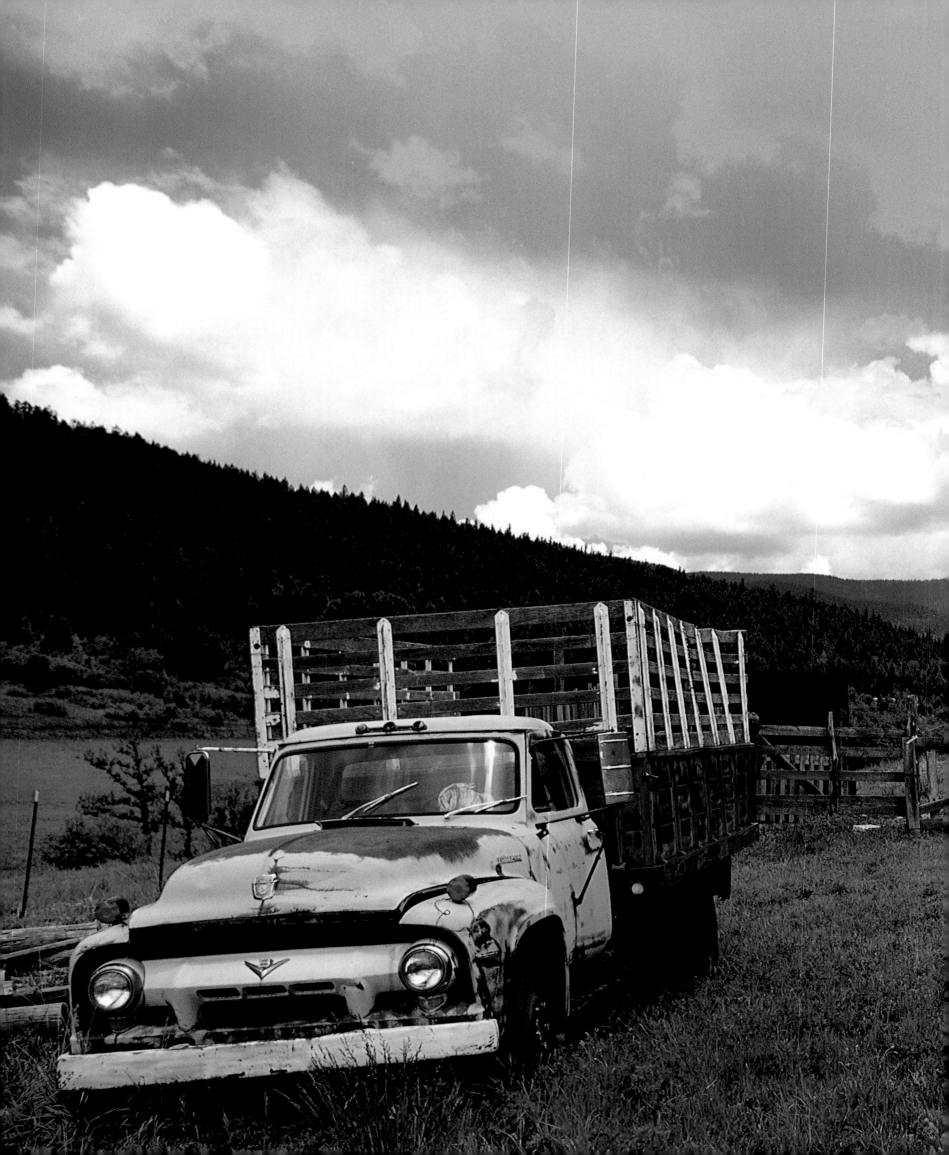

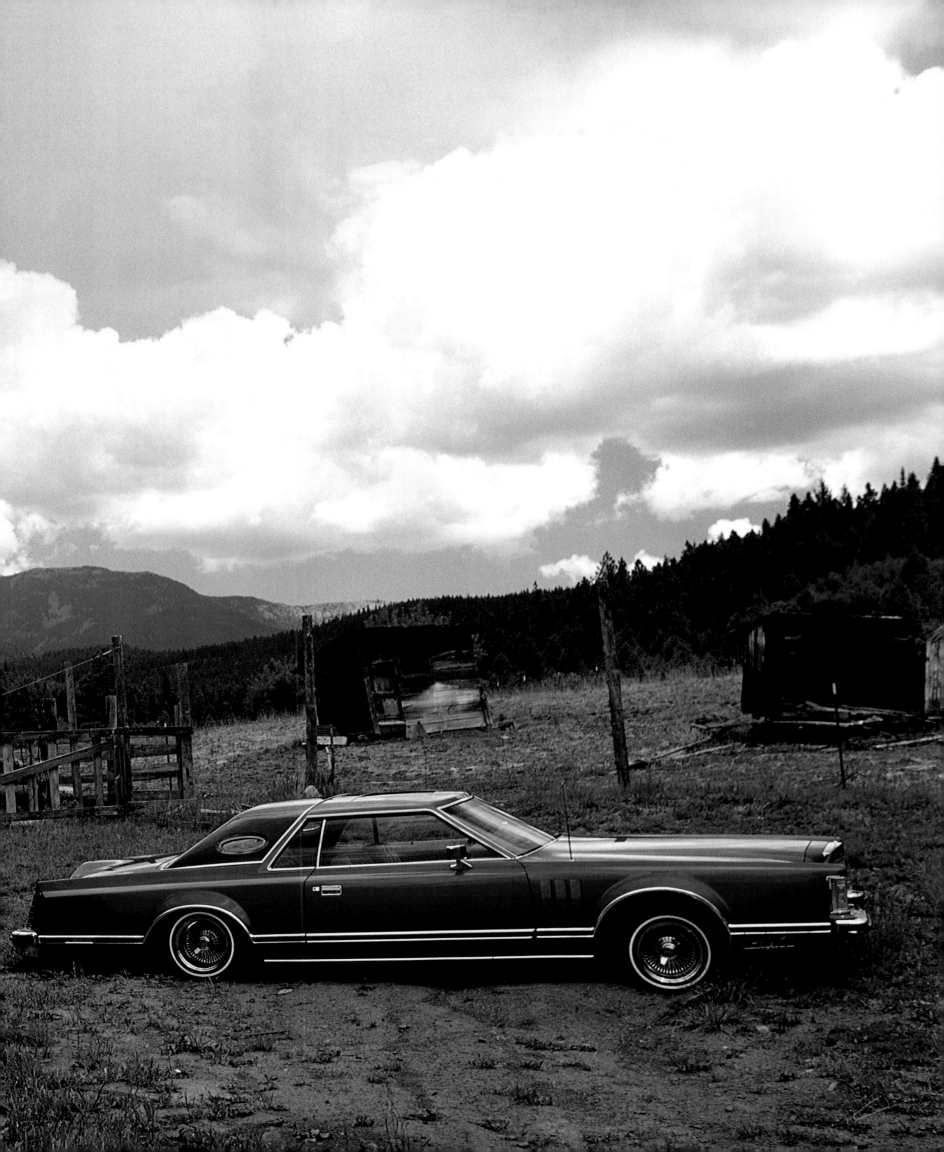

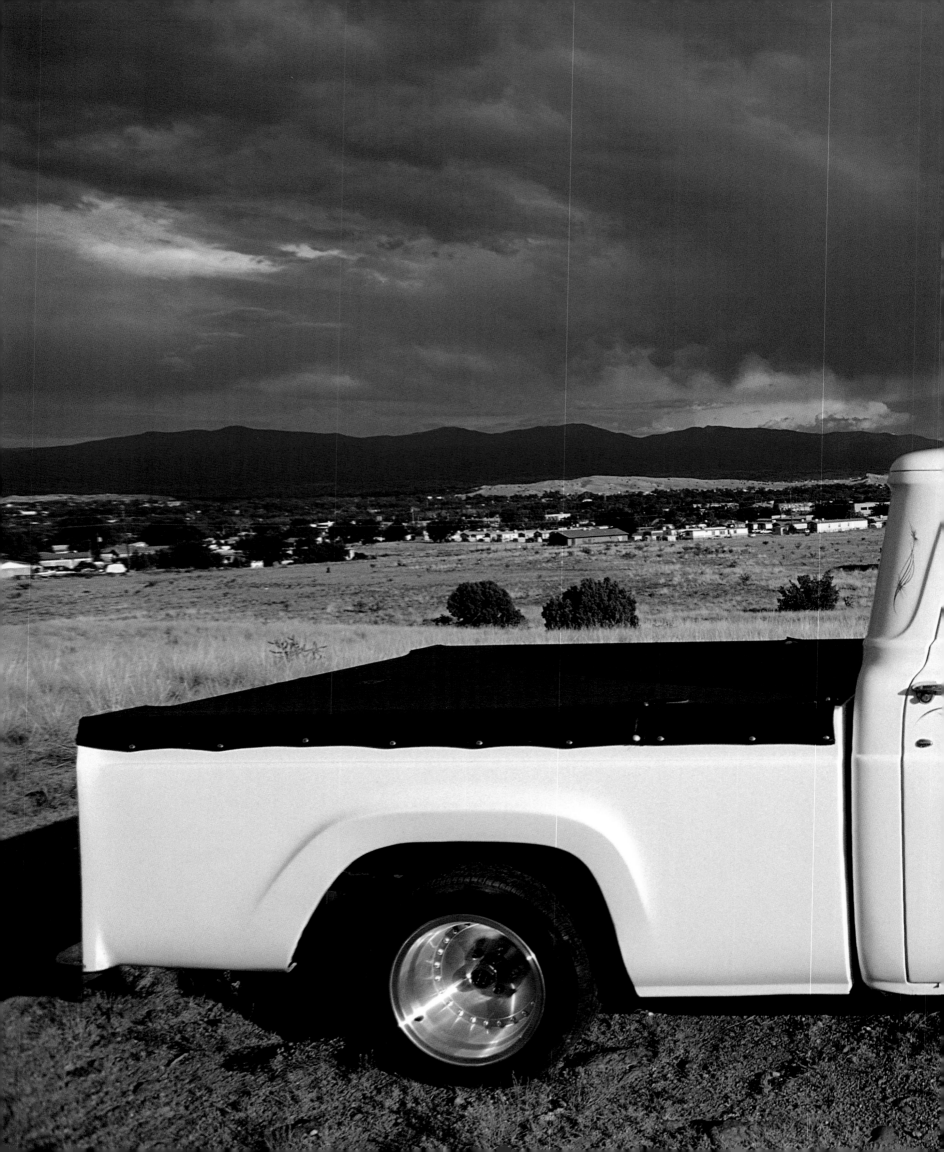

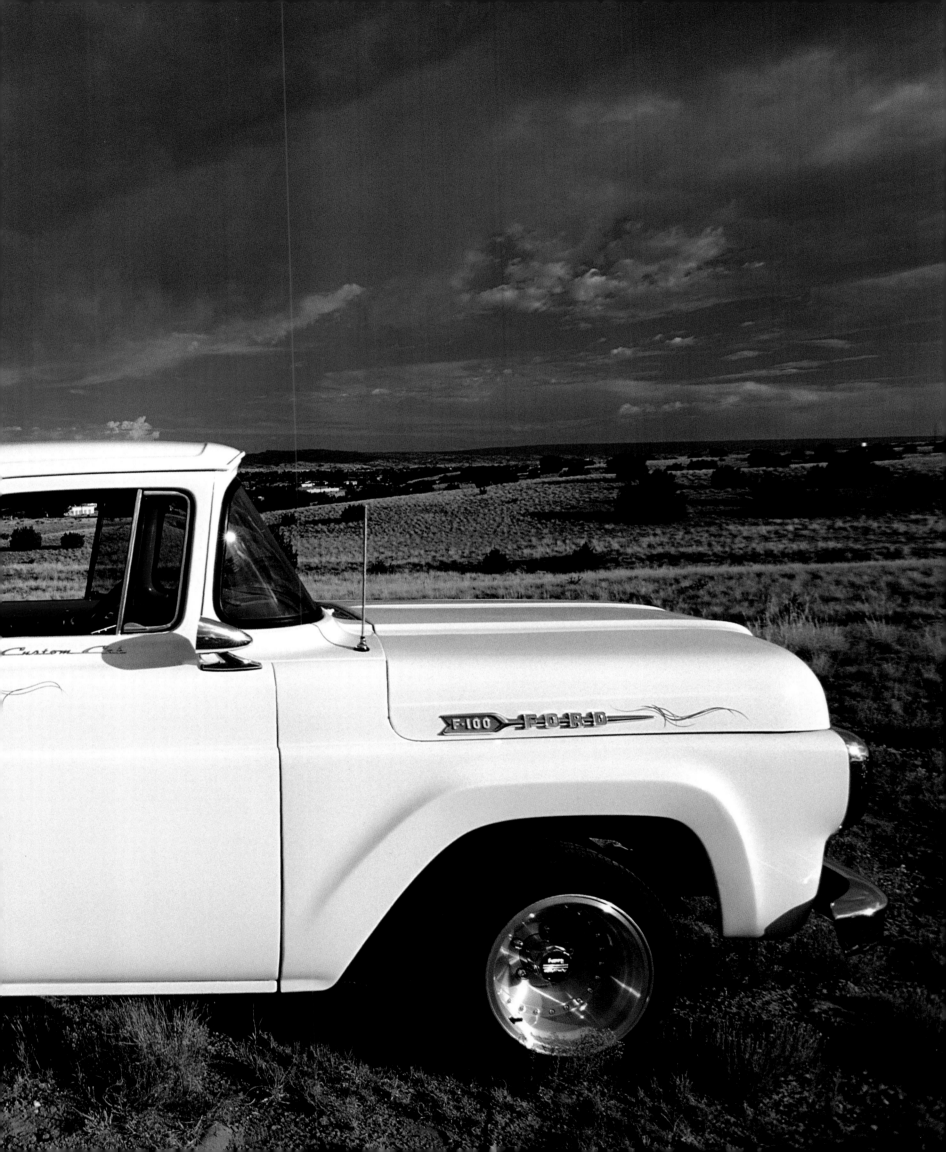

'77 Pontiac Grand Prix
Owner Xavier Nevarez of La Cienega

right
'66 Chevy Impala
Owner Willie Montoya of Los Alamos

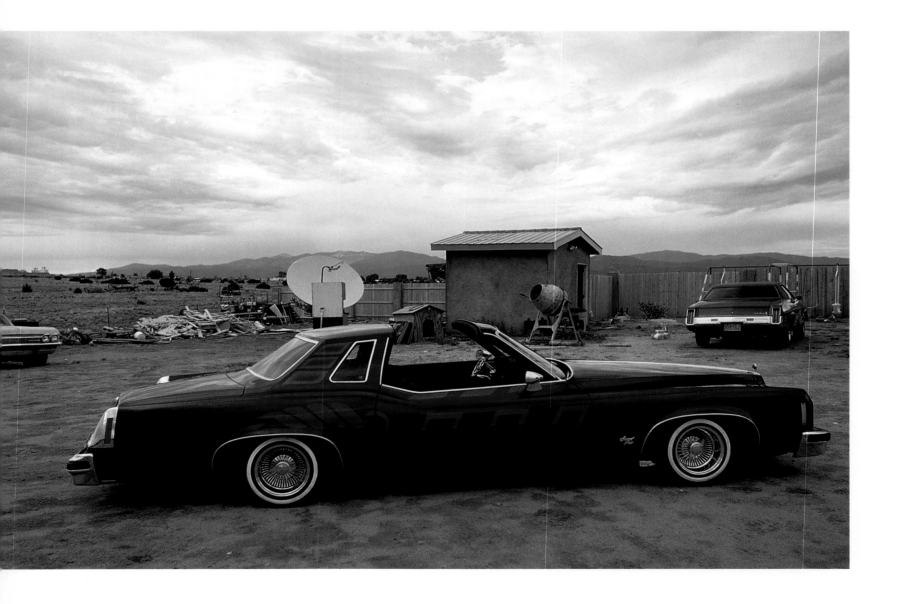

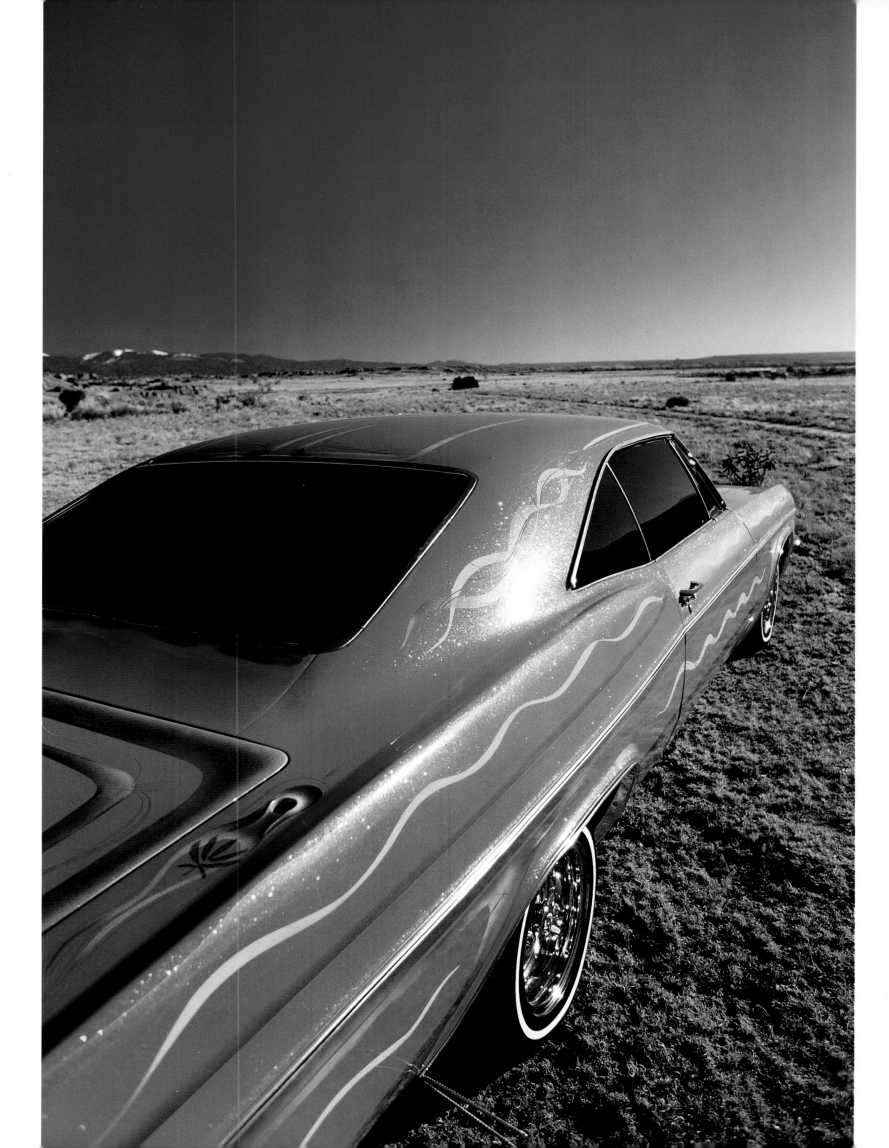

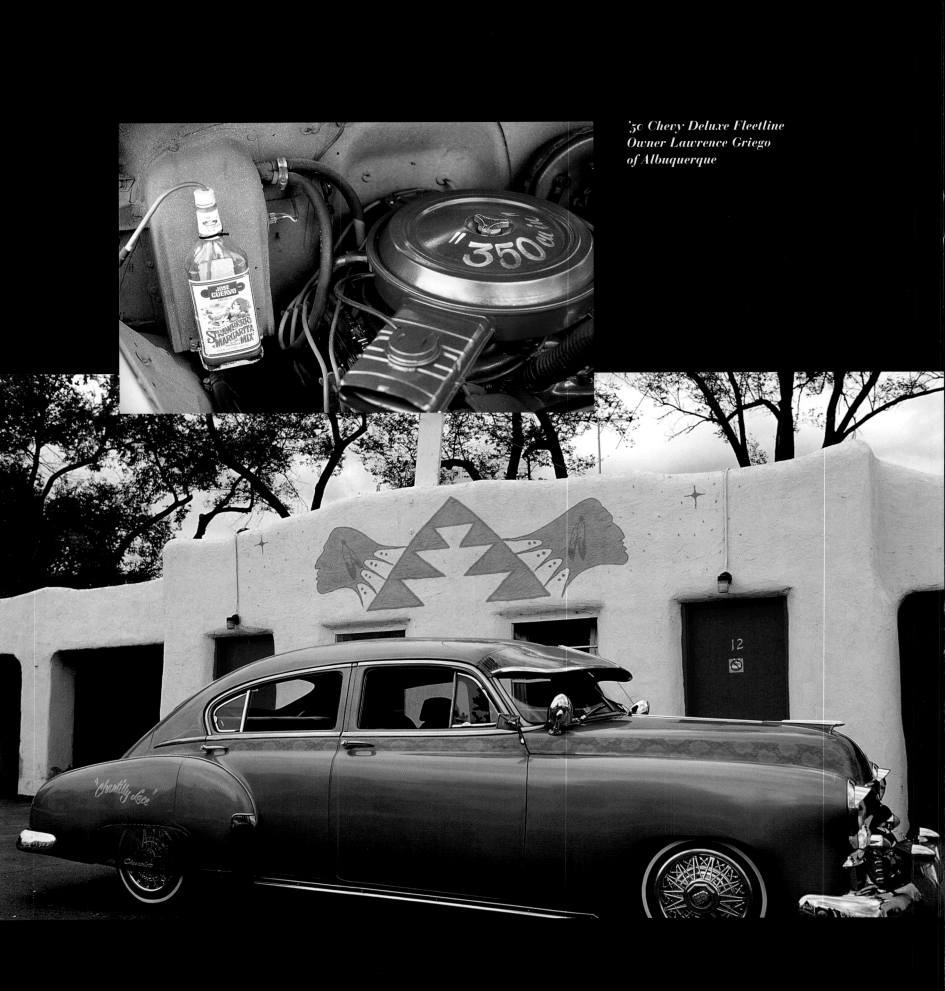

*'50 Chevy Deluxe Fleetline
Owner Lawrence Griego
of Albuquerque*

Fathers and Sons

When it comes to cars, Lawrence Grieg[o] and his father, Albert, have an unspoke[n] agreement: "He won't mess with one of m[y] cars and I won't mess with one of his ca[rs] unless we're together," Lawrence Grieg[o] says. "So, basically, we're always together[."]

With twelve cars between them, th[e] Griegos spend a lot of time in the[ir] Albuquerque garage. Lawrence has bee[n] taking automotive lessons from his fath[er] since he was a boy, and now that he's [a] father himself, Lawrence has introduc[ed] his son to the lowrider life-style.

"Me and my father and my little bo[y,] we're inseparable," Lawrence says. "It's the challenge of restori[ng] these lowriders, to see if we can do it, that keeps this family together[.] Two fine examples of meeting the challenge are "Chantilly Lace," [a] 1950 Chevrolet Deluxe Fleetline, and "Glamorous Life," a '64 Chevrol[et] Impala. After literally digging one car out of an arroyo and hauling th[e] other from a junkyard, they have now spent nearly $30,000 to resto[re] them to their original condition and give them a unique lowrider loo[k.]

"All the little $5 items you purchase add up down the road[,"] Lawrence says. "But the way we see it, your car is your personali[ty.] The nicer the car, the nicer the person. We're pretty nice people."

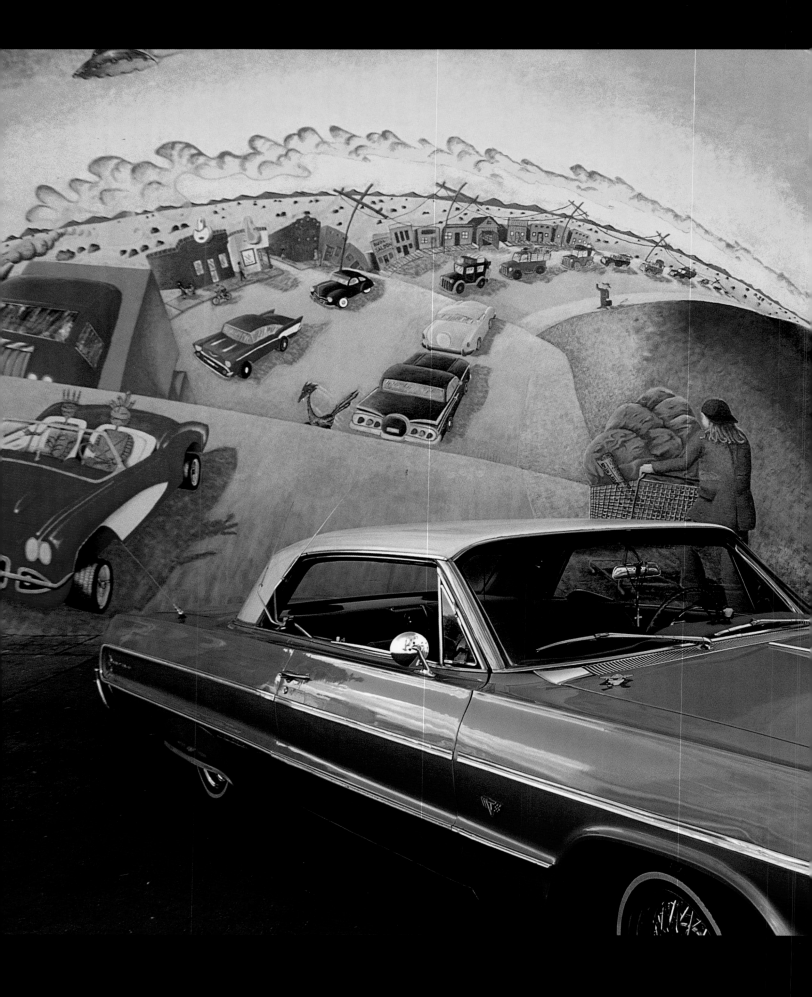

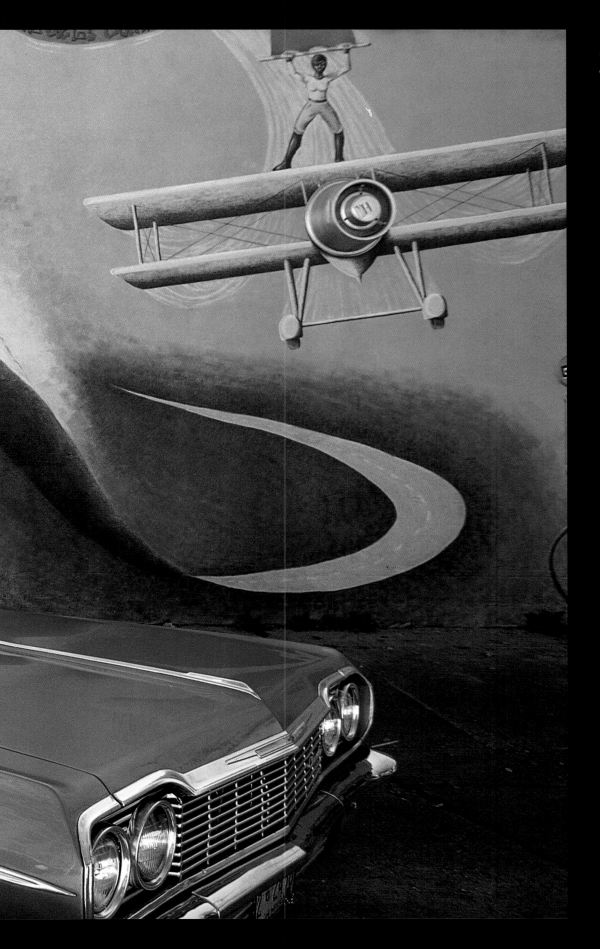

'64 Chevy Impala
Owner Albert Griego
of Albuquerque

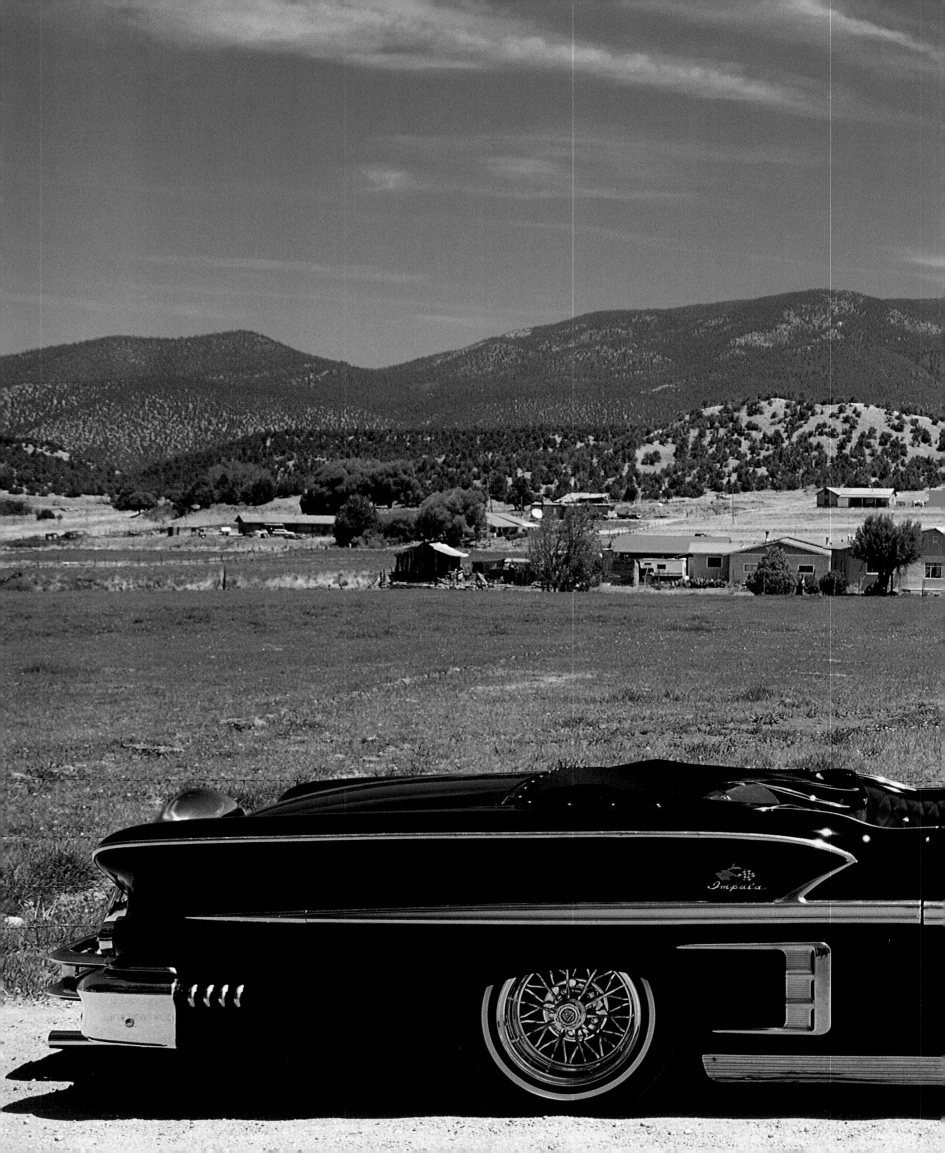

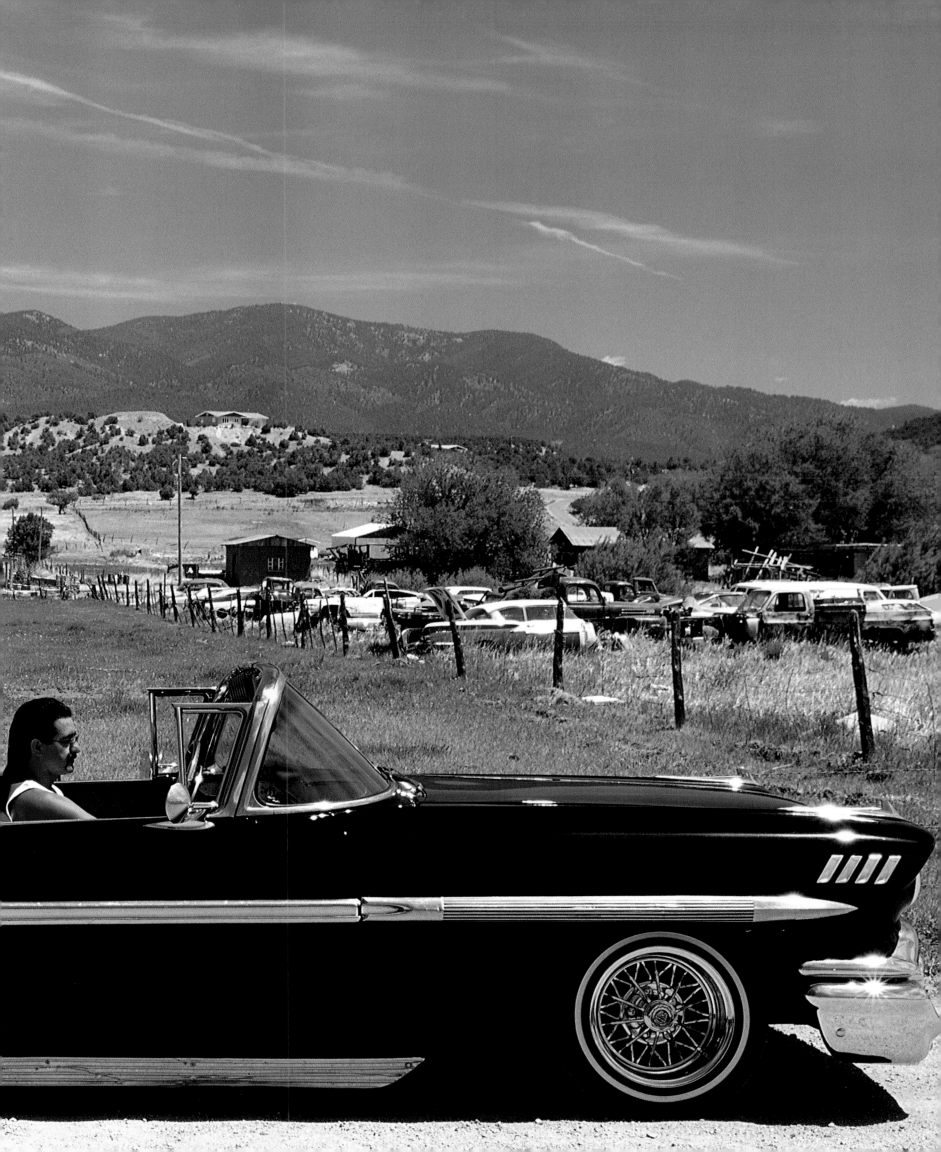

Acknowledgments

All the cars in this book, with one or two exceptions, were photographed at the owners' homes or in the owners' home towns.

I wish to express my thanks to Nicholas Herrera, Carlos Sanchez, and Eddie Gallegos, all of whom helped me find an endless number of cool cars to photograph. Many thanks also to Randy Martinez, a talented painter whose airbrushed creations adorn so many of these wonderful rides. I began to document Martinez's work in the early 1990s and it was through him that my interest in and respect for the art of the New Mexico lowrider grew. Without him, this book would not have happened. Terry Lynch and Brook and Mara Taylor also contributed greatly to this book and their hard work and friendship were invaluable throughout. Thanks also to Meridel Rubenstein, whose portraits of lowriders exhibited in the 1980s have always been a source of inspiration, and to Edward T. Hall, whose insights into different cultures have profoundly altered the way we view the world around us.

—J. P.

The authors also wish to acknowledge Mary Wachs, David Skolkin, Anna Gallegos, and Joanne O'Hare of the Museum of New Mexico Press for their hard work and encouragement throughout the production of this book. Also, a hearty *muchas gracias* to Juan Estevan Arellano, whose distinctive poetic voice gives the book an extra boost of adrenalin and authenticity.

Benito Córdova gave his unique scholarly viewpoint and articulate explanations of lowrider history.

Most importantly, we want to thank the numerous lowriders who generously gave their time, insight, and of course, their incredible cars to countless photography sessions, phone calls, and interviews. Among them are: Adam Alire; Gary Aragon; Steve Aragon; Leroy Baca; Carlos Carrillo; Leonel Chacon; Dennis "Chicago" Chavez; Frank Chavez; Orlando Coca; Lee and Bettie Córdova; Juan Dominguez; Eddie Gallegos; Nick and Antonio Gallegos; Adam Garcia; Louis Garcia; Annette and Arthur Gonzales; Antonio Gonzales; Albert, Lawrence and Jenero Griego; Jerry, Mae, Ryan, and Jerome Gurule; T. J. Gutierrez; Lino Herrera Jr.; Nicholas Herrera; Dion Jaramillo; Joseph Jaramillo; Jerry Leyba; David Lopez; Desi Lopez; Carlos Lucero; David Maes; Joe Maestas; Patrick Maestas; Chris Martinez of Córdova; Chris and Leroy Martinez of Chimayó; Ernest Martinez; Jerry Martinez; Joseph Martinez of Albuquerque; Joseph Martinez of Chimayó; Joseph Martinez of Española; Louis Martinez; Melecio Martinez; Paul F. Martinez; Tony Martinez; Arthur "Lolo" Medina; Floyd Montoya; Junior Montoya; Rhiannon Montoya; Willie Montoya; Lee and Anthony Naranjo; Xavier and Fabian Nevarez; Donald Ocana; Wray Ortiz Jr. and Wray Ortiz Sr.; Rey Ortiz; Clarence Pacheco; Julian Quintana; Fred and Olivama Rael; Jerome Reynolds; Jay Ritter; Atanacio "Tiny" Romero; Joseph Romero; Eddie Salazar; Carlos Sanchez; Norman Sanchez; Eloy and Allen Sandoval; Dean Tafoya; Eddie Tafoya; Arturo Trujillo; Delbert Trujillo; Duane Trujillo; Jerry Trujillo; Leroy Trujillo; Marvin Trujillo; Vince Trujillo; William "Wille" Trujillo; Jose Velarde; Andreas Vigil; and Benny and B. J. Vigil. The following car clubs were also extremely helpful: Classic Creations, Dukes, New Dimension, Prestigeous (sic) Few, Touch of Class, and Xpressions.

previous spread
'58 Chevy Impala
Owner Juan Dominguez of Chamisal